For as long as there has been art, there has been discussion about art. Over the past two centuries, as ideas and movements have succeeded each other with dizzying speed and the debate between various aesthetics has turned increasingly vivid, art criticism and theory have taken on an unprecedented relevance to the development of art itself.

ARTWORKS restores to print the most significant writings about art – whether letters and essays by the artists themselves, memoirs and polemics by those who lived with them in the thick of creation, or illuminating studies by some of our most prominent scholars and critics. Many of these works have long been unavailable in English, but they merit republication because the truths they convey remain valid and important. The list is eclectic because art is eclectic; taken as a whole, these titles reflect the history of art in all its color and variation, but they are bound together by a concern for their importance as primary documents.

These are writings that address art as being of both the eye and the mind, that recognize and celebrate the constant flux in which creation has occurred. And as such, they are crucial to any understanding or criticism of art today.

Futurist

Manifestos

Edited and with an introduction by Umbro Apollonio

Translated from the Italian by
Robert Brain, R. W. Flint, J. C. Higgitt, and Caroline Tisdal[1]

With a new afterword by Richard Humphreys

MFA PUBLICATIONS
a division of the Museum of Fine Arts, Boston

MFA PUBLICATIONS
a division of the Museum of Fine Arts, Boston
465 Huntington Avenue
Boston, Massachusetts 02115

Copyright © 1970 Verlag M. DuMont Schaubert, Cologne, and © 1970 Gabriele
Mazzotta Editore, Milan
Translation copyright © 1973 by Thames and Hudson Ltd., London

*For a complete listing of MFA Publications, please contact the publisher at the above
address, or call 617 369 4367.*

This translation was originally published in the United States by The Viking Press,
New York, in 1973.

PUBLISHER'S NOTE
In tracing publication dates, the reprint of *Lacerba* (bibl. 21) has been followed in
preference to the *Archivi* (bibl. 31) in those cases where the two differ. For editori-
al help thanks are due to Caroline Tisdall and Angelo Bozzolla.

ISBN 0-87846-627-4
Library of Congress Catalogue Card Number: 72-89124

Available through D.A.P. / Distributed Art Publishers
155 Sixth Avenue
New York, New York 10013
Tel.: 212 627 1999 · Fax: 212 627 9484

FIRST ARTWORKS EDITION, 2001
Printed and bound in the United States of America

Contents

Introduction by
Umbro Apollonio

This book is not a monograph on the Futurist artists but an illustrated anthology of their writings. It may well be that many readers will share the feelings of the German Expressionist Franz Marc, who wrote to Kandinsky in 1912: 'I cannot free myself from the strange contradiction that I find their ideas, at least for the main part, brilliant, but am in no doubt whatsoever as to the mediocrity of their works.' One can only judge for oneself: the works are illustrated here and elsewhere, and in this book the ideas are placed on record. This introduction is an attempt, by an Italian critic who has concerned himself very deeply with the art of our own time, to set some aspects of Futurism in the context of the development of twentieth-century ideas on art.

The movement needs to be considered as a single entity, not in the light of individual achievements. Nobody studies, say, the Bauhaus through its individual promoters and followers; its contribution is seen as a whole. The merit of Futurism as a movement lies in the fact that it refuted the idea of an art which is nothing but personal pleasure, remote from the complexities of everyday life. Indeed, the Futurists saw the practice of art as a fount of energy capable of playing a role in the management of civil affairs, to such an extent that no productive element of the environment should remain untouched by it.

Of course, this kind of explanation should be interpreted with one eye to concrete facts, and we should not accept all their boasts at face value; often these derive more from a passion for polemics than from

any profound examination of the situation. This is a trap that many commentators have fallen into; it is difficult to stand sufficiently aloof from a situation which is still bearing fruit. Thus, Umberto Boccioni stated that 'there is only one law for the artist, and that is modern life', and that 'the era of great mechanical individuality has begun'; but all too often he seems to have equated modernity with contemporary trappings such as floorshows, workers' housing, athletic competitions, trains, cocottes, apaches, hard liquor, and so on. What is more, the Futurists revived the Symbolist aesthetic at its most spurious, and drew from it a number of rather obvious metaphors and allegories. In 1905, when F. T. Marinetti founded his journal *Poesia*, he had as collaborator Sem Benelli, who was one of the most rhetorical jobbers of that type of literature. Then there were all those diverse yet interlocking theosophical, metaphysical, mysterious ideas on the fringe of the movement. Marinetti himself, when he likened the motor car to a Japanese monster, exemplified the particular brand of misguided whimsy which aimed at a conjunction, however precarious, between Symbolist orientalism and modernity. Similar links were, of course, present in Art Nouveau poetry and painting, from which the Futurists drew much; but in Art Nouveau we have, in most cases, a valid fusion in which the two elements interact with reciprocal and equal functions, and do not remain associated merely through a superficial analogy.

Futurism, in short, is a complex and composite phenomenon. In it we find various fruitful and vivid intuitions concerning the near future, and, at the same time, laborious revivals of declining themes which had already had their day; genuinely new formal solutions, accompanied by derivative and artificial mannerisms; impulses aiming at a free and progressive society, alongside an arrogantly imperialist and autocratic political viewpoint.

Among the many observations which arise from a careful reading of those Futurist writings which show the most genuine modernity (ignoring negative developments, which for the most part are found in the second phase), it seems to me worthwhile to cite some which show how the Futurists – notwithstanding the movement's many deviations and retrogressions – can be regarded as true prophets. Today cybernetics has invented machines to carry out the work of men, both physical and mental; well, Corradini and Settimelli, in their manifesto of 1914 on 'Weights, Measures and Prices of Artistic Genius', declared that 'there is no essential difference between a human brain and a machine. It is mechanically more complicated, that is all. . . . For a typewriter to have its E pressed and to write an X would be nonsensical. A broken

key is an attack of violent insanity. A human brain is a much more complicated machine. The logical relationships which govern it are numerous. They are imposed on it by the environment in which it is formed. . . . If our world were different, we would reason differently: if chairs falling over usually caused deafness of the left ear in all cavalry officers, this relationship would be true for us.' And if we disregard other inferences contained in this manifesto (a very unpractical and utopian one, in many ways), like the naive suggestion that public authorities should create a set of laws to regulate the trade in genius – this being measurable by the quantity of cerebral energy needed to produce a work of art – nevertheless it is undeniable that the authors foresaw the possibility of substituting mechanical devices in the performance of functions which were then still held to be the sole prerogative of human beings. Clearly, the writings of the Futurists are full of naive visionary enthusiasm. But we should be careful to distinguish from the very beginning how much is polemical coat-trailing and how much is the violent expression of feeling under the impulse of reality.

In the same manifesto it is maintained that emotion is a purely accessory feature of a work of art: qualifications such as 'beautiful' or 'ugly', 'I like it' or 'I don't like it', are variable statements which differ from one individual to another and are hence unverifiable. For this reason value should be determined by the rarity of the work. It would not be too fanciful to interpret this idea of rarity value in art in terms of information theory, in which aesthetic value is assessed according to the quantity of new, original information which a work contains. These items of information – which are also pieces of consciousness – are arranged, in everyday reality, in a certain order, which is soon grasped. It is up to the artist to discover connections and set up relationships between remote, discontinuous, alien and dissimilar elements. There seems to be a structuralist element here, which shows itself when the authors suggest the possibility of a genius creating a work of art once he is provided in advance with the data: '43 nouns, 12 atmospheric adjectives, 9 verbs in the infinitive, 3 prepositions, 13 articles and 25 mathematical or musical signs'. In this way the artist is removed from his arrogant and authoritarian position; and he becomes a workman, a man who is quite simply working for the good of civilization in the same way as other workers in technical or intellectual work.

Nowadays, there is a tendency to replace the term 'artist' with 'art worker', and 'scientist' with 'researcher'; and criticism, instead of making judgments in order to set up artistic hierarchies, tends to explain and reveal the incidence of specific ideas and to trace them back to their

various original contributory causes. It need not therefore come as a surprise that Corradini and Settimelli advise the replacement of such terms as 'critic' and 'criticism' by ones like 'measurer' and 'measurement'. We know very well that words modify attributes in an illusory way only; nevertheless they do serve to indicate specific attitudes in those who use them.

It may be that this kind of suspension of judgment entails the risk of accepting, just because it is progressive, even an art which is so thin in substance as to be negligible. However, what is of interest – over and above any levels of judgment, since we are not in any way clear as to the effective benefits transmitted by a work of art – is the modifying power and hence the catalytic consequences of certain operations performed on a creative plane.

Even the artist has his social responsibilities. When Marinetti says that a roaring motor car is more beautiful than the *Victory of Samothrace*, he may appear to be an iconoclast, in the same way as he does when he demands the destruction of museums, libraries and academies. But, let us keep to the facts of the day: it is widely admitted that schools of all kinds are in need of substantial change, and that art should not be created to sit in museums, in shrines full of dead heroes, but exist for the people. So were the implications of Marinetti's verbal vandalism really so absurd? It is all a question of approach.

Of course, I would never claim that, say, Jules Verne the technological visionary is a greater genius than Flaubert, as far as artistic achievement is concerned: I only wish to show how history can provide the most unexpected surprises, and how certain marvels may originate, not so much from private fantasies, but from concrete stimuli acting on a progressive mind, which may even exceed the intelligence of the generation in which this contradictory power is manifested.

Gino Severini was the most intelligent theorist that Futurism produced, and it was he who dwelt most enthusiastically on the aesthetic possibilities of science. He maintained that art should evolve hand in hand with science; and this can only have been suggested to him by the action of an art which would turn itself into a branch of knowledge and thereby involve all the mental faculties and ideas of mankind. As far back as 1916, in the *Mercure de France*, Severini maintained that great intellectual happenings gradually modify our attitudes to the universe and to all the elements of our civilization. Sensation, he said, becomes identified with the idea, because an object's image is produced through sight or touch. It is thus a matter of reconstructing the universe according to an architectural scheme which harmonizes with our psychology.

10

In some ways – especially as regards the interdependence of perception, sensation, psychology and aesthetics – Severini's ideas look ahead to the formulas of gestalt psychology, which were to play such an important role in the development of artistic phenomenology in our own times.

Severini was convinced of the existence of an aesthetic of numbers; and he had already predicted by 1913 (p. 125) the end of the painting or statue, in so far as they 'contain within them their own fates: museums, collectors' galleries, all equally bogged down in the past'. The new plastic creations, on the other hand, 'must live in the open air and fit into architectural schemes, with which they will share the active intervention of the outside world, of which they represent the particular essence'. Four years later, he even noted the advance of a kind of collective aesthetic derived from the combined efforts of several artists. He forestalled criticism by observing that this did not mean any denial of an individual's personality, since we know from our knowledge of art history that originality can have a collective aesthetic basis.

These brief comments of Severini's are astonishingly up-to-date, despite the fact that they did not form part of any homogeneous system of thought; an artist cannot be expected to have the mind of a philosopher. Nevertheless, it is admirable that an artist should have so wide a range of intellectual vision, and that in his work should be found the first signs of ideas that were to obtain confirmation in later decades. While Severini limited the scope of art to subjective matters, he nevertheless recognized the individual as both 'a centre of universal irradiation' and 'the point where centripetal forces converge', so that if all the lines of the universe converge on him, there is also a centrifugal expansion outwards from him. Severini stated that the process of constructing a machine did not differ in essence from the process of creating a work of art; but he also distinguished between them on the ground that one activity is disinterested and the other directed towards a finite goal. Modern criticism has largely discredited this kind of thinking, by finding signs of aesthetic expression in all aspects of human creativity, in degrees which are more or less relevant and more or less successful according to the extent of genius present in each individual. And yet Severini's ideas have acted historically as evolutionary stimuli. In fact, we cannot deny the truth of the conclusion Severini arrived at more than half a century ago, when he observed that science and philosophy – and particularly the philosophy of science – have opened up new horizons for modern artists.

Futurism remained a melting-pot of ideas, and only exceptionally did it find ways of creating suitable forms for them: the object, as such, still dominated Futurist paintings, and Futurist *States of Mind* always include an object. The Futurists frequently tried to dispense with this predominance, but in an anarchistic sense, very different from Mondrian's or Malevich's attempts to abolish thematic subjects. The Futurists' actual works do not always correspond to the stated premises in their writings and poetry. In some there is a marked absence of expressive innovations; in others we find a dearth of individuality and definition. And yet there is enough of a formal framework to bring out the aspirations behind all these compositions, to place them within the range of works known as Futurist. The question is a complex one, and if we scrutinize the facts of the case we are still left with a great deal of speculative and theoretical terms – terms fixed by the figurative process. The critic Carlo Ragghianti has indicated this clearly: 'to paint in this atmosphere of conceptual and critical relationships and preoccupations, to elaborate ideas in the insistent presence of polemical propositions and deductions, to temper the painting operation with external, logical and practical calculations, constitutes a situation which cannot exactly be called poetic, since the expressive process is continually subordinated or curbed'. (*Mondrian e l'arte del XX secolo*, Milan 1962.)

This kind of intellectualism is now becoming the rule in creative behaviour; by which I do not mean the moments of reflection which accompany the actual execution of a work of art, nor the less frequent, perhaps, but equally verifiable moment of intuiting connections during the creation of the work, but an essentially critical appraisal of the appearance of reality.

The Futurists, like the Cubists, were influenced by stereometry; the Cubists, however (at least in the beginning), took advantage of polyocular vision, so that the object is in a static situation, involved in relations with other objects and the environment, whereas the Futurists, for the most part, superimposed one object on another, or the environment on the object, breaking it up into a dynamic state which is the reflection of the surrounding movement. The transparency of the bodies in Cubist painting is such as to show the interweaving of different points of vision in a single object whose profiled fragments reappear displaced with respect to their original positions. The Futurists, on the other hand, present the object in all its solidity, almost indeed simulating its projection into the space which contains and conditions it. For the Cubists, the composition is always based on a single axis and portrayed in a regular pattern. The Futurists, on the other hand, used

12

several axes, which cross each other and introduce a combinatory play of multiple intersections. In the one case the projected rhythm is almost crystallographic; in the other, it is embedded in clearly profiled sections. Nevertheless it is a curious fact that the Futurists accused the Cubists of static qualities and did not understand their sense of dynamic tension. Cubist objects are left in a fixed and static condition; but this does not mean that their vision derives from a static view of the external world. What the Cubists confirmed was rather the motion inherent in the representation of an object even in a stationary position, as a result of the tensions to which it is subjected by the outside forces which crowd around it.

The Futurists' desire to penetrate all aspects of life presents the historian with an obvious problem, which can also be found in other works and at other times: cultural influences and linguistic innovations meet and merge in a state of feverish mutability which has to be assessed in terms of its own time. This was not a period of unanimous convictions, even among the Futurists themselves. From the symbolism of pure form, they passed rapidly on to the metaphysics of realistic form; from magniloquent and extremist revolutionism, they progressed to the most extreme variety of nihilism, as manifested in Dada, which attracted some of the Futurists and at the same time absorbed some of their ideas.

The First World War broke up many alliances, killed some of the principal figures, and halted the development of ideas that were still undergoing the process of maturation and definition. The subsequent return to neoclassical influences gave the lie to all that the avant-garde had stood for in the first two decades of the century. But Futurist ideas nevertheless continued to bear fruit, without fuss or clamour, without great rewards and with only occasional recognition. Then, gradually, Futurist principles began to emerge again, and led to related experiments ranging from the descriptive exaltation of movement to kinetic art, from a representational rationalism with multiple perspective to programmed art, from a geometricizing and polyhedral discipline to Neoconstructivism.

In a letter written from Paris in October 1911, Umberto Boccioni stated that he had already intuitively anticipated most of the innovations he found in the modern paintings so much admired there. He was referring, in particular, to the Cubists Metzinger, Le Fauconnier, Léger and Gleizes; as he states quite clearly, he had not yet seen Picasso and Braque. Nothing of the complex aspirations of the most advanced modern painting had escaped his notice (and these are his own words).

This can only mean that some kind of intimate communion of spirit had encouraged both groups, Cubists and Futurists, to proceed in a certain direction. It might be better to say that they had all absorbed a similar cultural climate and were advancing towards similar elaborations and results. Italy was not at that time much in the swim as far as European culture was concerned. But there was certainly a circulation of ideas and paintings, mostly through reproductions in photographs and journals. We have evidence that Giacomo Balla brought back from his 1901 Paris trip many reproductions of Impressionist and Pointillist paintings and showed them to his friends.

Indirect or direct, as it may be, we cannot ignore the fact that there existed a continuous diffusion of the ideas which were stirring the intellectual and artistic world at the time. Problems of 'formal psychology' and 'descriptive geometry', while not exactly the order of the day, were at least fairly widely aired in cultural circles. Suggestions and reflections on the growth of scientific and mechanical ideas were no longer an absolute novelty. Studies on dynamics – in full progress at that time – together with speculations on the dimension of time, no doubt also had their effect on artistic ideas. And it was not without reason that visual artists showed a great interest in the theatre, in other forms of live entertainment, and in the cinema – expressive techniques in which rhythm and movement, both in objective representation and in indirect evocation, are of the essence. At least from Delacroix to Seurat, we have frequent references to scientific, experimental and deductive theories of colour; and, what is more, these references were pertinent and fruitful. It is obvious that the law of simultaneous contrast was translated by Seurat into purely poetic terms (although the same cannot be said of Signac); but there existed all along an active relationship between the scientific and artistic disciplines. The same instruments which technology was discovering and perfecting lent productive aid to artistic developments – witness the impact of photography.

Photography, when it began, aimed at recording a fact, documenting news, arresting a phenomenon in movement at its most significant point: we can see this reflected in the works of Degas, for example. Then photography was used in attempts to represent temporal rhythms, to describe fragmented series of movements, making explicit all the details involved. In 1872, Eadweard Muybridge (1830–1904) began to take photographs – repeated rapid exposures – of the consecutive phases in the movements of men and animals. The results of his studies were published in 1887. A decade later, Ottomar Anschütz (1846–1907) continued and perfected Muybridge's experiments with the collabor-

ation of the American painter Thomas Eakins (1844-1916). The physiologist E. J. Marey (1830-1904) presented in 1882 his 'chrono-photographs' with sequences taken by a photographic gun. He published *Le Mouvement* (1889), *La Photographie du mouvement* (1892) and *La Chronophotographie* (1899). The consequences in terms of painting are easily recognizable both in Balla's *Dog*, 1912, and Marcel Duchamp's *Nude Descending a Staircase*, 1911-12. Even more directly inspired by these experiments was Balla's *Swallows*, 1913, whose original model was Marey's photograph of a flight of birds, taken in 1880.

The Futurists, before 1910, were still bound up with Symbolism, and even metaphysics and occultism, as well as with Art Nouveau, Point-illism and a cultural climate dominated by the works of Munch, Redon, Hodler, Signac, Sartorio, De Carolis, Pellizza da Volpedo, Grubicy and Previati. Apparently Boccioni, for instance, received little stimulus from his first trip to Paris in 1906, apart from a greater comprehension of Cézanne's painting. On the other hand, the trip he made towards the end of 1911 had concrete and clearly recognizable effects, which can be traced in his works. This journey led to twelve months of intensive activity. Symbolism, propagated in Italy by Marinetti's journal *Poesia*, had made its mark on Boccioni (he says he admired Dürer and Michelangelo, also Bellini, for their love of truth); and only the meeting with Gaetano Previati in February 1908 had the effect of making his allegorical inclinations less conventional and academic. However, he was still captivated by Symbolism in 1910, when he was proposing to paint the 'idea' of sleep. At the same time as dedicating himself to activities of this kind, he was writing to Severini that he thought Balla 'a long way away from the new intellectual and artistic movement'. He considered Balla to be an experimenter and pioneer, whose discoveries would be worked by others. In his Paduan diary, Boccioni finally notes that he was searching for a 'virility composed of a precise and exact positivism. Poetry must consist of straight lines and calculus; everything must become rectangular, square, pentagonal, etc. I find this true of all the functions of life'.

In Padua he was reading Nietzsche – he remarked on the unpleasant elements lurking in the idea of the Superman – and then Verne. He also became acquainted with the works of Walt Whitman, in which industrial motifs and modern machinery are used with clarity and total conviction. From the 1890s, Whitman was widely read in France, and Marinetti must certainly have read the first poems when they appeared; the Italian translation of *Leaves of Grass* came out in 1907. (It is curious, incidentally, that these poems also had a strong appeal for the German

Expressionists of Die Brücke.) Another widely read book was *Les Chants modernes* by Maxime du Camp, published in 1855, which was really a hymn to science and an attack on the ideals of Greek beauty.

All the Futurists, major and minor, were convinced of these basic ideas. Most of them, however, gave them only superficial representation, based primarily on thematic studies, without devoting themselves to the real subject. This is inevitable so long as an innovation remains on the level of surprise, not having become a part of consciousness. Nevertheless people like Boccioni, Balla, Severini and Prampolini found for the ideas of technological progress an appropriate formal expression; and for this reason they were the figures who counted for most in the artistic field. They threw off the shackles of the nineteenth century in order to exploit the resources of the imagination. Relations with the Cubists, with Delaunay, Villon and Duchamp, with Larionov, Goncharova, Tatlin and Malevich, with Wyndham Lewis and Nevinson, with Stella, the German Expressionists and Dada, all came about through their mediation. On the level of ideas, interactions were even more widespread, and involved many other collaborators. As a result the new movement spread from painting and sculpture to poetry, theatre, architecture, stage design, music, ballet, photography, the cinema, typography, furnishing and fashion.

Futurism cannot be understood and evaluated according to the usual norms of art criticism; it is art and it is also non-art; it is something more and something less than art. In any case, it was certainly involved with art, with an art which was becoming transformed, and which for some meant a transformation to the point of death. 'We shall put the spectator in the centre of the picture': Carrà claimed this phrase as his own (whether justly or not). It is a valid principle, not only for the manifesto in which it is found (p. 28), but also for our entire concept of Futurism. It is valid in the sense that, even if it may have seemed incomprehensible at the time, it is now the pivot of all contemporary artistic activity, no matter in what form it is carried out. Bodies and objects are no longer opaque, no longer immobile. Light penetrates objects, emanates from them or constructs them. Creative development takes place on the level of their basic structures. A whole new world of art has grown up. And those who have since tried to reject the implications of Futurism, referring the origins of modern art to some point or other in the past, have wasted their time. As has happened so often in history, a new path had been taken; the die was cast.

Translation R B (abridged)

I Carlo Carrà *The Red Horseman* 1913

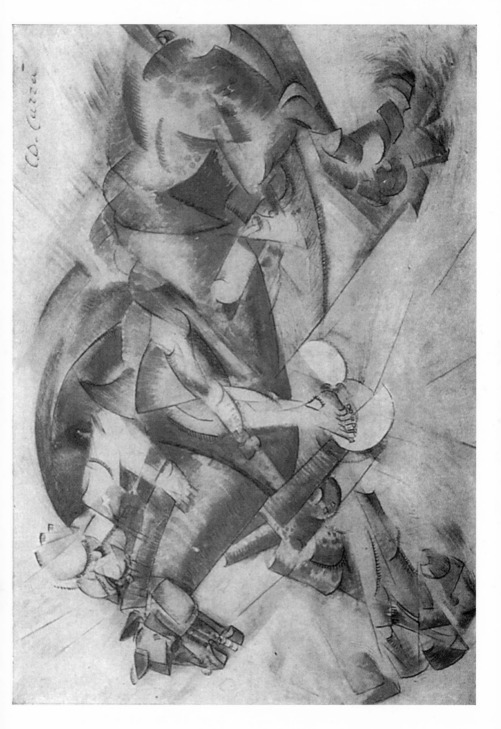

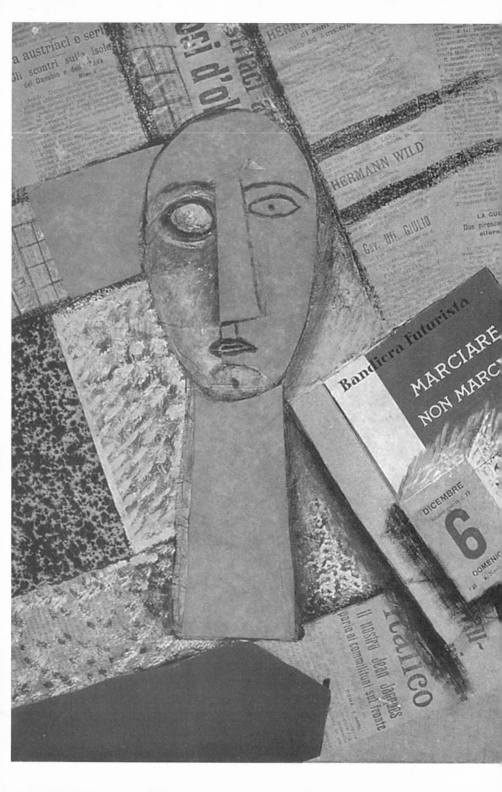

Documents

F. T. Marinetti
The Founding and Manifesto of Futurism 1909

We had stayed up all night, my friends and I, under hanging mosque lamps with domes of filigreed brass, domes starred like our spirits, shining like them with the prisoned radiance of electric hearts. For hours we had trampled our atavistic ennui into rich oriental rugs, arguing up to the last confines of logic and blackening many reams of paper with our frenzied scribbling.

An immense pride was buoying us up, because we felt ourselves alone at that hour, alone, awake, and on our feet, like proud beacons or forward sentries against an army of hostile stars glaring down at us from their celestial encampments. Alone with stokers feeding the hellish fires of great ships, alone with the black spectres who grope in the red-hot bellies of locomotives launched down their crazy courses, alone with drunkards reeling like wounded birds along the city walls.

Suddenly we jumped, hearing the mighty noise of the huge double-decker trams that rumbled by outside, ablaze with coloured lights, like villages on holiday suddenly struck and uprooted by the flooding Po and dragged over falls and through gorges to the sea.

Then the silence deepened. But, as we listened to the old canal muttering its feeble prayers and the creaking bones of sickly palaces above

19

II Carlo Carrà *Composition with Female Figure* 1915

their damp green beards, under the windows we suddenly heard the famished roar of automobiles.

'Let's go!' I said. 'Friends, away! Let's go! Mythology and the Mystic Ideal are defeated at last. We're about to see the Centaur's birth and, soon after, the first flight of Angels! ... We must shake the gates of life, test the bolts and hinges. Let's go! Look there, on the earth, the very first dawn! There's nothing to match the splendour of the sun's red sword, slashing for the first time through our millennial gloom!'

We went up to the three snorting beasts, to lay amorous hands on their torrid breasts. I stretched out on my car like a corpse on its bier, but revived at once under the steering wheel, a guillotine blade that threatened my stomach.

The raging broom of madness swept us out of ourselves and drove us through streets as rough and deep as the beds of torrents. Here and there, sick lamplight through window glass taught us to distrust the deceitful mathematics of our perishing eyes.

I cried, 'The scent, the scent alone is enough for our beasts.'

And like young lions we ran after Death, its dark pelt blotched with pale crosses as it escaped down the vast violet living and throbbing sky.

But we had no ideal Mistress raising her divine form to the clouds, nor any cruel Queen to whom to offer our bodies, twisted like Byzantine rings! There was nothing to make us wish for death, unless the wish to be free at last from the weight of our courage!

And on we raced, hurling watchdogs against doorsteps, curling them under our burning tyres like collars under a flatiron. Death, domesticated, met me at every turn, gracefully holding out a paw, or once in a while hunkering down, making velvety caressing eyes at me from every puddle.

'Let's break out of the horrible shell of wisdom and throw ourselves like pride-ripened fruit into the wide, contorted mouth of the wind! Let's give ourselves utterly to the Unknown, not in desperation but only to replenish the deep wells of the Absurd!'

The words were scarcely out of my mouth when I spun my car around with the frenzy of a dog trying to bite its tail, and there, suddenly, were two cyclists coming towards me, shaking their fists, wobbling like two equally convincing but nevertheless contradictory arguments. Their stupid dilemma was blocking my way – Damn! Ouch! ... I stopped short and to my disgust rolled over into a ditch with my wheels in the air. ...

20

O maternal ditch, almost full of muddy water! Fair factory drain! I gulped down your nourishing sludge; and I remembered the blessed black breast of my Sudanese nurse. ... When I came up – torn, filthy, and stinking – from under the capsized car, I felt the white-hot iron of joy deliciously pass through my heart!

A crowd of fishermen with handlines and gouty naturalists were already swarming around the prodigy. With patient, loving care those people rigged a tall derrick and iron grapnels to fish out my car, like a big beached shark. Up it came from the ditch, slowly, leaving in the bottom, like scales, its heavy framework of good sense and its soft upholstery of comfort.

They thought it was dead, my beautiful shark, but a caress from me was enough to revive it; and there it was, alive again, running on its powerful fins!

And so, faces smeared with good factory muck – plastered with metallic waste, with senseless sweat, with celestial soot – we, bruised, our arms in slings, but unafraid, declared our high intentions to all the *living* of the earth:

MANIFESTO OF FUTURISM

1. We intend to sing the love of danger, the habit of energy and fearlessness.

2. Courage, audacity, and revolt will be essential elements of our poetry.

3. Up to now literature has exalted a pensive immobility, ecstasy, and sleep. We intend to exalt aggressive action, a feverish insomnia, the racer's stride, the mortal leap, the punch and the slap.

4. We affirm that the world's magnificence has been enriched by a new beauty: the beauty of speed. A racing car whose hood is adorned with great pipes, like serpents of explosive breath – a roaring car that seems to ride on grapeshot is more beautiful than the *Victory of Samothrace*.

5. We want to hymn the man at the wheel, who hurls the lance of his spirit across the Earth, along the circle of its orbit.

6. The poet must spend himself with ardour, splendour, and generosity, to swell the enthusiastic fervour of the primordial elements.

7. Except in struggle, there is no more beauty. No work without an aggressive character can be a masterpiece. Poetry must be conceived as a violent attack on unknown forces, to reduce and prostrate them before man.

8. We stand on the last promontory of the centuries! ... Why should we look back, when what we want is to break down the mysterious doors

of the Impossible? Time and Space died yesterday. We already live in the absolute, because we have created eternal, omnipresent speed.

9. We will glorify war – the world's only hygiene – militarism, patriotism, the destructive gesture of freedom-bringers, beautiful ideas worth dying for, and scorn for woman.

10. We will destroy the museums, libraries, academies of every kind, will fight moralism, feminism, every opportunistic or utilitarian cowardice.

11. We will sing of great crowds excited by work, by pleasure, and by riot; we will sing of the multicoloured, polyphonic tides of revolution in the modern capitals; we will sing of the vibrant nightly fervour of arsenals and shipyards blazing with violent electric moons; greedy railway stations that devour smoke-plumed serpents; factories hung on clouds by the crooked lines of their smoke; bridges that stride the rivers like giant gymnasts, flashing in the sun with a glitter of knives; adventurous steamers that sniff the horizon; deep-chested locomotives whose wheels paw the tracks like the hooves of enormous steel horses bridled by tubing; and the sleek flight of planes whose propellers chatter in the wind like banners and seem to cheer like an enthusiastic crowd.

It is from Italy that we launch through the world this violently upsetting incendiary manifesto of ours. With it, today, we establish *Futurism*, because we want to free this land from its smelly gangrene of professors, archaeologists, *ciceroni* and antiquarians. For too long has Italy been a dealer in second-hand clothes. We mean to free her from the numberless museums that cover her like so many graveyards.

Museums: cemeteries! ... Identical, surely, in the sinister promiscuity of so many bodies unknown to one another. Museums: public dormitories where one lies forever beside hated or unknown beings. Museums: absurd abattoirs of painters and sculptors ferociously slaughtering each other with colour-blows and line-blows, the length of the fought-over walls!

That one should make an annual pilgrimage, just as one goes to the graveyard on All Souls' Day – that I grant. That once a year one should leave a floral tribute beneath the *Gioconda*, I grant you that. ... But I don't admit that our sorrows, our fragile courage, our morbid restlessness should be given a daily conducted tour through the museums. Why poison ourselves? Why rot?

And what is there to see in an old picture except the laborious contortions of an artist throwing himself against the barriers that thwart his desire to express his dream completely? ... Admiring an

old picture is the same as pouring our sensibility into a funerary urn instead of hurling it far off, in violent spasms of action and creation.

Do you, then, wish to waste all your best powers in this eternal and futile worship of the past, from which you emerge fatally exhausted, shrunken, beaten down?

In truth I tell you that daily visits to museums, libraries, and academies (cemeteries of empty exertion, Calvaries of crucified dreams, registries of aborted beginnings!) are, for artists, as damaging as the prolonged supervision by parents of certain young people drunk with their talent and their ambitious wills. When the future is barred to them, the admirable past may be a solace for the ills of the moribund, the sickly, the prisoner. ... But we want no part of it, the past, we the young and strong *Futurists*!

So let them come, the gay incendiaries with charred fingers! Here they are! Here they are! ... Come on! set fire to the library shelves! Turn aside the canals to flood the museums! ... Oh, the joy of seeing the glorious old canvases bobbing adrift on those waters, discoloured and shredded! ... Take up your pickaxes, your axes and hammers and wreck, wreck the venerable cities, pitilessly!

The oldest of us is thirty: so we have at least a decade for finishing our work. When we are forty, other younger and stronger men will probably throw us in the wastebasket like useless manuscripts – we want it to happen!

They will come against us, our successors, will come from far away, from every quarter, dancing to the winged cadence of their first songs, flexing the hooked claws of predators, sniffing doglike at the academy doors the strong odour of our decaying minds, which will already have been promised to the literary catacombs.

But we won't be there. ... At last they'll find us – one winter's night – in open country, beneath a sad roof drummed by a monotonous rain. They'll see us crouched beside our trembling aeroplanes in the act of warming our hands at the poor little blaze that our books of today will give out when they take fire from the flight of our images.

They'll storm around us, panting with scorn and anguish, and all of them, exasperated by our proud daring, will hurtle to kill us, driven by a hatred the more implacable the more their hearts will be drunk with love and admiration for us.

Injustice, strong and sane, will break out radiantly in their eyes.

Art, in fact, can be nothing but violence, cruelty, and injustice.

The oldest of us is thirty: even so we have already scattered treasures, a thousand treasures of force, love, courage, astuteness, and raw will-power; have thrown them impatiently away, with fury, carelessly, unhesitatingly, breathless, and unresting. . . . Look at us! We are still untired! Our hearts know no weariness because they are fed with fire, hatred, and speed! . . . Does that amaze you? It should, because you can never remember having lived! Erect on the summit of the world, once again we hurl our defiance at the stars!

You have objections? – Enough! Enough! We know them. . . . We've understood! . . . Our fine deceitful intelligence tells us that we are the revival and extension of our ancestors – Perhaps! . . . If only it were so! – But who cares? We don't want to understand! . . . Woe to anyone who says those infamous words to us again!

Lift up your heads!

Erect on the summit of the world, once again we hurl defiance to the stars!

Published in *Le Figaro* (Paris), 20 February 1909
Translation R W F

Umberto Boccioni, Carlo Carrà, Luigi Russolo, Giacomo Balla, Gino Severini
Manifesto of the Futurist Painters 1910

TO THE YOUNG ARTISTS OF ITALY!
The cry of rebellion which we utter associates our ideals with those of the Futurist poets. These ideals were not invented by some aesthetic clique. They are the expression of a violent desire which boils in the veins of every creative artist today.

We will fight with all our might the fanatical, senseless and snobbish religion of the past, a religion encouraged by the vicious existence of museums. We rebel against that spineless worshipping of old canvases, old statues and old bric-a-brac, against everything which is filthy and worm-ridden and corroded by time. We consider the habitual contempt for everything which is young, new and burning with life to be unjust and even criminal.

Comrades, we tell you now that the triumphant progress of science makes profound changes in humanity inevitable, changes which are

hacking an abyss between those docile slaves of past tradition and us free moderns, who are confident in the radiant splendour of our future.

We are sickened by the foul laziness of artists who, ever since the sixteenth century, have endlessly exploited the glories of the ancient Romans.

In the eyes of other countries, Italy is still a land of the dead, a vast Pompeii, white with sepulchres. But Italy is being reborn. Its political resurgence will be followed by a cultural resurgence. In the land inhabited by the illiterate peasant, schools will be set up; in the land where doing nothing in the sun was the only available profession, millions of machines are already roaring; in the land where traditional aesthetics reigned supreme, new flights of artistic inspiration are emerging and dazzling the world with their brilliance.

Living art draws its life from the surrounding environment. Our forebears drew their artistic inspiration from a religious atmosphere which fed their souls; in the same way we must breathe in the tangible miracles of contemporary life – the iron network of speedy communications which envelops the earth, the transatlantic liners, the dreadnoughts, those marvellous flights which furrow our skies, the profound courage of our submarine navigators and the spasmodic struggle to conquer the unknown. How can we remain insensible to the frenetic life of our great cities and to the exciting new psychology of night-life; the feverish figures of the bon viveur, the cocotte, the apache and the absinthe drinker?

We will also play our part in this crucial revival of aesthetic expression: we declare war on all artists and all institutions which insist on hiding behind a façade of false modernity, while they are actually ensnared by tradition, academicism and, above all, a nauseating cerebral laziness.

We condemn as insulting to youth the acclamations of a revolting rabble for the sickening reflowering of a pathetic kind of classicism in Rome; the neurasthenic cultivation of hermaphroditic archaism which they rave about in Florence; the pedestrian, half-blind handiwork of '48 which they are buying in Milan; the work of pensioned-off government clerks which they think the world of in Turin; the hotchpotch of encrusted rubbish of a group of fossilized alchemists which they are worshipping in Venice. We are going to rise up against all superficiality and banality – all the slovenly and facile commercialism which makes the work of most of our highly respected artists throughout Italy worthy of our deepest contempt.

Away then with hired restorers of antiquated incrustations. Away with affected archaeologists with their chronic necrophilia! Down with the critics, those complacent pimps! Down with gouty academics and drunken, ignorant professors!

Ask these priests of a veritable religious cult, these guardians of old aesthetic laws, where we can go and see the works of Giovanni Segantini today. Ask them why the officials of the Commission have never heard of the existence of Gaetano Previati. Ask them where they can see Medardo Rosso's sculpture, or who takes the slightest interest in artists who have not yet had twenty years of struggle and suffering behind them, but are still producing works destined to honour their fatherland?

These paid critics have other interests to defend. Exhibitions, competitions, superficial and never disinterested criticism, condemn Italian art to the ignominy of true prostitution.

And what about our esteemed 'specialists'? Throw them all out. Finish them off! The Portraitists, the Genre Painters, the Lake Painters, the Mountain Painters. We have put up with enough from these impotent painters of country holidays.

Down with all marble-chippers who are cluttering up our squares and profaning our cemeteries! Down with the speculators and their rein-forced-concrete buildings! Down with laborious decorators, phoney ceramicists, sold-out poster painters and shoddy, idiotic illustrators!

These are our final CONCLUSIONS:

With our enthusiastic adherence to Futurism, we will:

1. Destroy the cult of the past, the obsession with the ancients, pedantry and academic formalism.
2. Totally invalidate all kinds of imitation.
3. Elevate all attempts at originality, however daring, however violent.
4. Bear bravely and proudly the smear of 'madness' with which they try to gag all innovators.
5. Regard art critics as useless and dangerous.
6. Rebel against the tyranny of words: 'Harmony' and 'good taste' and other loose expressions which can be used to destroy the works of Rembrandt, Goya, Rodin. . . .
7. Sweep the whole field of art clean of all themes and subjects which have been used in the past.
8. Support and glory in our day-to-day world, a world which is going to be continually and splendidly transformed by victorious Science.

The dead shall be buried in the earth's deepest bowels! The threshold of the future will be swept free of mummies! Make room for youth, for violence, for daring!

Published as a leaflet by
Poesia (Milan), 11 February 1910
Translation R B

Umberto Boccioni, Carlo Carrà, Luigi Russolo, Giacomo Balla, Gino Severini
Futurist Painting: Technical Manifesto 1910

On the 18th of March, 1910, in the limelight of the Chiarella Theatre of Turin, we launched our first manifesto to a public of three thousand people – artists, men of letters, students and others; it was a violent and cynical cry which displayed our sense of rebellion, our deep-rooted disgust, our haughty contempt for vulgarity, for academic and pedantic mediocrity, for the fanatical worship of all that is old and worm-eaten.

We bound ourselves there and then to the movement of Futurist Poetry which was initiated a year earlier by F. T. Marinetti in the columns of the *Figaro*.

The battle of Turin has remained legendary. We exchanged almost as many knocks as we did ideas, in order to protect from certain death the genius of Italian Art.

And now during a temporary pause in this formidable struggle we come out of the crowd in order to expound with technical precision our programme for the renovation of painting, of which our Futurist Salon at Milan was a dazzling manifestation.

Our growing need of truth is no longer satisfied with Form and Colour as they have been understood hitherto.

The gesture which we would reproduce on canvas shall no longer be a fixed *moment* in universal dynamism. It shall simply be the *dynamic sensation* itself.

Indeed, all things move, all things run, all things are rapidly changing. A profile is never motionless before our eyes, but it constantly appears

27

and disappears. On account of the persistency of an image upon the retina, moving objects constantly multiply themselves; their form changes like rapid vibrations, in their mad career. Thus a running horse has not four legs, but twenty, and their movements are triangular.

All is conventional in art. Nothing is absolute in painting. What was truth for the painters of yesterday is but a falsehood today. We declare, for instance, that a portrait must not be like the sitter, and that the painter carries in himself the landscapes which he would fix upon his canvas.

To paint a human figure you must not paint it; you must render the whole of its surrounding atmosphere.

Space no longer exists: the street pavement, soaked by rain beneath the glare of electric lamps, becomes immensely deep and gapes to the very centre of the earth. Thousands of miles divide us from the sun; yet the house in front of us fits into the solar disk.

Who can still believe in the opacity of bodies, since our sharpened and multiplied sensitiveness has already penetrated the obscure manifestations of the medium? Why should we forget in our creations the doubled power of our sight, capable of giving results analogous to those of the X-rays?

It will be sufficient to cite a few examples, chosen amongst thousands, to prove the truth of our arguments.

The sixteen people around you in a rolling motor bus are in turn and at the same time one, ten, four, three; they are motionless and they change places; they come and go, bound into the street, are suddenly swallowed up by the sunshine, then come back and sit before you, like persistent symbols of universal vibration.

How often have we not seen upon the cheek of the person with whom we are talking the horse which passes at the end of the street.

Our bodies penetrate the sofas upon which we sit, and the sofas penetrate our bodies. The motor bus rushes into the houses which it passes, and in their turn the houses throw themselves upon the motor bus and are blended with it.

The construction of pictures has hitherto been foolishly traditional. Painters have shown us the objects and the people placed before us. We shall henceforward put the spectator in the centre of the picture.

As in every realm of the human mind, clear-sighted individual research has swept away the unchanging obscurities of dogma, so must the vivifying current of science soon deliver painting from academism.

We would at any price re-enter into life. Victorious science has nowadays disowned its past in order the better to serve the material needs of

28

our time; we would that art, disowning its past, were able to serve at last the intellectual needs which are within us.

Our renovated consciousness does not permit us to look upon man as the centre of universal life. The suffering of a man is of the same interest to us as the suffering of an electric lamp, which, with spasmodic starts, shrieks out the most heartrending expressions of colour. The harmony of the lines and folds of modern dress works upon our sensitiveness with the same emotional and symbolical power as did the nude upon the sensitiveness of the old masters.

In order to conceive and understand the novel beauties of a Futurist picture, the soul must be purified; the eye must be freed from its veil of atavism and culture, so that it may at last look upon Nature and not upon the museum as the one and only standard.

As soon as ever this result has been obtained, it will be readily admitted that brown tints have never coursed beneath our skin; it will be discovered that yellow shines forth in our flesh, that red blazes, and that green, blue and violet dance upon it with untold charms, voluptuous and caressing.

How is it possible still to see the human face pink, now that our life, redoubled by noctambulism, has multiplied our perceptions as colourists? The human face is yellow, red, green, blue, violet. The pallor of a woman gazing in a jeweller's window is more intensely iridescent than the prismatic fires of the jewels that fascinate her like a lark.

The time has passed for our sensations in painting to be whispered. We wish them in future to sing and re-echo upon our canvases in deafening and triumphant flourishes.

Your eyes, accustomed to semi-darkness, will soon open to more radiant visions of light. The shadows which we shall paint shall be more luminous than the high-lights of our predecessors, and our pictures, next to those of the museums, will shine like blinding daylight compared with deepest night.

We conclude that painting cannot exist today without Divisionism. This is no process that can be learned and applied at will. Divisionism, for the modern painter, must be an *innate complementariness* which we declare to be essential and necessary.

Our art will probably be accused of tormented and decadent cerebralism. But we shall merely answer that we are, on the contrary, the primitives of a new sensitiveness, multiplied hundredfold, and that our art is intoxicated with spontaneity and power.

WE DECLARE:

1. That all forms of imitation must be despised, all forms of originality glorified.

2. That it is essential to rebel against the tyranny of the terms 'harmony' and 'good taste' as being too elastic expressions, by the help of which it is easy to demolish the works of Rembrandt, of Goya and of Rodin.

3. That the art critics are useless or harmful.

4. That all subjects previously used must be swept aside in order to express our whirling life of steel, of pride, of fever and of speed.

5. That the name of 'madman' with which it is attempted to gag all innovators should be looked upon as a title of honour.

6. That innate complementariness is an absolute necessity in painting, just as free metre in poetry or polyphony in music.

7. That universal dynamism must be rendered in painting as a dynamic sensation.

8. That in the manner of rendering Nature the first essential is sincerity and purity.

9. That movement and light destroy the materiality of bodies.

WE FIGHT:

1. Against the bituminous tints by which it is attempted to obtain the patina of time upon modern pictures.

2. Against the superficial and elementary archaism founded upon flat tints, and which, by imitating the linear technique of the Egyptians, reduces painting to a powerless synthesis, both childish and grotesque.

3. Against the false claims to belong to the future put forward by the secessionists and the independents, who have installed new academies no less trite and attached to routine than the preceding ones.

4. Against the nude in painting, as nauseous and as tedious as adultery in literature.

We wish to explain this last point. Nothing is *immoral* in our eyes; it is the monotony of the nude against which we fight. We are told that the subject is nothing and that everything lies in the manner of treating it. That is agreed; we too, admit that. But this truism, unimpeachable and absolute fifty years ago, is no longer so today with regard to the nude, since artists obsessed with the desire to expose the bodies of their mistresses have transformed the Salons into arrays of unwholesome flesh!

We demand, for ten years, the total suppression of the nude in painting.

Published as a leaflet by
Poesia (Milan), 11 April 1910
This English version from the catalogue
of the 'Exhibition of Works by
the Italian Futurist Painters',
Sackville Gallery, London, March 1912

Balilla Pratella
Manifesto of Futurist Musicians 1910

I appeal to the *young*. Only they should listen, and only they can understand what I have to say. Some people are born old, slobbering spectres of the past, cryptogams swollen with poison. To them no words or ideas, but a single injunction: *the end.*

I appeal to the *young*, to those who are thirsty for the new, the actual, the lively. They follow me, faithful and fearless, along the roads of the future, gloriously preceded by my, by our, intrepid brothers, the Futurist poets and painters, beautiful with violence, daring with rebellion, and luminous with the animation of genius.

A year has passed since a jury composed of Pietro Mascagni, Giacomo Orefice, Guglielmo Mattioli, Rodolfo Ferrari and the critic Gian Battista Nappi announced that my musical Futurist work entitled *La Sina d'Vargöun*, based on a free verse poem, also by me, had won a prize of 10,000 lire against all other contenders. This prize was to cover the cost of performance of the work thus recognized as superior and worthy, according to the bequest of the Bolognese, Cincinnato Baruzzi.

The performance, which took place in December 1909, in the Teatro Comunale in Bologna, brought with it success in the form of enthusiasm, base and stupid criticisms, generous defence on the part of friends and strangers, respect and imitation from my enemies.

After such a triumphal entry into Italian musical society and after establishing contact with the public, publishers and critics, I was able to judge with supreme serenity the intellectual mediocrity, commercial

baseness and misoneism that reduce Italian music to a unique and almost unvarying form of vulgar melodrama, an absolute result of which is our inferiority when compared to the Futurist evolution of music in other countries.

In Germany, after the glorious and revolutionary era dominated by the sublime genius of Wagner, Richard Strauss almost elevated the baroque style of instrumentation into an essential form of art, and although he cannot hide the aridity, commercialism and banality of his spirit with harmonic affectations and skilful, complicated and ostentatious acoustics, he nevertheless does struggle to combat and overcome the past with innovatory talent.

In France, Claude Debussy, a profoundly subjective artist and more a literary man than a musician, swims in a diaphanous and calm lake of tenuous, delicate, clear blue and constantly transparent harmonies. He presents instrumental symbolism and a monotonous polyphony of harmonic sensations conveyed through a scale of whole tones – a new system, but a system nevertheless, and consequently a voluntary limitation. But even with these devices he is not always able to mask the scanty value of his one-sided themes and rhythms and his almost total lack of ideological development. This development consists, as far as he is concerned, in the primitive and infantile periodic repetition of a short and poor theme, or in rhythmic, monotonous and vague progressions. Having returned in his operatic formulae to the stale concepts of Florentine chamber music which gave birth to melodrama in the seventeenth century, he has still not yet succeeded in completely reforming the music drama of his country. Nevertheless, he more than any other fights the past valiantly and there are many points at which he overcomes it. Stronger than Debussy in ideas, but musically inferior, is G. Charpentier.

In England, Edward Elgar is cooperating with our efforts to destroy the past by pitting his will to amplify classical symphonic forms, seeking richer ways of thematic development and multiform variations on a single theme. Moreover, he directs his energy not merely to the exuberant variety of the instruments, but to the variety of their combinational effects, which is in keeping with our complex sensibility.

In Russia, Modeste Mussorgsky, renewed by the spirit of Nikolai Rimsky-Korsakov, grafts the primitive national element on to the formulae inherited from others, and by seeking dramatic truth and harmonic liberty he abandons tradition and consigns it to oblivion. Alexander Glazunov is moving in the same direction, although still primitive and far from a pure and balanced concept of art.

In Finland and Sweden, also, innovatory tendencies are being nourished by means of national musical and poetical elements, and the works of Sibelius confirm this.

And in Italy?

The vegetating schools, conservatories and academies act as snares for youth and art alike. In these hot-beds of impotence, masters and professors, illustrious deficients, perpetuate traditionalism and combat any effort to widen the musical field.

The result is prudent repression and restriction of any free and daring tendency; constant mortification of impetuous intelligence; unconditioned propping-up of imitative and incestuous mediocrity; prostitution of the great glories of the music of the past, used as insidious arms of offence against budding talent; limitation of study to a useless form of acrobatics floundering in the perpetual last throes of a behindhand culture that is already dead.

The young musical talents stagnating in the conservatories have their eyes fixed on the fascinating mirage of opera under the protection of the big publishing houses. Most of them end up bad – and all the worse for lack of ideological and technical foundations. Very few get so far as to see their work staged, and most of these pay out money to secure venal and ephemeral successes, or polite toleration.

Pure symphony, the last refuge, harbours the failed opera composers, who justify themselves by preaching the death of the music drama as an absurd and anti-musical form. On the other hand they confirm the traditional claim that the Italians are not born equipped for the symphony, revealing themselves equally inept in this most noble and vital form of composition. The cause of their double failure is unique, and is not to be sought in the completely guiltless and incessantly slandered forms of opera and symphony, but in the writers' own impotence.

They make use, in their ascent to fame, of that absurd swindle that is called *well-made music*, the falsification of all that is true and great, a worthless copy sold to a public that lets itself be cheated by its own free will.

But the rare fortunates who, through multiple renunciations, have managed to obtain the protection of the large publishers, to whom they are tied by illusory and humiliating *noose-contracts*, these represent the classes of serfs, cowards and those who voluntarily sell themselves.

The great publisher-merchants rule over everything; they impose commercial limitations on operatic forms, proclaiming which models are not to be excelled, unsurpassable: the base, rickety and vulgar operas of Giacomo Puccini and Umberto Giordano.

Publishers pay poets to waste their time and intelligence in concocting and seasoning – in accordance with the recipes of that grotesque pastry cook called Luigi Illica – that fetid cake that goes by the name of opera libretto.

Publishers discard any opera that surpasses mediocrity, since they have a monopoly to disseminate and exploit their wares and defend the field of action from any dreaded attempt at rebellion.

Publishers assume protection and power over public taste, and, with the complicity of the critics, they evoke as example or warning amidst the tears and general chaos, our alleged Italian monopoly of melody and of *bel canto*, and our never sufficiently praised opera, that heavy and suffocating crop of our nation.

Only Pietro Mascagni, the publishers' favourite, has had the spirit and power to rebel against the traditions of art, against publishers and the deceived and spoilt public. His personal example, first and unique in Italy, has unmasked the infamy of publishing monopolies and the venality of the critics. He has hastened the hour of our liberation from commercial czarism and dilettantism in music; Pietro Mascagni has shown great talent in his real attempts at innovation in the harmonic and lyrical aspects of opera, even though he has not yet succeeded in freeing himself from traditional forms.

The shame and filth that I have denounced in general terms faithfully represent Italy's past in its relationship with art and with the customs of today: industry of the dead, cult of cemeteries, parching of the vital sources.

Futurism, the rebellion of the life of intuition and feeling, quivering and impetuous spring, declares inexorable war on doctrines, individuals and works that repeat, prolong or exalt the past at the expense of the future. It proclaims the conquest of amoral liberty, of action, conscience and imagination. It proclaims that Art is *disinterest, heroism and contempt for easy success.*

I unfurl to the freedom of air and sun the red flag of Futurism, calling to its flaming symbol such young composers as have hearts to love and fight, minds to conceive, and brows free of cowardice. And I shout with joy at feeling myself unfettered from all the chains of tradition, doubt, opportunism and vanity.

I, who repudiate the title of *Maestro* as a stigma of mediocrity and ignorance, hereby confirm my enthusiastic adhesion to Futurism, offering to the young, the bold and the reckless these my irrevocable CONCLUSIONS:

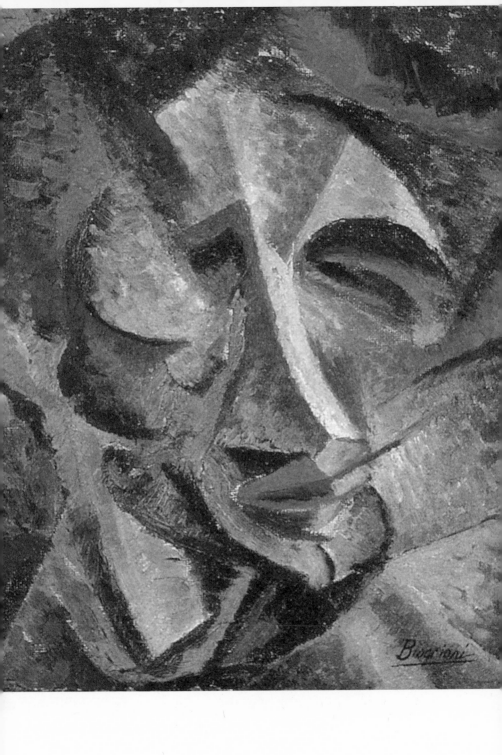

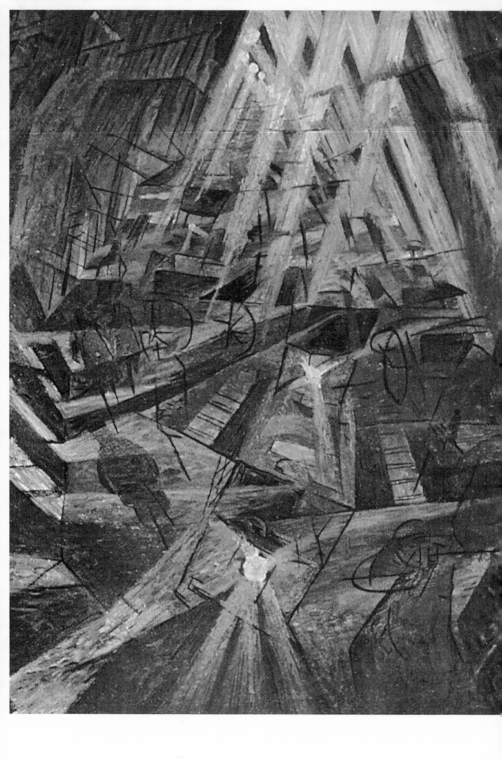

1. To convince young composers to desert schools, conservatories and musical academies, and to consider free study as the only means of regeneration.

2. To combat the venal and ignorant critics with assiduous contempt, liberating the public from the pernicious effects of their writings.

To found with this aim in view a musical review that will be independent and resolutely opposed to the criteria of conservatory professors and to those of the debased public.

3. To abstain from participating in any competition with the customary closed envelopes and related admission charges, denouncing all mystifications publicly, and unmasking the incompetence of juries, which are generally composed of fools and impotents.

4. To keep at a distance from commercial or academic circles, despising them, and preferring a modest life to bountiful earnings acquired by selling art.

5. The liberation of individual musical sensibility from all imitation or influence of the past, feeling and singing with the spirit open to the future, drawing inspiration and aesthetics from nature, through all the human and extra-human phenomena present in it. Exalting the man-symbol everlastingly renewed by the varied aspects of modern life and its infinity of intimate relationships with nature.

6. To destroy the prejudice for 'well-made' music – rhetoric and impotence – to proclaim the unique concept of Futurist music, as absolutely different from music to date, and so to shape in Italy a Futurist musical taste, destroying doctrinaire, academic and soporific values, declaring the phrase 'let us return to the old masters' to be hateful, stupid and vile.

7. To proclaim that the reign of the singer must end, and that the importance of the singer in relation to a work of art is the equivalent of the importance of an instrument in the orchestra.

8. To transform the title and value of the 'operatic libretto' into the title and value of 'dramatic or tragic poem for music', substituting free verse for metric structure. Every opera writer must absolutely and necessarily be the author of his own poem.

9. To combat categorically all historical reconstructions and traditional stage sets and to declare the stupidity of the contempt felt for contemporary dress.

IV Umberto Boccioni *The Forces of a Street* 1911

10. To COMBAT THE TYPE OF BALLAD WRITTEN BY TOSTI AND COSTA, NAUSEATING NEAPOLITAN SONGS AND SACRED MUSIC WHICH, HAVING NO LONGER ANY REASON TO EXIST, GIVEN THE BREAKDOWN OF FAITH, HAS BECOME THE EXCLUSIVE MONOPOLY OF IMPOTENT CONSERVATORY DIRECTORS AND A FEW INCOMPLETE PRIESTS.

11. To PROVOKE IN THE PUBLIC AN EVERGROWING HOSTILITY TOWARDS THE EXHUMATION OF OLD WORKS WHICH PREVENTS THE APPEARANCE OF INNOVATORS, TO ENCOURAGE THE SUPPORT AND EXALTATION OF EVERYTHING IN MUSIC THAT APPEARS ORIGINAL AND REVOLUTIONARY, AND TO CONSIDER AS AN HONOUR THE INSULTS AND IRONIES OF MORIBUNDS AND OPPORTUNISTS.

And now the reactions of the traditionalists are poured on my head in all their fury. I laugh serenely and care not a jot; I have climbed beyond the past, and I loudly summon young musicians to the flag of Futurism which, launched by the poet Marinetti in *Le Figaro* in Paris, has in a short space of time conquered most of the intellectual centres of the world.

11 October 1910
Published in Pratella's *Musica futurista per orchestra riduzione per pianoforte*. Bologna, 1912
Translation CT

Anton Giulio Bragaglia
Futurist Photodynamism 1911

To begin with, Photodynamism cannot be interpreted as an innovation applicable to photography in the way that chronophotography was. Photodynamism is a creation that aims to achieve ideals that are quite contrary to the objectives of *all* the representational means of today. If it can be associated at all with photography, cinematography and chronophotography, this is only by virtue of the fact that, like them, it has its origins in the wide field of photographic science, the technical means forming common ground. All are based on the physical properties of the camera.

We are certainly not concerned with the aims and characteristics of cinematography and chronophotography. We are not interested in the precise reconstruction of movement, which has already been broken up and analysed. We are involved only in the area of movement which produces sensation, the memory of which still palpitates in our awareness.

We despise the precise, mechanical, glacial reproduction of reality, and take the utmost care to avoid it. For us this is a harmful and negative element, whereas for cinematography and chronophotography it is the very essence. They in their turn overlook the trajectory, which for us is the essential value.

The question of cinematography in relation to us is absolutely idiotic, and can only be raised by a superficial and imbecilic mentality motivated by the most crass ignorance of our argument.

Cinematography does not trace the shape of movement. It subdivides it, without rules, with mechanical arbitrariness, disintegrating and shattering it without any kind of aesthetic concern for rhythm. It is not within its coldly mechanical power to satisfy such concerns.

Besides which, cinematography never analyses movement. It shatters it in the frames of the film strip, quite unlike the action of Photodynamism, which analyses movement precisely in its details. And cinematography never synthesizes movement, either. It merely reconstructs fragments of reality, already coldly broken up, in the same way as the hand of a chronometer deals with time even though this flows in a continuous and constant stream.

Photography too is a quite distinct area; useful in the perfect anatomical reproduction of reality; necessary and precious therefore for aims that are absolutely contrary to ours, which are artistic *in themselves*, scientific in their researches, but nevertheless always directed towards art.

And so both photography and Photodynamism possess their own singular qualities, clearly divided, and are very different in their importance, their usefulness and their aims.

Marey's chronophotography, too, being a form of cinematography carried out on a single plate or on a continuous strip of film, even if it does not use frames to divide movement which is already scanned and broken up into instantaneous shots, still shatters the action. The instantaneous images are even further apart, fewer and more autonomous than those of cinematography, so that this too cannot be called analysis.

In actual fact, Marey's system is used, for example, in the teaching of gymnastics. And out of the hundred images that trace a man's jump the few that are registered are just sufficient to describe and to teach to the young the principal stages of a jump.

But although this may be all very well for the old Marey system, for gymnastics and other such applications, it is not enough for us. With about five extremely rigid instantaneous shots we cannot obtain even

the *reconstruction* of movement, let alone the *sensation*. Given that chronophotography certainly does not reconstruct movement, or give the sensation of it, any further discussion of the subject would be idle, except that the point is worth stressing, as there are those who, with a certain degree of elegant malice, would identify Photodynamism with chronophotography, just as others insisted on confusing it with cinematography.

Marey's system, then, seizes and freezes the action in its principal stages, those which best serve its purpose. It thus describes a theory that could be equally deduced from a series of instantaneous photographs. They could similarly be said to belong to different subjects, since, if a fraction of a stage is removed, no link unites and unifies the various images. They are *photographic, contemporaneous,* and appear to belong to *more* than one subject. To put it crudely, chronophotography could be compared with a clock on the face of which only the quarter-hours are marked, cinematography to one on which the minutes too are indicated, and Photodynamism to a third on which are marked not only the seconds, but also the *intermovemental* fractions existing in the passages between seconds. This becomes an almost infinitesimal calculation of movement.

In fact it is only through our researches that it is possible to obtain a vision that is proportionate, in terms of the strength of the images, to the very tempo of their existence, and to the speed with which they have lived in a space and in us.

The greater the speed of an action, the less intense and broad will be its trace when registered with Photodynamism. It follows that the slower it moves, the less it will be dematerialized and distorted. The more the image is distorted, the less real it will be. It will be more ideal and lyrical, further extracted from its personality and closer to *type*, with the same evolutionary effect of distortion as was followed by the Greeks in their search for their type of beauty.

There is an obvious difference between the photographic mechanicality of chronophotography–embryonic and rudimentary cinematography – and the tendency of Photodynamism to move away from that mechanicality, following its own ideal, and completely opposed to the aims of all that went before (although we do propose to undertake our own scientific researches into movement).

Photodynamism, then, analyses and synthesizes movement at will, and to great effect. This is because it does not have to resort to disintegration for observation, but possesses the power to record the continuity of an action in space, to trace in a face, for instance, not only

the expression of passing states of mind, as photography and cine-matography have never been able to, but also the immediate shifting of volumes that results in the immediate transformation of ex-pression.

A shout, a tragical pause, a gesture of terror, the entire scene, the complete external unfolding of the intimate drama, can be expressed in one single work. And this applies not only to the point of departure or that of arrival – nor merely to the intermediary stage, as in chrono-photography – but continuously, from beginning to end, because in this way, as we have already said, the *intermovemental* stages of a movement can also be invoked.

In fact, where scientific research into the evolution and modelling of movement are concerned, we declare Photodynamism to be exhaustive and essential, given that no precise means of analysing a movement exists (we have already partly examined the rudimentary work of chronophotography).

And so – just as the study of anatomy has always been essential for an artist – now a knowledge of the paths traced by bodies in action and of their transformation in motion will be indispensable for the painter of movement.

In the composition of a painting, the optical effects observed by the artist are not enough. A precise analytical knowledge of the essential properties of the effect, and of its causes, are essential. The artist may know how to synthesize such analyses, but within such a synthesis the skeleton, the precise and almost invisible analytical elements, must exist. These can only be rendered visible by the scientific aspects of Photodynamism.

In fact, every vibration is the rhythm of infinite minor vibrations, since every rhythm is built up of an infinite quantity of vibrations. In so far as human knowledge has hitherto conceived and considered movement in its *general rhythm*, it has fabricated, so to speak, an alge-bra of movement. This has been considered *simple* and *finite* (cf. Spencer: *First Principles – The Rhythm of Motion*). But Photodynamism has revealed and represented it as *complex*, raising it to the level of an *infinitesimal calculation of movement* (see our latest works, e.g. *The Carpenter, The Bow, Changing Positions*).

Indeed, we represent the movement of a pendulum, for example, by relating its speed and its tempo to two orthogonal axes.

We will obtain a continuous and infinite sinusoidal curve.

But this applies to a theoretical pendulum, an immaterial one. The representation we will obtain from a material pendulum will differ from

the theoretical one in that, after a longer or shorter (but always *finite*) period, it will stop.

It should be clear that in both cases the lines representing such movement are continuous, and do not portray the reality of the phenomenon. In reality, these lines should be composed of an infinite number of minor vibrations, introduced by the resistance of the point of union. This does not move with smooth continuity but in a jerky way caused by infinite coefficients. Now, a *synthetic* representation is more effective, even when its essence envelops an *analytically divisionist* value, than a synthetic impressionist one (meaning divisionism and impressionism in the philosophical sense). In the same way the representation of realistic movement will be much more effective in synthesis – containing in its essence an analytical divisionist value (e.g. *The Carpenter*, *The Bow*, etc.), than in analysis of a superficial nature, that is, when it is not minutely interstatic but expresses itself only in successive static states (e.g. *The Typist*).

Therefore, just as in Seurat's painting the essential question of chromatic divisionism (synthesis of effect and analysis of means) had been suggested by the scientific enquiries of Rood, so today the need for movemental divisionism, that is, synthesis of effect and analysis of means in the painting of movement, is indicated by Photodynamism. But – and this should be carefully noted – this analysis is infinite, profound and sensitive, rather than immediately perceptible.

This question has already been raised by demonstrating that, just as anatomy is essential in static reproduction, so the anatomy of an action – intimate analysis – is indispensable in the representation of movement. This will not resort to thirty images of the same object to represent an object in movement, but will render it *infinitely multiplied and extended*, whilst the figure *present* will appear *diminished*.

Photodynamism, then, can establish results from positive data in the construction of moving reality, just as photography obtains its own positive results in the sphere of static reality.

The artist, in search of the forms and combinations that characterize whatever state of reality interests him, can, by means of Photodynamism, establish a foundation of experience that will facilitate his researches and his intuition when it comes to the dynamic representation of reality. After all, the steady and essential relationships which link the development of any real action with artistic conception are indisputable, and are affirmed independently of formal analogies with reality.

Once this essential affinity has been established, not only between artistic conception and the representation of reality, but also between

artistic conception and application, it is easy to realize how much information dynamic representation can offer to the artist who is engaged in a profound search for it.

In this way light and movement in general, light acting as movement, and hence the movement of light, are revealed in Photodynamism. Given the transcendental nature of the phenomenon of movement, it is only by means of Photodynamism that the painter can know what happens in the intermovemental states, and become acquainted with the *volumes of individual motions*. He will be able to analyse these in minute detail, and will come to know the *increase in aesthetic value of a flying figure*, or its *diminution*, relative to light and to the dematerialization consequent upon motion. Only with Photodynamism can the artist be in possession of the elements necessary for the construction of a work of art embodying the desired-for synthesis.

With reference to this the sculptor Roberto Melli wrote to me explaining that, in his opinion, Photodynamism 'must, in the course of these new researches into movement which are beginning to make a lively impression on the artist's consciousness, take the place which has until now been occupied by drawing, a physical and mechanical phenomenon very different from the physical transcendentalism of Photodynamism. Photodynamism is to drawing what the new aesthetic currents are to the art of the past.' . . .

Now, with cinematography and Marey's equivalent system the viewer moves abruptly from one state to another, and thus is limited to the states that compose the movement, without concern for the intermovemental states of the action; and with photography he sees only one state. But with Photodynamism, remembering what took place between one stage and another, a work is presented that transcends the human condition, becoming a *transcendental photograph of movement*. For this end we have also envisaged a machine which will render actions visible, more effectively than is now today possible with actions traced from one point, but at the same time keeping them related to the time in which they were made. They will remain idealized by the distortion and by the destruction imposed by the motion and light which translate themselves into trajectories.

So it follows that when you tell us that the images contained in our Photodynamic works are unsure and difficult to distinguish, you are merely noting a pure characteristic of Photodynamism. For Photodynamism, it is desirable and correct to record the images in a distorted state, since images themselves are inevitably transformed in movement. Besides this, our aim is to make a determined move away from reality,

since cinematography, photography and chronophotography already exist to deal with mechanically precise and cold reproduction.

We seek the interior essence of things: pure movement; and we prefer to see everything in motion, since as things are dematerialized in motion they become idealized, while still retaining, deep down, a strong skeleton of truth.

This is our aim, and it is by these means that we are attempting to raise photography to the heights which today it strives impotently to attain, being deprived of the elements essential for such an elevation because of the criteria of order that make it conform with the precise reproduction of reality. And then, of course, it is also dominated by that ridiculous and brutal negative element, the instantaneous exposure, which has been presented as a great scientific strength when in fact it is a laughable absurdity.

But where the scientific analysis of movement is concerned – that is, in the multiplication of reality for the study of its deformation in motion – we possess not merely one but a whole scale of values applied to an action. We repeat the idea, we insist, we impose and return to it without hesitation and untiringly, until we can affirm it absolutely with the obsessive demonstration of exterior and internal quality which is essential for us.

And it is beyond doubt that by way of such *multiplication of entities* we will achieve a *multiplication of values,* capable of enriching any fact with a more *imposing personality.*

In this way, if we repeat the principal states of the action, the figure of a dancer – moving a foot, in mid-air, pirouetting – will, even when not possessing its own trajectory or offering a dynamic sensation, be much more like a dancer, and much more like dancing, than would a single figure frozen in just one of the states that build up a movement.

The picture therefore can be invaded and pervaded by the essence of the subject. It can be *obsessed by the subject to the extent that it energetically invades and obsesses the public with its own values.* It will not exist as a passive object over which an unconcerned public can take control for its own enjoyment. It will be an active thing that imposes its own extremely free essence on the public, though this will not be graspable with the insipid facility common to all images that are too faithful to ordinary reality.

To further this study of reality multiplied in its volumes, and the multiplication of the lyrical plastic sensation of these, we have conceived a method of research, highly original in its mechanical means, which we have already made known to some of our friends.

44

But in any case, at the moment we are studying the trajectory, the synthesis of action, that which exerts a fascination over our senses, the vertiginous lyrical expression of life, the lively invoker of the magnificent dynamic feeling with which the universe incessantly vibrates.

We will endeavour to extract not only the aesthetic expression of the motives, but also the inner, sensorial, cerebral and psychic emotions that we feel when an action leaves its superb, unbroken trace.

This is in order to offer to others the necessary factors for the reproduction of the desired feeling.

And it is on our current researches into the *interior* of an action that all the emotive artistic values existing in Photodynamism are based.

To those who believe that there is no need for such researches to be conducted with photographic means, given that painting exists, we would point out that, although avoiding competing with painting, and working in totally different fields, the means of photographic science are so swift, so fertile, and so powerful in asserting themselves as much more forward looking and much more in sympathy with the evolution of life than all other old means of representation.

<div style="text-align: right">

First mentioned in an advertisement
in *Lacerba* (Florence), 1 July 1913
Translation CT

</div>

Umberto Boccioni, Carlo Carrà, Luigi Russolo, Giacomo Balla, Gino Severini
The Exhibitors to the Public 1912

We may declare, without boasting, that the first Exhibition of Italian Futurist Painting, recently held in Paris and now brought to London, is the most important exhibition of Italian painting which has hitherto been offered to the judgment of Europe.

For we are young and our art is violently revolutionary.

What we have attempted and accomplished, while attracting around us a large number of skilful imitators and as many plagiarists without talent, has placed us at the head of the European movement in painting, by a road different from, yet, in a way, parallel with, that followed by the Post-impressionists, Synthetists and Cubists of France, led by their masters Picasso, Braque, Derain, Metzinger, Le Fauconnier, Gleizes, Léger, Lhote, etc.

While we admire the heroism of these painters of great worth, who

have displayed a laudable contempt for artistic commercialism and a powerful hatred of academism, we feel ourselves and we declare ourselves to be absolutely opposed to their art.

They obstinately continue to paint objects motionless, frozen, and all the static aspects of Nature; they worship the traditionalism of Poussin, of Ingres, of Corot, ageing and petrifying their art with an obstinate attachment to the past, which to our eyes remains totally incomprehensible.

We, on the contrary, with points of view pertaining essentially to the future, seek for a style of motion, a thing which has never been attempted before us.

Far from resting upon the examples of the Greeks and the Old Masters, we constantly extol individual intuition; our object is to determine completely new laws which may deliver painting from the wavering uncertainty in which it lingers.

Our desire, to give as far as possible to our pictures a solid construction, can never bear us back to any tradition whatsoever. Of that we are firmly convinced.

All the truths learnt in the schools or in the studios are abolished for us. Our hands are free enough and pure enough to start everything afresh.

Is it indisputable that several of the aesthetic declarations of our French comrades display a sort of masked academism.

Is it not, indeed, a return to the Academy to declare that the subject, in painting, is of perfectly insignificant value?

We declare, on the contrary, that there can be no modern painting without the starting point of an absolutely modern sensation, and none can contradict us when we state that *painting* and *sensation* are two inseparable words.

If our pictures are Futurist, it is because they are the result of absolutely Futurist conceptions, ethical, aesthetic, political, social.

To paint from the posing model is an absurdity, and an act o mental cowardice, even if the model be translated upon the picture in linear, spherical or cubic forms.

To lend an allegorical significance to an ordinary nude figure, deriving the meaning of the picture from the objects held by the model or from those which are arranged about him, is to our mind the evidence of a traditional and academic mentality.

This method, very similar to that employed by the Greeks, by Raphael, by Titian, by Veronese, must necessarily displease us.

While we repudiate Impressionism, we emphatically condemn the

present reaction which, in order to kill Impressionism, brings back painting to old academic forms.

It is only possible to react against Impressionism by surpassing it.

Nothing is more absurd than to fight it by adopting the pictural laws which preceded it.

The points of contact which the quest of style may have with the so-called *classic art* do not concern us.

Others will seek, and will, no doubt, discover, these analogies which in any case cannot be looked upon as a return to methods, conceptions and values transmitted by classical painting.

A few examples will illustrate our theory.

We see no difference between one of those nude figures commonly called *artistic* and an anatomical plate. There is, on the other hand, an enormous difference between one of these nude figures and our Futurist conception of the human body.

Perspective, such as it is understood by the majority of painters, has for us the very same value which they lend to an engineer's design.

The simultaneousness of states of mind in the work of art: that is the intoxicating aim of our art.

Let us explain again by examples. In painting a person on a balcony, seen from inside the room, we do not limit the scene to what the square frame of the window renders visible; but we try to render the sum total of visual sensations which the person on the balcony has experienced; the sun-bathed throng in the street, the double row of houses which stretch to right and left, the beflowered balconies, etc. This implies the simultaneousness of the ambient, and, therefore, the dislocation and dismemberment of objects, the scattering and fusion of details, freed from accepted logic, and independent from one another.

In order to make the spectator live in the centre of the picture, as we express it in our manifesto, the picture must be the synthesis of *what one remembers* and of *what one sees*.

You must render the invisible which stirs and lives beyond intervening obstacles, what we have on the right, on the left, and behind us, and not merely the small square of life artificially compressed, as it were, by the wings of a stage.

We have declared in our manifesto that what must be rendered is the *dynamic sensation*, that is to say, the particular rhythm of each object, its inclination, its movement, or, more exactly, its interior force.

It is usual to consider the human being in its different aspects of motion or stillness, of joyous excitement or grave melancholy.

What is overlooked is that all inanimate objects display, by their lines, calmness or frenzy, sadness or gaiety. These various tendencies lend to the lines of which they are formed a sense and character of weighty stability or of aerial lightness.

Every object reveals by its lines how it would resolve itself were it to follow the tendencies of its forces.

This decomposition is not governed by fixed laws but it varies according to the characteristic personality of the object and the emotions of the onlooker.

Furthermore, every object influences its neighbour, not by reflections of light (the foundation of *Impressionistic primitivism*), but by a real competition of lines and by real conflicts of planes, following the emotional law which governs the picture (the foundation of *Futurist primitivism*).

With the desire to intensify the aesthetic emotions by blending, so to speak, the painted canvas with the soul of the spectator, we have declared that the latter *must in future be placed in the centre of the picture.*

He shall not be present at, but participate in the action. If we paint the phases of a riot, the crowd bustling with uplifted fists and the noisy onslaughts of cavalry are translated upon the canvas in sheaves of lines corresponding with all the conflicting forces, following the general law of violence of the picture.

These *force-lines* must encircle and involve the spectator so that he will in a manner be forced to struggle himself with the persons in the picture.

All objects, in accordance with what the painter Boccioni happily terms *physical transcendentalism*, tend to the infinite by their *force-lines*, the continuity of which is measured by our intuition.

It is these *force-lines* that we must draw in order to lead back the work of art to true painting. We interpret nature by rendering these objects upon the canvas as the beginnings or the prolongations of the rhythms impressed upon our sensibility by these very objects.

After having, for instance, reproduced in a picture the right shoulder or the right ear of a figure, we deem it totally vain and useless to reproduce the left shoulder or the left ear. We do not draw sounds, but their vibrating intervals. We do not paint diseases, but their symptoms and their consequences.

We may further explain our idea by a comparison drawn from the evolution of music.

Not only have we radically abandoned the motive fully developed according to its determined and, therefore, artificial equilibrium, but we suddenly and purposely intersect each motive with one or more other motives of which we never give the full development but merely the initial, central, or final notes.

As you see, there is with us not merely variety, but chaos and clashing of rhythms, totally opposed to one another, which we nevertheless assemble into a new harmony.

We thus arrive at what we call the *painting of states of mind.*

In the pictural description of the various states of mind of a leave-taking, perpendicular lines, undulating and as it were worn out, clinging here and there to silhouettes of empty bodies, may well express languidness and discouragement.

Confused, and trepidating lines, either straight or curved, mingled with the outlined hurried gestures of people calling one another, will express a sensation of chaotic excitement.

On the other hand, horizontal lines, fleeting, rapid and jerky, brutally cutting into half lost profiles of faces or crumbling and rebounding fragments of landscape, will give the tumultuous feelings of the persons going away.

It is practically impossible to express in words the essential values of painting.

The public must also be convinced that in order to understand aesthetic sensations to which one is not accustomed, it is necessary to forget entirely one's intellectual culture, not in order to *assimilate* the work of art, but to *deliver one's self up* to it heart and soul.

We are beginning a new epoch of painting.

We are sure henceforward of realizing conceptions of the highest importance and the most unquestionable originality. Others will follow who, with equal daring and determination, will conquer those summits of which we can only catch a glimpse. That is why we have proclaimed ourselves to be *the primitives of a completely renovated sensitiveness.*

In several of the pictures which we are presenting to the public, vibration and motion endlessly multiply each object. We have thus justified our famous statement regarding the *running horse which has not four legs, but twenty.*

One may remark, also, in our pictures spots, lines, zones of colour which do not correspond to any reality, but which, in accordance with a

law of our interior mathematics, musically prepare and enhance the emotion of the spectator.

We thus create a sort of emotive ambience, seeking by intuition the sympathies and the links which exist between the exterior (concrete) scene and the interior (abstract) emotion. Those lines, those spots, those zones of colour, apparently illogical and meaningless, are the mysterious keys to our pictures.

We shall no doubt be taxed with an excessive desire to define and express in tangible form the subtle ties which unite our abstract interior with the concrete exterior.

Yet, could we leave an unfettered liberty of understanding to the public which always sees, as it has been taught to see, through eyes warped by routine?

We go our way, destroying each day in ourselves and in our pictures the realistic forms and the obvious details which have served us to construct a bridge of understanding between ourselves and the public. In order that the crowd may enjoy our marvellous spiritual world, of which it is ignorant, we give it the material sensation of that world.

We thus reply to the coarse and simplistic curiosity which surrounds us by the brutally realistic aspects of our primitivism.

Conclusion: Our Futurist painting embodies three new conceptions of painting:

1. That which solves the question of volumes in a picture, as opposed to the liquefaction of objects favoured by the vision of the Impressionists.
2. That which leads us to translate objects according to the *force-lines* which distinguish them, and by which is obtained an absolutely new power of objective poetry.
3. That (the natural consequence of the other two) which would give the emotional ambience of a picture, the synthesis of the various abstract rhythms of every object, from which there springs a fount of pictural lyricism hitherto unknown.

5 February 1912

(*N.B.* All the ideas contained in this preface were developed at length in the lecture on Futurist Painting, delivered by the painter, Boccioni, at the Circolo Internazionale Artistico, at Rome, on 29 May 1911.)

Exhibition catalogue, Galerie Bernheim-Jeune, Paris.
This English version from the catalogue
of the 'Exhibition of Works by
the Italian Futurist Painters',
Sackville Gallery, London, March 1912

Umberto Boccioni
Technical Manifesto of Futurist Sculpture 1912

All the sculpture on monuments and in exhibitions to be seen in all European cities presents such a pathetic spectacle of barbarism, ineptitude and tedious imitation that my Futurist eyes turn away from it with the deepest loathing!

Sculpture in every country is dominated by the moronic mimicry of old, inherited formulas; this blind imitation is encouraged by the ghastly facility with which it can be done. Latin countries are bowed down under the opprobrious burden of the Greeks and Michelangelo, which is borne in Belgium and France with a certain seriousness and talent, and in Italy with grotesque imbecility. In the Teutonic countries we find nothing but a kind of gothicky, Hellenophilic fatuity which is being turned out in Berlin or feebly reproduced with effeminate fuss by the German academics of Munich. In Slav countries, on the other hand, we have a discordant clash between an Archaic Greek style and Nordic and Oriental prodigies. There is an unformed mass of accumulated influences, from the excesses of complicated Asiatic detail to the infantile and grotesque over-simplification of the Lapps and Eskimos.

In all these sculptures, even in those which have a breath of bold innovation, we see the perpetuation of the same old kind of misapprehension: an artist copies a nude or studies classical statues with the naive conviction that here he will find a style that equates to modern sensibility without stepping outside the traditional concepts of sculptural form. These concepts, along with such famous catchwords as 'ideals of beauty', which everyone speaks of in hushed tones, are never separated from the glorious periods of ancient Greece and its later decadence.

It is almost inexplicable that thousands of sculptors can go on, generation after generation, constructing puppet figures without bothering to ask themselves why the sculpture halls arouse boredom or horror, or are left absolutely deserted; or why monuments are unveiled in squares all over the world to the accompaniment of general mirth or incomprehension. The same situation does not exist in painting, since painting is continually undergoing renewal. Though this process of modernization is very slow, it still provides the best and clearest condemnation of all the plagiaristic and sterile work being turned out by all the sculptors of our own days.

Sculpture must learn one absolute truth: to construct and try to create, now, with elements which have been stolen from the Egyptians,' the Greeks or Michelangelo is like trying to draw water from a dry well with a bottomless bucket.

There can be no renewal in art unless its whole essence is brought up to date. This essence lies in the vision and the conception of the lines and masses which form the internal arabesque. Art does not become an expression of our own times merely by reproducing the external aspects of contemporary life; and hence sculpture as it has been understood by artists of the last and present centuries is a monstrous anachronism.

Sculpture has not progressed because of the limits inherent within the accepted field of the academic concept of the nude. An art that must take all the clothes off a man or woman in order to produce any emotive effect is a dead art! Painting has given itself a shot in the arm, has broadened and deepened its scope, using the facts of landscape and the environment which act simultaneously on the human figure and on objects, thereby achieving our Futurist INTERPENETRATION OF PLANES (Futurist Painting: Technical Manifesto, 11 April 1910). Sculpture may also be able to find new sources of inspiration along these lines and hence renew its style and extend its plastic capacities to the kind of objects, which up till now a kind of barbaric idiocy has persuaded us to believe were divided up or intangible – and, therefore, inexpressible in plastic form.

We must take the object which we wish to create and begin with its central core. In this way we shall uncover new laws and new forms which link it invisibly but mathematically to an EXTERNAL PLASTIC INFINITY and to an INTERNAL PLASTIC INFINITY. This new plastic art will then be a translation, in plaster, bronze, glass, wood or any other material, of those atmospheric planes which bind and intersect things. This vision, which I have called PHYSICAL TRANSCENDENTALISM (Lecture on Futurist Painting, May 1911 [Lost; but see p. 50]), could provide for the plastic arts those sympathetic effects and mysterious affinities which create formal and reciprocal influences between the different planes of an object.

Sculpture must, therefore, make objects live by showing their extensions in space as sensitive, systematic and plastic; no one still believes that an object finishes off where another begins or that there is anything around us – a bottle, a car, a house, a hotel, a street – which cannot be cut up and sectionalized by an arabesque of straight curves.

T. Marinetti

2 Umberto Boccioni
Morning 1909

3 Umberto Boccioni
Impression 1909

4 Giacomo Balla *Arc Lamp* 1909

5 Carlo Carrà *Theatre Exit* 19●

6 Gino Severini
The Wafer Seller
1908–09

igi Russolo *Tina's Hair – Effects of Light on man's Face* 1910

8 Umberto Boccioni *The City Rising* 1910

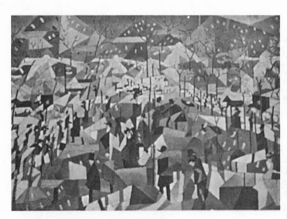

9 Gino Severini *The Boulevard* 1910

11 Carlo Carrà *Girl Swimmers* 1910

larinetti, Carrà, Boccioni and Russolo in netti's house, Milan, 1911

12 Umberto **Boccioni** in his studio

Umberto Boccioni *States of Mind I: The Farewells* 1911

14 Umberto Boccioni
Study for 'Those Who Go' 1911

Umberto Boccioni *States of Mind II: Those Who Go* 1911

17 Umberto Boccioni
Study for 'Those Who Stay' 1911

16 Umberto Boccioni
States of Mind III: Those Who Stay 1911

18 Umberto Boccioni
States of Mind II: Those Who Go 1911

19 Umberto Boccioni
States of Mind III: Those Who Stay 1911

20 Umberto Boccioni
States of Mind I: The Farewells 1911

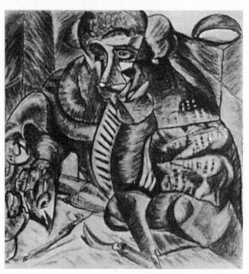

21 Umberto Boccioni *Study for 'Antigraceful'* 1912

22 Umberto Boccioni
Fusion of Head and Window 1911–12

arlo Carrà
Movement of the Moonlight 1911

24 Carlo Carrà
Portrait of Marinetti 1910–11

25 Luigi Russolo
House + Light + Sky
1911

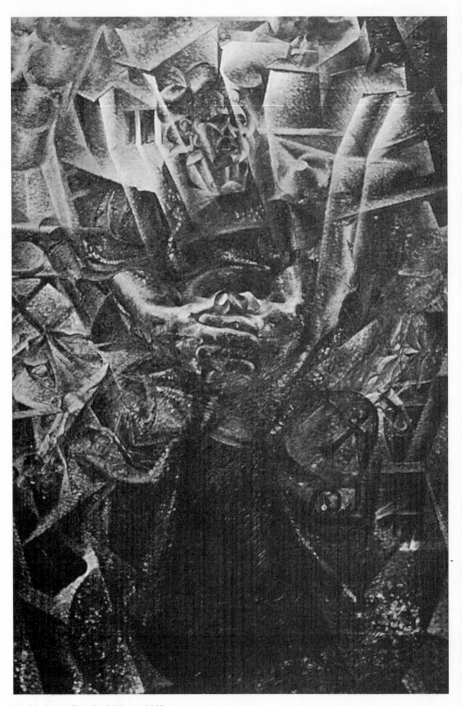

26 Umberto Boccioni *Matter* 1912

Two attempts have been made to bring sculpture into the twentieth century: one was concerned with the decorative side of style; the other merely with the plastic side – materials. The former was a nameless and disorganized movement lacking any coordinating technical genius, and since it was too much tied up with the economic necessities of the building trade, it produced only pieces of traditional sculpture, which were more or less decoratively synthesized and framed by architectural, decorative motifs or mouldings. All houses and blocks of flats with a claim to modernity incorporate essays of this kind in marble, cement or beaten metal.

The second attempt was more attractive, more detached and more poetic; but it was too isolated and fragmentary. It lacked any synthesis of thought which might have resulted in the formulation of a law. To make new art it is not enough to believe in it fervently. You must be prepared to champion your cause and set up certain rules as a guideline towards progress. Here I am referring to the genius of Medardo Rosso, an Italian, the only great modern sculptor who has tried to open up a whole new field of sculpture, by his representation in plastic art of the influences of the environment and the atmospheric links which bind it to his subject.

Of the other three great contemporary sculptors, Constantin Meunier has contributed nothing in the way of fresh sensibilities to sculpture. His statues are nearly always a clever fusion of Greek heroism and the humble athleticism of the docker, the sailor or the miner. His plastic concepts and his construction of statues and bas-reliefs still belong to the world of the Parthenon and the classical hero, in spite of the fact that he was the first artist who tried to create and deify subjects which before his time were held of little account, or were only given mediocre or realistic interpretations.

Bourdelle's sculpture – a mass of abstract architectonic forms – shows a severity which is almost pure fury. His temperament is that of the grimly passionate and sincere experimenter, but unfortunately he does not know how to free himself from certain archaic influences and the example of all those unnamed masons who made our Gothic cathedrals.

Rodin's mental agility is much greater than the others, and this allows him to move on from the Impressionism of his Balzac portrait to the uncertainty of his *Burghers of Calais* and all his other Michelangelo-type sins. He brings to his sculpture an unquiet inspiration, a grandiose lyrical impetus, which would have been well and truly modern if Michelangelo and Donatello had not already possessed them

in almost the identical form four hundred years ago, or if he himself had used these gifts to show a completely new sort of reality.

So, in the works of these three great geniuses we find influences from different periods: Greek for Meunier; Gothic for Bourdelle; and the Italian Renaissance for Rodin.

The work of Medardo Rosso, on the other hand, is revolutionary, modern, profound, and necessarily contained. In his sculptures there are no heroes and no symbols, but the planes in the forehead of a woman, or child, which betray a hint of spatial liberation, will have far greater importance in the history of the spirit than that with which he has been credited in our times. Unfortunately the Impressionists' need for experiment has limited the researches of Medardo Rosso to a species of both high and low relief. This shows that he is still conceiving the figure as something of a world to itself, with a traditional foundation, imbued with descriptive aims.

Medardo Rosso's revolution, then, although very important, springs from extrinsic, pictorial concepts, and ignores the problem of constructing planes. The sensitive touch of the thumb, imitating the lightness of Impressionist brushwork, gives a sense of vibrant immediacy to his works, but necessitates a rapid execution from life which deprives a work of art of any elements of universality. Consequently he has fallen prey to the same qualities and defects as the Impressionist painters; although it is from their experiments that our own aesthetic revolution springs, we shall move away to a diametrically opposed position.

In sculpture as in painting, renewal is impossible without looking for the STYLE OF MOVEMENT, that is, making a systematic and definitive synthesis of the fragmentary, accidental and hence analytical approach of the Impressionists. And this systematization of the vibrations of lights and the interpretations of planes will produce a Futurist sculpture, whose basis will be architectural, not only as a construction of masses, but in such a way that the sculptural block itself will contain the architectural elements of the *sculptural environment* in which the object exists.

In this way we shall be producing a sculpture of the ENVIRONMENT.

A piece of Futurist sculpture will contain all those wonderful mathematical and geometrical elements of which objects are composed in our own times. And these objects will not be juxtaposed with a statue, like explanatory attributes or detached decorative elements, but, following the laws of a new concept of harmony they will be encapsulated inside the muscular lines of a body. In this way, the cogs of

a machine might easily appear out of the armpits of a mechanic, or the lines of a table could cut a reader's head in two, or a book with its fanned-out pages could intersect the reader's stomach.

Traditionally, a statue cuts into, and stands out from, the atmosphere of the place where it is on view; Futurist painting has gone beyond all these antiquated concepts of the rhythmic continuities of lines in a figure, of its isolation from its background, and of the INVISIBLE ENVELOPING SPACE. 'Futurist poetry,' according to the poet Marinetti, 'now that it has destroyed traditional rhythms and created free verse, now destroys Latin syntax and phrasing. Futurist poetry is a spontaneous and uninterrupted current of analogies, all intuitively bound by their essential substance. So that we have imagination without strings, and words-in-freedom.' The Futurist music of Balilla Pratella is also breaking away from the chronometric tyranny of rhythm.

Why should sculpture be the one to lag behind, loaded down with laws which no one has the right to impose? Let's turn everything upside down and proclaim the ABSOLUTE AND COMPLETE ABOLITION OF FINITE LINES AND THE CONTAINED STATUE. LET'S SPLIT OPEN OUR FIGURES AND PLACE THE ENVIRONMENT INSIDE THEM. We declare that the environment must form part of the plastic whole, a world of its own, with its own laws: so that the pavement can jump up on to your table, or your head can cross a street, while your lamp twines a web of plaster rays from one house to the next.

We want the entire visible world to tumble down on top of us, merging and creating a harmony on purely intuitive grounds; a leg, an arm or an object has no importance except as an element in the plastic rhythm of the whole, and can be eliminated, not because we are trying to imitate a Greek or Roman fragment, but in order to conform with the general harmony the artist is trying to create. A sculptural whole, like a painting, should not resemble anything but itself, since figures and objects in art should exist without regard to their logical aspect.

Thus a figure may have one arm clothed and the other unclothed, while the different lines of a vase of flowers may run around with complete abandon between the lines of a hat and those of a neck.

Thus transparent planes, glass, strips of metal sheeting, wire, street-lamps or house-lights may all indicate planes – the shapes, tones and semitones of a new reality.

In the same way a new intuitive shading of white, grey, black, can add to the emotive power of surfaces, while the hue of a coloured plane should be used to accentuate the abstract meaning of a plastic fact.

What we said when we talked about force-lines in painting (Preface-Manifesto, Catalogue of First Futurist Exhibition, Paris, February 1912 [see p. 48, above]) is also applicable to sculpture – bringing the static muscular line to life in the dynamic force-line. In the muscular line the straight line must be given pride of place since it is the only one which corresponds to the internal simplicity of the synthesis by which we oppose external, baroque exhibitionism.

However the straight line will not lead us to imitate the Egyptians, the primitives or the savages, as it has some sculptors desperately trying to free themselves from the hold of the Greeks. Our straight lines will be living and palpitating. This will show everyone the necessities inherent in the limitless expressive potentialities of matter, and its severe and fundamental bareness will be the symbol of the severity of steel in the lines of modern machinery.

We should finally like to state that in sculpture the artist must not be afraid of any new method of achieving REALITY. There is no fear more stupid than one which makes the artist nervous of departing from the art in which he works. There is neither painting nor sculpture, neither music nor poetry: there is only creation! Hence if a composition seems to demand a particular rhythmic movement which will add to or contrast with the circumscribed rhythms of the SCULPTURAL WHOLE (the basic requirement of any work of art), you may use any kind of contraption to give an adequate sense of rhythmic movement to planes or lines.

We cannot forget that the swing of a pendulum or the moving hands of a clock, the in-and-out motion of a piston inside a cylinder, the engaging and disengaging of two cog-wheels, the fury of a fly-wheel or the whirling of a propeller, are all plastic and pictorial elements, which any Futurist work of sculpture should take advantage of. The opening and closing of a valve creates a rhythm which is just as beautiful to look at as the movements of an eyelid, and infinitely more modern.

CONCLUSIONS

1. Achieve an abstract reconstruction of planes and volumes in order to determine form of sculpture and not figurative value.

2. Abolish in sculpture as in all other art the TRADITIONAL 'SUBLIME' IN SUBJECT-MATTER.

3. Deny in sculpture any attempt at realistic, episodic structures; affirm the absolute necessity of using all elements of reality in order to rediscover the basic elements of plastic sensitivity. By considering bodies and their parts as PLASTIC ZONES, any Futurist sculptural composition

64

will contain planes of wood or metal, either motionless or in mechanical motion, in creating an object; spherical fibrous forms for hair, semicircles of glass for a vase, wire and netting for atmospheric planes, etc.

4. Destroy the literary and traditional 'dignity' of marble and bronze statues. Refuse to accept the exclusive nature of a single material in the construction of a sculptural whole. Insist that even twenty different types of materials can be used in a single work of art in order to achieve plastic movement. To mention a few examples: glass, wood, cardboard, iron, cement, hair, leather, cloth, mirrors, electric lights, etc.

5. Maintain that, in the intersecting planes of a book and a corner of a table, in the straight lines of a match, in a blind drawn across a window, there is more truth than in all the knotted muscles, all the breasts and buttocks of heroes and Venuses, which are still the main inspiration of our demented modern sculptors.

6. Only use very modern and up-to-date subjects in order to arrive at the discovery of NEW PLASTIC IDEAS.

7. A straight line is the only way to discover the primitive purity of a new architectural structure of masses and sculptural zones.

8. There can be no renewal unless it is through ENVIRONMENTAL SCULPTURE, since only by this means can plastic art develop and come to MODEL THE ATMOSPHERE which surrounds our objects.

9. The things we are creating are only a bridge between an outer plastic infinity and an inner plastic infinity, hence objects can never be finite, but intersect each other through an infinite combination of powers which attract and repel.

10. Destroy the systematic nude and the traditional concept behind statuary and monuments.

11. Courageously refuse to accept any work, whatever the reward, which does not, in itself, involve a pure construction of plastic elements which have been completely renewed.

Published as a leaflet by
Poesia (Milan), 11 April 1912
Translation R B

Bruno Corra
Abstract Cinema - Chromatic Music 1912

It could be said that the only display of the art of colours currently in use is the painting. A painting is a medley of colours placed in reciprocal relationships in order to represent an idea. (You will note that I have defined painting as the art of colour. For brevity's sake, I will not concern myself with line, an element taken from another art.) A new and more rudimentary form of pictorial art can be created by placing masses of colour harmoniously arranged in relationship to each other over a surface, so as to give pleasure to the eye without representing any image. This would correspond to what in music is known as harmony, and we can therefore call it chromatic harmony. These two forms of art, chromatic harmony and the painting, are *spatial*; music tells us of the existence of something essentially different, the mingling of chromatic tones presented to the eye successively, a *motif* of colours, a chromatic theme. I shall not, since it is not yet necessary, go on to speak of a fourth form of art, corresponding to musical drama, which would give rise to chromatic drama.

Consequently, two years ago, after the entire theory had been minutely established, we decided to make a serious attempt to create a music of colours. We immediately began to think of the instruments, which perhaps did not exist, and which we would have to have made to order, to enable us to realize these theories. We travelled untrodden roads, letting intuition guide us for the most part, but always proceeding concurrently, in order not to be led astray, with our study of the physics of light and sound, the works of Tyndall and of many others.

Naturally we applied and exploited the laws of parallelism between the arts which had already been determined. For two months each studied on his own without communicating his results – afterwards we presented, discussed and amalgamated our observations. This confirmed our idea, which had anyway preceded our study of physics, of adhering to music and transferring the tempered scale of music into the field of colour. We knew, however, that the chromatic scale consists of only one octave, and that, on the other hand, the eye, unlike the ear, does not possess *the power of resolution* (although, rethinking this point, I realize that one must have reservations). Yet we felt the obvious need of a subdivision of the solar spectrum, even an artificial and arbitrary one (since the effect stems principally from the *relationships* between the colours that impress the eye). Consequently we selected four equally

distanced gradations in each colour. We had four reds chosen at equal distances in the spectrum, four greens, four violets, etc. In this way we managed to extend the seven colours in four octaves. After the violet of the first octave came the red of the second, and so on. To translate all this into practice we naturally used a series of twenty-eight coloured electric light bulbs, corresponding to twenty-eight keys. Each bulb was fitted with an oblong reflector: the first experiments were done with direct light, and in the subsequent ones a sheet of ground glass was placed in front of the light bulb. The keyboard was exactly like that of a piano (but was less extensive). When an octave was played, for example, the two colours were mingled, as are two sounds on the piano.

This chromatic piano, when it was tried out, gave quite good results, so much so that at first we were under the illusion that we had resolved the problem definitively. We amused ourselves by finding all sorts of chromatic mixtures, we composed a few colour sonatinas – *notturni* in violet and *mattinate* in green. We translated, with a few necessary modifications, a Venetian barcarolle by Mendelssohn, a rondo by Chopin, a Mozart sonata. But at last, after three months of experiment-ation, we had to confess that with these means no further progress could be made. We obtained the most graceful effects, it is true, but never to the extent that we felt fully gripped. We had at our disposition only twenty-eight tones, the fusions did not work well, the sources of light were not strong enough, if we used powerful bulbs the excessive heat made them discolour in a few days, and then we had to recolour them exactly, with considerable loss of time. We felt very clearly that, in order to obtain the large orchestral effects which alone can convince the masses, we needed to have a truly stupefying intensity of light at our disposition – only then could we emerge from the restricted field of scientific experiment to enter directly into its practice.

We turned our thoughts to cinematography, and it seemed to us that this medium, slightly modified, would give excellent results, since its light potency was the strongest one could desire. The other problem concerning the need to have hundreds of colours at our disposition was also resolved, since, by exploiting the phenomenon of the persistence of an image on the retina, we would indeed have been able to make many colours merge, in our eye, into a single hue. To achieve this it was sufficient to pass all the component colours in front of the lens in less than a tenth of a second. In this way with a simple cinematographic instrument, with a machine of small dimensions, we would have ob-tained the innumerable and extremely powerful effects of large musical orchestras, the true chromatic symphony. This was the theory. In

practice, the results, after we had acquired the camera, procured many hundreds of metres of film, removed the gelatine and applied the colour, were, as always, mixed. To achieve a harmonious, gradual and uniform sequence of chromatic themes we had removed the rotating switch and had managed to get rid of the shutter action, too; but this was exactly the reason for the failure of the experiment, and meant that in place of the expected marvellous harmony there exploded over the screen a cataclysm of incomprehensible colours. It was only subsequently that we understood the reason. We replaced all the parts we had removed, and decided to consider the film to be coloured as divided into *bars*, each one as long as the space between four perforations, which corresponds, at least in films of the Pathé gauge, to one complete rotation of the switch. We prepared another length of film and tried again. The fusion of the colours was perfect, and that was the important factor. As for the effect, it was not all that good, but we had already realized that where this was concerned we could not reasonably expect much, unless one had the ability, acquired only by long experience, to mentally project on to the screen the development of a motive as it is gradually applied with the brush on to the celluloid. This ability implies the mental fusion of many colours into one single colour, and the dissection of a hue into all its components.

At this point, seeing that our experiences had got us positively on a solid road, we felt it necessary to pause to effect every possible improvement on the machine we were using. The projector remained unchanged. We merely replaced the arc lamp we had used until then with another arc lamp three times as strong. We made repeated experiments with the screen, using a simple white canvas, a white canvas soaked in glycerine, a tinfoil surface, a canvas covered with an impasto that resulted, by reflection, in a sort of phosphorescence, an approximately cubical cage of very fine gauze penetrable by the light rays, which gave a fluctuating effect of clouds of white smoke. At last we returned to a white canvas stretched over a wall. All furniture was removed and the entire room, walls, ceiling and floor, painted white. During the rehearsals we wore white shrouding drapes (incidentally: once chromatic music is established, be it our works or those of others, a fashion will follow encouraging the well-dressed spectator to go to the theatre of colour dressed in white. Tailors can get to work on it now). To date we have not been able to achieve better results, and we have continued to work in our white room, which, in any case, serves us quite adequately.

Before describing, since I cannot do otherwise, the most recent suc-

cessful colour symphonies, I will attempt to give the reader some idea of this, though it will be far from the effect of the encounter of colours extended in time. I will place under the reader's eyes a few sketches (here to hand) for a *film* planned long since. This will precede public performances, accompanied by suitable explanations. (It will consist of fifteen or so extremely simple chromatic motives, each about a minute long and each divided from the next. These will serve to communicate to the public the legitimacy of chromatic music, to help it grasp its mechanisms and put it in the right frame of mind to enjoy the colour symphony which will follow, simple at first, then little by little more complex.) To hand I have three chromatic themes sketched in on strips of celluloid. The first is the simplest one could imagine. It has two colours only, complementaries, red and green. To begin with the whole screen is green, then in the centre a small red six-pointed star appears. This rotates on itself, the points vibrating like tentacles and enlarges, enlarges until it fills the whole screen. The entire screen is red, and then unexpectedly a nervous rash of green spots breaks out all over it. These grow until they absorb all the red and the entire canvas is green. This lasts a minute. The second theme has three colours – pale blue, white and yellow. In a blue field two lines, one yellow, one white, move, bend together, detach themselves and curl up. Then they undulate towards each other and intertwine. This is an example of a linear, as well as chromatic, theme. The third is composed of seven colours, the seven colours of the solar spectrum in the form of small cubes arranged initially on a horizontal line at the bottom of the screen against a black background. These move in small jerks, grouping together, crashing against each other, shattering and reforming, diminishing and enlarging, forming columns and lines, interpenetrating, deforming, etc.

And now it only remains for me to inform the reader of our most recent experiments. These are two films, both of about two hundred metres. The first is entitled *The Rainbow*. The colours of the rainbow constitute the dominant theme, which appears occasionally in different forms and with ever-increasing intensity until it finally explodes with dazzling violence. The screen is initially grey, then in this grey background there gradually appears a very slight agitation of radiant tremors which seem to rise out of the grey depths, like bubbles in a spring, and when they reach the surface they explode and disappear. The entire symphony is based on this effect of contrast between the cloudy grey of the background and the rainbow, and the struggle between them. The struggle increases, the spectrum, suffocated beneath the ever blacker vortices which roll from background to foreground,

manages to free itself, flashes, then disappears again to reappear more intensely close to the frame. Finally, in an unexpected dusty disintegration, the grey crumbles and the spectrum triumphs in a whirling of catherine-wheels which disappear in their turn, buried under an avalanche of colours. The second is called *The Dance*, the predominant colours being carmine, violet and yellow, which are continually united, separated and hurled upwards in an agile pirouetting of spinning tops.

I have done. There is no point in writing any more, since I could never succeed in giving more than the vaguest idea of colour. One can only imagine it for oneself.

All one can do is open the way and I think I have done this, a little. I would like to add some comments about chromatic drama, with which we have made some interesting experiments, but this would be going too far. Perhaps I will deal with them in another article on the music of colours which I hope, together with this, will prepare the public to judge serenely the sonatas they will soon see in the theatre.

Are there people in Italy who are seriously interested in these things? If so, let them write to me and I will have great pleasure in communicating to them all (and it is a great deal) that I have not been able to write and which will smooth the path.

From *Il pastore, il gregge e la zampogna*,
Libreria Beltrami, 1912; vol. I
(a collection of critical articles
edited by Corra and Settimelli).
Translation C T

Valentine de Saint-Point
Futurist Manifesto of Lust 1913

A reply to those dishonest journalists who twist phrases to make the Idea seem ridiculous;
to those women who only think what I have dared to say;
to those for whom Lust is still nothing but a sin;
to all those who in Lust can only see Vice, just as in Pride they see only vanity.

Lust, when viewed without moral preconceptions and as an essential part of life's dynamism, is a force.

Lust is not, any more than pride, a mortal sin for the race that is strong. Lust, like pride, is a virtue that urges one on, a powerful source of energy.

Lust is the expression of a being projected beyond itself. It is the painful joy of wounded flesh, the joyous pain of a flowering. And whatever secrets unite these beings, it is a union of flesh. It is the sensory and sensual synthesis that leads to the greatest liberation of spirit. It is the communion of a particle of humanity with all the sensuality of the earth. It is the panic shudder of a particle of the earth.

LUST IS THE QUEST OF THE FLESH FOR THE UNKNOWN, just as Cerebration is the spirit's quest for the unknown. Lust is the act of creating, it is Creation.

Flesh creates in the way that the spirit creates. In the eyes of the Universe their creation is equal. One is not superior to the other and creation of the spirit depends on that of the flesh.

We possess body and spirit. To curb one and develop the other shows weakness and is wrong. A strong man must realize his full carnal and spiritual potentiality. The satisfaction of their lust is the conquerors' due. After a battle in which men have died, IT IS NORMAL FOR THE VICTORS, PROVEN IN WAR, TO TURN TO RAPE IN THE CONQUERED LAND, SO THAT LIFE MAY BE RE-CREATED.

When they have fought their battles, soldiers seek sensual pleasures, in which their constantly battling energies can be unwound and renewed. The modern hero, the hero in any field, experiences the same desire and the same pleasure. The artist, that great universal medium, has the same need. And the exaltation of the initiates of those religions still sufficiently new to contain a tempting element of the unknown, is no more than sensuality diverted spiritually towards a sacred female image.

ART AND WAR ARE THE GREAT MANIFESTATIONS OF SENSUALITY; LUST IS THEIR FLOWER. A people exclusively spiritual or a people exclusively carnal would be condemned to the same decadence – sterility.

LUST EXCITES ENERGY AND RELEASES STRENGTH. Pitilessly it drove primitive man to victory, for the pride of bearing back to a woman the spoils of the defeated. Today it drives the great men of business who direct the banks, the press and international trade to increase their wealth by creating centres, harnessing energies and exalting the crowds, to worship and glorify with it the object of their lust. These men, tired but strong, find time for lust, the principal motive force of their action

and of the reactions caused by their actions affecting multitudes and worlds.

Even among the new peoples where sensuality has not yet been released or acknowledged, and who are neither primitive brutes nor the sophisticated representatives of the old civilizations, woman is equally the great galvanizing principle to which all is offered. The secret cult that man has for her is only the unconscious drive of a lust as yet barely woken. Amongst these peoples as amongst the peoples of the north, but for different reasons, lust is almost exclusively concerned with procreation. But lust, under whatever aspects it shows itself, whether they are considered normal or abnormal, is always the supreme spur.

The animal life, the life of energy, the life of the spirit, sometimes demand a respite. And effort for effort's sake calls inevitably for effort for pleasure's sake. These efforts are not mutually harmful but complementary, and realize fully the total being.

For heroes, for those who create with the spirit, for dominators of all fields, lust is the magnificent exaltation of their strength. For every being it is a motive to surpass oneself with the simple aim of self-selection, of being noticed, chosen, picked out.

Christian morality alone, following on from pagan morality, was fatally drawn to consider lust as a weakness. Out of the healthy joy which is the flowering of the flesh in all its power it has made something shameful and to be hidden, a vice to be denied. It has covered it with hypocrisy, and this has made a sin of it.

WE MUST STOP DESPISING DESIRE, this attraction at once delicate and brutal between two bodies, of whatever sex, two bodies that want each other, striving for unity. We must stop despising Desire, disguising it in the pitiful clothes of old and sterile sentimentality.

It is not lust that disunites, dissolves and annihilates. It is rather the mesmerizing complications of sentimentality, artificial jealousies, words that inebriate and deceive, the rhetoric of parting and eternal fidelities, literary nostalgia – all the histrionics of love.

WE MUST GET RID OF THE ILL-OMENED DEBRIS OF ROMANTICISM, counting daisy petals, moonlight duets, heavy endearments, false hypocritical modesty. When beings are drawn together by a physical attraction, let them – instead of talking only of the fragility of their hearts – dare to express their desires, the inclinations of their bodies, and to anticipate the possibilities of joy and disappointment in their future carnal union.

Physical modesty, which varies according to time and place, has only the ephemeral value of a social virtue.

WE MUST FACE UP TO LUST IN FULL CONSCIOUSNESS. We must make of it what a sophisticated and intelligent being makes of himself and of his life; WE MUST MAKE LUST INTO A WORK OF ART. To allege unwariness or bewilderment in order to explain an act of love is hypocrisy, weakness and stupidity.

We should desire a body consciously, like any other thing.

Love at first sight, passion or failure to think, must not prompt us to be constantly giving ourselves, nor to take beings, as we are usually inclined to do due to our inability to see into the future. We must choose intelligently. Directed by our intuition and will, we should compare the feelings and desires of the two partners and avoid uniting and satisfying any that are unable to complement and exalt each other.

Equally consciously and with the same guiding will, the joys of this coupling should lead to the climax, should develop its full potential, and should permit to flower all the seeds sown by the merging of two bodies. Lust should be made into a work of art, formed like every work of art, both instinctively and consciously.

WE MUST STRIP LUST OF ALL THE SENTIMENTAL VEILS THAT DISFIGURE IT. These veils were thrown over it out of mere cowardice, because smug sentimentality is so satisfying. Sentimentality is comfortable and there-fore demeaning.

In one who is young and healthy, when lust clashes with sentimen-tality, lust is victorious. Sentiment is a creature of fashion, lust is eternal. Lust triumphs, because it is the joyous exaltation that drives one beyond oneself, the delight in possession and domination, the perpetual victory from which the perpetual battle is born anew, the headiest and surest intoxication of conquest. And as this certain conquest is temporary, it must be constantly won anew.

Lust is a force, in that it refines the spirit by bringing to white heat the excitement of the flesh. The spirit burns bright and clear from a healthy, strong flesh, purified in the embrace. Only the weak and the sick sink into the mire and are diminished. And lust is a force in that it kills the weak and exalts the strong, aiding natural selection.

Lust is a force, finally, in that it never leads to the insipidity of the definite and the secure, doled out by soothing sentimentality. Lust is the eternal battle, never finally won. After the fleeting triumph, even during the ephemeral triumph itself, reawakening dissatisfaction spurs a human being, driven by an orgiastic will, to expand and surpass him-self.

Lust is for the body what an ideal is for the spirit – the magnificent Chimaera, that one ever clutches at but never captures, and which the

young and the avid, intoxicated with the vision, pursue without rest.
LUST IS A FORCE.

Published as a leaflet by
Direzione del Movimento Futurista,
Milan, 11 January 1913
(A reply to press comment on lectures given
by the writer at the 1912 Futurist exhibition
in Brussels and Paris).
Translation JCH

Luigi Russolo
The Art of Noises (extracts) 1913

Dear Balilla Pratella, *great Futurist composer*,
In Rome, in the Costanzi Theatre, packed to capacity, while I was listening to the orchestral performance of your overwhelming FUTURIST MUSIC, with my Futurist friends, Marinetti, Boccioni, Carrà, Balla, Soffici, Papini and Cavacchioli, a new art came into my mind which only you can create, the Art of Noises, the logical consequence of your marvellous innovations.

Ancient life was all silence. In the nineteenth century, with the invention of the machine, Noise was born. Today, Noise triumphs and reigns supreme over the sensibility of men. For many centuries life went by in silence, or at most in muted tones. The strongest noises which interrupted this silence were not intense or prolonged or varied. If we overlook such exceptional movements as earthquakes, hurricanes, storms, avalanches and waterfalls, nature is silent.

Amidst this dearth of *noises*, the first *sounds* that man drew from a pierced reed or stretched string were regarded with amazement as new and marvellous things. Primitive races attributed *sound* to the gods; it was considered sacred and reserved for priests, who used it to enrich the mystery of their rites.

And so was born the concept of sound as a thing in itself, distinct and independent of life, and the result was music, a fantastic world superimposed on the real one, an inviolable and sacred world. It is

74

easy to understand how such a concept of music resulted inevitably in the hindering of its progress by comparison with the other arts. The Greeks themselves, with their musical theories calculated mathematically by Pythagoras and according to which only a few consonant intervals could be used, limited the field of music considerably, rendering harmony, of which they were unaware, impossible.

The Middle Ages, with the development and modification of the Greek tetrachordal system, with the Gregorian chant and popular songs, enriched the art of music, but continued to consider sound *in its development in time*, a restricted notion, but one which lasted many centuries, and which can still be found in the Flemish contrapuntalists' most complicated polyphonies.

The chord did not exist, the development of the various parts was not subordinated to the chord that these parts put together could produce; the conception of the parts was horizontal not vertical. The desire, search and taste for a simultaneous union of different sounds, that is for the chord (complex sound), were gradually made manifest, passing from the consonant perfect chord with a few passing dissonances, to the complicated and persistent dissonances that characterize contemporary music.

At first the art of music sought and achieved purity, limpidity and sweetness of sound. Then different sounds were amalgamated, care being taken, however, to caress the ear with gentle harmonies. Today music, as it becomes continually more complicated, strives to amalgamate the most dissonant, strange and harsh sounds. In this way we come ever closer to *noise-sound*.

THIS MUSICAL EVOLUTION IS PARALLELED BY THE MULTIPLICATION OF MACHINES, which collaborate with man on every front. Not only in the roaring atmosphere of major cities, but in the country too, which until yesterday was normally silent, the machine today has created such a variety and rivalry of noises that pure sound, in its exiguity and monotony, no longer arouses any feeling.

To excite and exalt our sensibilities, music developed towards the most complex polyphony and the maximum variety, seeking the most complicated successions of dissonant chords and vaguely preparing the creation of MUSICAL NOISE. This evolution towards 'noise sound' was not possible before now. The ear of an eighteenth-century man could never have endured the discordant intensity of certain chords produced by our orchestras (whose members have trebled in number since then). To our ears, on the other hand, they sound pleasant, since our hearing has already been educated by modern life, so teeming with variegated

75

noises. But our ears are not satisfied merely with this, and demand an abundance of acoustic emotions.

On the other hand, musical sound is too limited in its qualitative variety of tones. The most complex orchestras boil down to four or five types of instrument, varying in timbre: instruments played by bow or plucking, by blowing into metal or wood, and by percussion. And so modern music goes round in this small circle, struggling in vain to create new ranges of tones.

THIS LIMITED CIRCLE OF PURE SOUNDS MUST BE BROKEN, AND THE INFINITE VARIETY OF 'NOISE-SOUND' CONQUERED.

Besides, everyone will acknowledge that all [musical] sound carries with it a development of sensations that are already familiar and exhausted, and which predispose the listener to boredom in spite of the efforts of all the innovatory musicians. We Futurists have deeply loved and enjoyed the harmonies of the great masters. For many years Beethoven and Wagner shook our nerves and hearts. Now we are satiated and WE FIND FAR MORE ENJOYMENT IN THE COMBINATION OF THE NOISES OF TRAMS, BACKFIRING MOTORS, CARRIAGES AND BAWLING CROWDS THAN IN REHEARING, for example, THE 'EROICA' OR THE 'PASTORAL'.

We cannot see that enormous apparatus of force that the modern orchestra represents without feeling the most profound and total disillusion at the paltry acoustic results. Do you know of any sight more ridiculous than that of twenty men furiously bent on redoubling the mewing of a violin? All this will naturally make the music-lovers scream, and will perhaps enliven the sleepy atmosphere of concert halls. Let us now, as Futurists, enter one of these hospitals for anaemic sounds. There: the first bar brings the boredom of familiarity to your ear and anticipates the boredom of the bar to follow. Let us relish, from bar to bar, two or three varieties of genuine boredom, waiting all the while for the extraordinary sensation that never comes.

Meanwhile a repugnant mixture is concocted from monotonous sensations and the idiotic religious emotion of listeners buddhistically drunk with repeating for the nth time their more or less snobbish or second-hand ecstasy.

Away! Let us break out since we cannot much longer restrain our desire to create finally a new musical reality, with a generous distribution of resonant slaps in the face, discarding violins, pianos, doublebasses and plaintive organs. Let us break out!

It's no good objecting that noises are exclusively loud and disagreeable to the ear.

28 Anton Giulio Bragaglia *Balla in Front of his Picture* 1912

29 Anton Giulio Bragaglia *Young Man Rocking* 1911

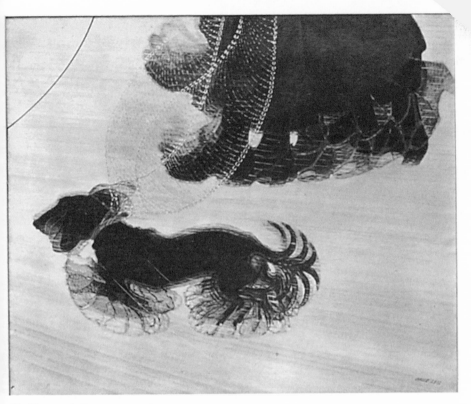

30 Giacomo Balla *Dynamism of a Dog on a Leash* 1912

31 Giacomo Balla
Little Girl Running on a Balcony
1912

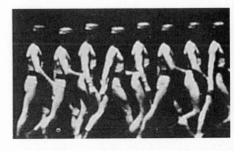

32 E. J. Marey *Chronophotograph* 1884(?)

33 Anton Giulio Bragaglia
The Guitarist 1912

34 Giacomo Balla
The Violinist's Hands 1912

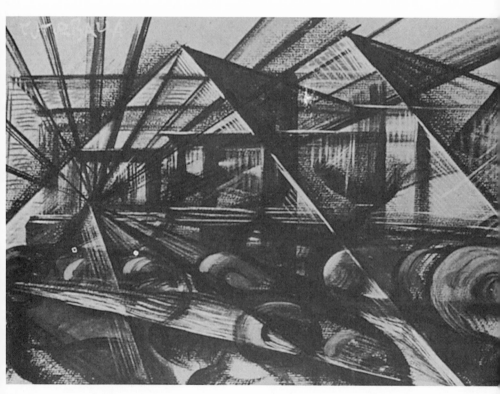

35 Giacomo Balla *Dynamic Depths* 1912

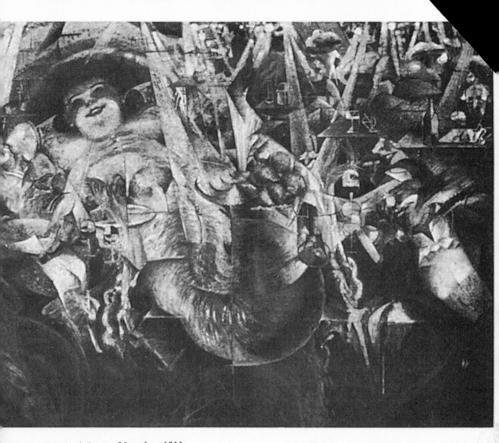

Umberto Boccioni *Burst of Laughter* 1911

Umberto Boccioni
dy for 'Fusion of Head and Window' 1912

37 Umberto Boccioni *Horizontal Volumes* 1912

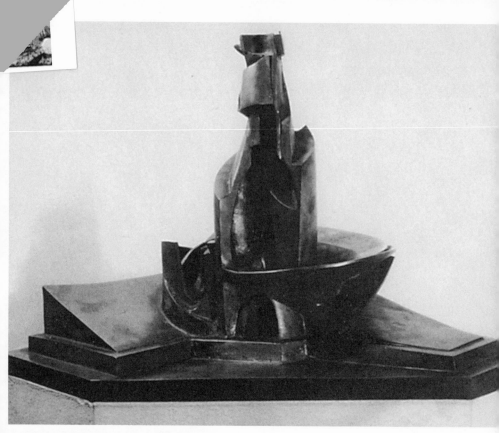

39 Umberto Boccioni *Development of a Bottle in Space* 1912

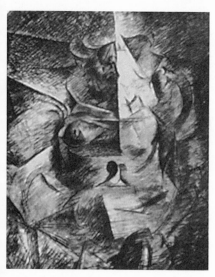

40 Umberto Boccioni
Study for 'Head + House + Light' 1912

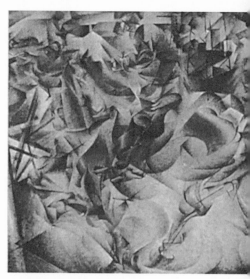

41 Umberto Boccioni
Elasticity 1912

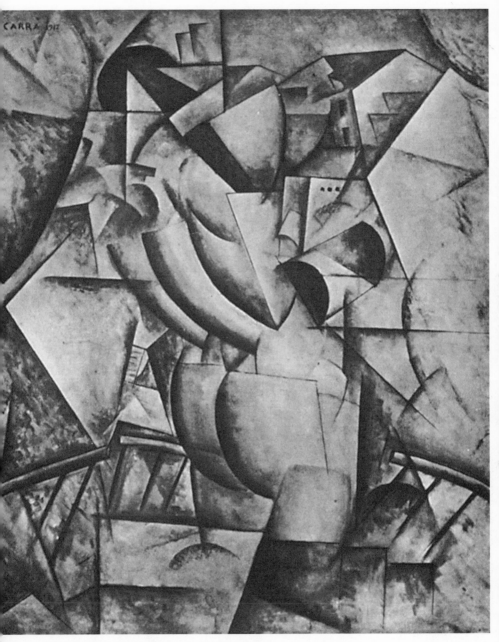

arlo Carrà *Simultaneity – The Woman on the Balcony* 1912

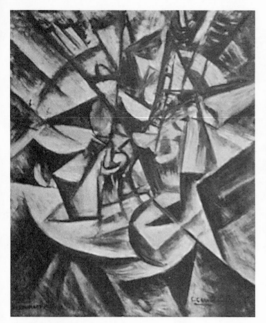

43 Carlo Carrà
Plastic Transcendences 1912

44 Carlo Carrà
Synthesis of a Café-Concert 1912

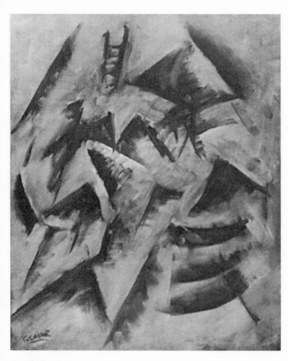

45 Carlo Carrà
Rhythms of Lines 1912

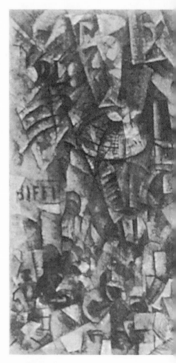

46 Carlo Carrà
The Milan Arcade 1912

It seems pointless to enumerate all the graceful and delicate noises that afford pleasant sensations.

To convince ourselves of the amazing variety of noises, it is enough to think of the rumble of thunder, the whistle of the wind, the roar of a waterfall, the gurgling of a brook, the rustling of leaves, the clatter of a trotting horse as it draws into the distance, the lurching jolts of a cart on pavings, and of the generous, solemn, white breathing of a nocturnal city; of all the noises made by wild and domestic animals, and of all those that can be made by the mouth of man without resorting to speaking or singing.

Let us cross a great modern capital with our ears more alert than our eyes, and we will get enjoyment from distinguishing the eddying of water, air and gas in metal pipes, the grumbling of noises that breathe and pulse with indisputable animality, the palpitation of valves, the coming and going of pistons, the howl of mechanical saws, the jolting of a tram on its rails, the cracking of whips, the flapping of curtains and flags. We enjoy creating mental orchestrations of the crashing down of metal shop blinds, slamming doors, the hubbub and shuffling of crowds, the variety of din, from stations, railways, iron foundries, spinning mills, printing works, electric power stations and underground railways. . . .

WE WANT TO ATTUNE AND REGULATE THIS TREMENDOUS VARIETY OF NOISES HARMONICALLY AND RHYTHMICALLY.

To attune noises does not mean to detract from all their irregular movements and vibrations in time and intensity, but rather to give gradation and tone to the most strongly predominant of these vibrations.

Noise in fact can be differentiated from sound only in so far as the vibrations which produce it are confused and irregular, both in time and intensity.

EVERY NOISE HAS A TONE, AND SOMETIMES ALSO A HARMONY THAT PREDOMINATES OVER THE BODY OF ITS IRREGULAR VIBRATIONS.

Now, it is from this dominating characteristic tone that a practical possibility can be derived for attuning it, that is to give to a certain noise not merely one tone, but a variety of tones, without losing its characteristic tone, by which I mean the one which distinguishes it. In this way any noise obtained by a rotating movement can offer an entire ascending or descending chromatic scale, if the speed of the movement is increased or decreased.

Every manifestation of our life is accompanied by noise. The noise, therefore, is familiar to our ear, and has the power to conjure up life itself. Sound, alien to our life, always musical and a thing unto itself,

an occasional but unnecessary element, has become to our ears what an overfamiliar face is to our eyes. Noise, however, reaching us in a confused and irregular way from the irregular confusion of our life, never entirely reveals itself to us, and keeps innumerable surprises in reserve. We are therefore certain that by selecting, coordinating and dominating all noises we will enrich men with a new and unexpected sensual pleasure.

Although it is characteristic of noise to recall us brutally to real life, THE ART OF NOISE MUST NOT LIMIT ITSELF TO IMITATIVE REPRODUCTION. It will achieve its most emotive power in the acoustic enjoyment, in its own right, that the artist's inspiration will extract from combined noises.

Here are the *6 families of noises* of the Futurist orchestra which we will soon set in motion mechanically:

1	2	3	4	5	6
Rumbles	Whistles	Whispers	Screeches	Noises	Voices of
Roars	Hisses	Murmurs	Creaks	obtained	animals
Explosions	Snorts	Mumbles	Rustles	by percus-	and men:
Crashes		Grumbles	Buzzes	sion on	Shouts
Splashes		Gurgles	Crackles	metal,	Screams
Booms			Scrapes	wood,	Groans
				skin,	Shrieks
				stone,	Howls
				terracotta,	Laughs
				etc.	Wheezes
					Sobs

In this inventory we have encapsulated the most characteristic of the fundamental noises; the others are merely the associations and combinations of these. THE RHYTHMIC MOVEMENTS OF A NOISE ARE INFINITE: JUST AS WITH TONE THERE IS ALWAYS A PREDOMINANT RHYTHM, but around this numerous other secondary rhythms can be felt.

CONCLUSIONS

1. Futurist musicians must continually enlarge and enrich the field of sounds. This corresponds to a need in our sensibility. We note, in fact, in the composers of genius, a tendency towards the most complicated dissonances. As these move further and further away from pure sound, they almost achieve *noise-sound*. This need and this tendency cannot be satisfied except by the *adding* and the *substitution of noises for sounds*.
2. Futurist musicians must substitute for the limited variety of tones

possessed by orchestral instruments today the infinite variety of tones of noises, reproduced with appropriate mechanisms.

3. The musician's sensibility, liberated from facile and traditional Rhythm, must find in noises the means of extension and renewal, given that every noise offers the union of the most diverse rhythms apart from the predominant one.

4. Since every noise contains a PREDOMINANT GENERAL TONE in its irregular vibrations it will be easy to obtain in the construction of instruments which imitate them a sufficiently extended variety of tones, semitones, and quarter-tones. This variety of tones will not remove the characteristic tone from each noise, but will amplify only its texture or extension.

5. The practical difficulties in constructing these instruments are not serious. Once the mechanical principle which produces the noise has been found, its tone can be changed by following the same general laws of acoustics. If the instrument is to have a rotating movement, for instance, we will increase or decrease the speed, whereas if it is not to have rotating movement the noise-producing parts will vary in size and tautness.

6. The new orchestra will achieve the most complex and novel aural emotions not by incorporating a succession of life-imitating noises, but by manipulating fantastic juxtapositions of these varied tones and rhythms. Therefore an instrument will have to offer the possibility of tone changes and varying degrees of amplification.

7. The variety of noises is infinite. If today, when we have perhaps a thousand different machines, we can distinguish a thousand different noises, tomorrow, as new machines multiply, we will be able to distinguish ten, twenty or THIRTY THOUSAND DIFFERENT NOISES, NOT MERELY IN A SIMPLY IMITATIVE WAY, BUT TO COMBINE THEM ACCORDING TO OUR IMAGINATION.

8. We therefore invite young musicians of talent to conduct a sustained observation of all noises, in order to understand the various rhythms of which they are composed, their principal and secondary tones. By comparing the various tones of noises with those of sounds, they will be convinced of the extent to which the former exceed the latter. This will afford not only an understanding, but also a taste and passion for noises. After being conquered by Futurist eyes our multiplied sensibilities will at last hear with Futurist ears. In this way the motors and machines of our industrial cities will one day be consciously attuned, so that every factory will be transformed into an intoxicating orchestra of noises.

Dear Pratella, I submit these my statements to your Futurist genius, inviting your discussion. I am not a musician, I have therefore no acoustical predilections, nor any works to defend. I am a Futurist painter using a much loved art to project my determination to renew everything. And so, bolder than a professional musician could be, unconcerned by my apparent incompetence and convinced that all rights and all possibilities open up to daring, I have been able to initiate the great renewal of music by means of the Art of Noises.

11 March 1913
Published as a booklet by Direzione del Movimento Futurista, Milan,
1 July 1913
Translation CT

Umberto Boccioni
The Plastic Foundations of Futurist Sculpture and Painting 1913

Our constructive idealism has taken its laws from the new certainties given us by science.

It consists of pure plastic elements, born of an ultrasensitivity which has come as a result of the new conditions of life created by scientific discoveries.

Our aim is to destroy four centuries of Italian tradition.

We must consider works of art (in sculpture or in painting) as structures of a new inner reality, which the elements of external reality are helping to build up into a system of plastic analogy, which was almost completely unknown before us. It is through this kind of analogy, which is the very essence of poetry, that we shall achieve the plastic state of mind.

When I say that sculpture must try and model the atmosphere, I mean that I want to suppress, i.e. FORGET, all the traditional and sentimental values concerning atmosphere, the recent *verismo*, which veils objects, making them diaphanous or distant like a dream, etc., etc. For me this atmosphere is like a material substance which exists between objects, distorting plastic values. Instead of making it float overhead like a puff of air (because culture taught me that atmosphere is intangible and made of gas, etc.), I feel it, seek it, seize hold of it and emphasize it by using all the various effects which light, shadows and streams of energy have upon it. In this way I create the atmosphere.

When we begin to grasp this truth in Futurist sculpture, we shall see the shape of the atmosphere where before was only emptiness or, as

with the Impressionists, mist. This mist was already a step towards an atmospheric plasticity, towards a PHYSICAL TRANSCENDENTALISM which, in turn, is another step towards the perception of analogous phenomena, which have hitherto remained hidden from our obtuse sensibilities. These phenomena include the perception of the luminous emanations of our bodies, of the kind I spoke of in my first lecture in Rome, and which has already been found to appear on the photographic plate.

Now this tangible measuring of what formerly appeared to be empty space, this clear superimposition of new strata on what we call real objects and those shapes which determine them – this new aspect of reality is one of the bases of our painting and sculpture. It should now be clear, then, why an infinity of lines and currents emanate from our objects, making them live in the environment which has been created by their vibrations.

Areas between one object and another are not merely empty spaces but continuing materials of different intensities, which we reveal with visible lines which do not correspond to any photographic truth. This is why in our paintings we do not have objects and empty spaces but only a greater or lesser intensity and solidity of space.

With this it becomes abundantly clear what I mean by the solidification of Impressionism.

This measuring of objects, and of the atmospheric forms which they create and in which they are contained, forms the QUANTITATIVE value of an object. If we then go deeper into our perceptive faculties and translate the other value, that is the QUALITATIVE value, we shall discover the MOTION, the impulse of the object. This motion is a quality, and, in our sculptural aesthetic, quality equals feeling.

Any accusations that we are merely being 'cinematographic' make us laugh – they are just vulgar idiocies. We are not trying to split each individual image – we are looking for a symbol, or better, a single form, to replace these old concepts of division with new concepts of continuity.

Any dividing up of an object's motion is an arbitrary action, and equally arbitrary is the subdivision of matter. Henri Bergson said: 'Any division of matter into autonomous bodies with absolutely defined contours is an artificial division', and elsewhere: 'Any movement, viewed as a transition from one state of rest to another, is absolutely indivisible.'

Have we discovered a formula which provides continuity in space? Art formulas have pronounced things to be masterpieces; and as a result a period of evolution has always come to an end; what can we say about our work which is only a few months old? We are still

experimenting and there is no better field for our researches than the inebriating modernity of contemporary life.

Hence, in spite of our violent aspirations towards something definitive, we deny today, at this stage in our development, any possibility of an abstract solution, any kind of plastic conceptualization, which by a special determination might practically replace the individual's intuition.

Any attempt to lay down the law in a situation where there is a gap between external and internal realities is a highly dangerous practice, as the cold image-making of some of the Cubists proves.

So, those who believe, in theory, in some of our statements about a new plastic translation of reality, are wrong to try to experience emotions from our canvases by approaching them with the old state of mind.

The only important thing to remember is this: in Futurist art, the viewpoint has completely changed.

Modern painting, however subjective, has hitherto always presented a spectacle of images which exist in front of our eyes. And though the Cubists showed objects in all their complexity – a painting being constructed through a harmonious combination of one or more complexities within an environmental complexity – the spectacle itself did not change.

What we want to do is to show the living object in its dynamic growth: i.e. provide a synthesis of those transformations undergone by an object due to its twin motions, one relative, the other absolute.

We want to give a style to our movement. We don't want to observe, dissect or transpose into pictorial terms. We identify ourselves with the thing itself, which is a profoundly different matter.

Hence, for us, the object has no form in itself; the only definable thing is the line which reveals the relationship between the object's weight (quantity) and its expansion (quality).

This has suggested to us the notion of force-lines, which characterize the object and enable us to see it as a whole – it is the essential interpretation of the object, the perception of life itself. Ours is a search for the definitive, through a succession of intuitive stages.

We reject any *a priori* reality; this is what divides us from the Cubists and places us Futurists on the extreme fringe of the painting world. In Italy we are the only artists today who are trying to give art those attributes which have always been characteristic of Italian art, during its best periods: style and reality.

Published in *Lacerba* (Florence), 15 March 1913
Translation RB

Carlo Carrà
Plastic Planes as Spherical Expansions in Space 1913

The architectural basis of a painting (in our Futurist concept of a new expression of form) is itself a response to a symphonic concept of coloured, but not chromatic, shapes, of weight and volume within a general movement of form, determined by internal organic changes.

So, there are no equal subdivisions of structural parts, as was customary with the artists of the past – instead we have the applied construction of abstract forms. Constructions of a-rhythmical forms, the clash between concrete and abstract forms. Constructions of veiled shapes with transparent ones, the repeating of different parts of given bodies which break up, intersect and interpenetrate each other. The right angle serves to give an expression of calm austerity and gravity, when the composition requires a simple rhythm, neutral and without passion. In other cases, with this same objective of neutrality, horizontal and vertical lines are used separately.

A pictorial composition constructed of right angles cannot go beyond what is known in music as plainchant (*canto fermo*). The acute angle, on the other hand, is passionate and dynamic, expressing will and a penetrating force. And the obtuse angle, as a geometrical expression, represents oscillation, the diminution of this will and this force. Finally, a curved line has an intermediary function, and serves, together with the obtuse angle, as a link, a kind of transitional form between the other angles.

By using this method to perceive the construction of a painting, we Futurists group together abstract forms which are purely geometrical (the simple and complex) and perspective planes which are either closer or more distant. When I say 'close' or 'distant' I am referring to *emotive realities* and not to the apparent nearness or distance in relation to the observer, as perspective was traditionally explained.

This pseudo-scientific method can be seen in the works of the Impressionists, and was an initial mistake which has led to disastrous consequences.

Our way of treating perspective transcends – in originality, in emotive intensity, in suggestiveness and in plastic complexity – all the following: (1) the method of perspective used by Paolo Uccello, Carpaccio, Mantegna, Raphael and Veronese; (2) the methods used by all the Primitives, who, compared to us, are very much the slaves of apparent and superficial realities; (3) the method of showing perspective which is used

by the insane, and which we, nevertheless, believe to be superior to those employed by all the painters mentioned above.

Finally, we insist that our concept of perspective is the total antithesis of all static perspective.

It is dynamic and chaotic in application, producing in the mind of the observer a veritable mass of plastic emotions; this is because each particular perspective in our painting corresponds to a vibration in the mind. In this way we have achieved architectural unity within the painting, which allows a more intense, more living and more profound truth to leap off the canvas. And the painting, with its mysterious content of complex rhythms, acquires a force which stirs and enthrals the observer more by what it suggests than by what is materially expressed in it.

<div align="right">Published in Lacerba (Florence), 15 March 1913
Translation R B</div>

Umberto Boccioni
Plastic Dynamism 1913

Plastic dynamism is the simultaneous action of the motion characteristic of an object (its absolute motion), mixed with the transformation which the object undergoes in relation to its mobile and immobile environment (its relative motion). Therefore, it is not true that only the decomposition of an object's shape constitutes dynamism. Certainly decomposition and distortion in themselves have dynamic value, in so far as they break up the continuity of a line, interrupting the rhythm of a silhouette, increasing interactions and indicating possible directions of a shape. But this is not the Futurist concept of plastic dynamism, any more than a trajectory, the sway in a pendulum, or movement from point A to point B.

Dynamism is the lyrical conception of forms, interpreted in the infinite manifestations of the relativity between absolute motion and relative motion, between the environment and the object which come together to form the appearance of a whole: *environment + object*.

It is the creation of a new form which expresses the relativity between weight and expansion, between rotation and revolution; here, in fact,

we have life itself caught in a form which life has created in its *infinite succession of events.*

It seems clear to me that this *succession* is not to be found in the repetition of legs, arms and faces, as many people have idiotically believed, but is achieved through the intuitive search for *the one single form which produces continuity in space.* This is the key to making an object live in universal terms. Therefore, instead of the old-fashioned concept of a sharp differentiation of bodies, instead of the modern concept of the Impressionists with their subdivision and repetition and rough indications of images, we would substitute a *concept of dynamic continuity* as the only form. And it is not by accident that I say 'form' instead of 'line' since *dynamic form* is a species of fourth dimension, both in painting and sculpture, which cannot exist perfectly without the complete concurrence of those three dimensions which determine volume: height, width, depth.

For sculpture we have tried to break the unity of material into several materials, each one of which serves to characterize, through its own natural diversity, differences in the weight and expansion of molecular volumes, and which together create the initial dynamic element.

Attempts to find realist form have always led sculpture and painting further and further away from their origin: architecture. Architecture represents for sculpture what composition does for painting; in fact, the absence of architectural elements is one of the negative characteristics of Impressionist sculpture.

However, pre-Impressionist studies of form have inevitably resulted in dead forms and, as a consequence, immobility; and this immobility is one of the main characteristics of Cubist sculpture.

Between *real* and *ideal* forms, between new forms (Impressionist) and traditional forms (Greek) we have discovered a form which is variable, evolutionary, and quite different from any other concepts which have existed up till now. We Futurists have discovered form in movement, and the movement of form. Only through this dual conception of form can we give a hint of plastic life in our work, without having extracted and removed it from its living environment, which would mean arresting its motion.

In sculpture, therefore, we are not necessarily looking for *pure form*, but for *pure plastic rhythm*, not the construction of an object, but the construction of an object's action. We have abolished pyramidal architecture to arrive at spiral architecture. A body in movement, therefore, is not simply an immobile body subsequently set in motion, but a *truly mobile object*, which is a reality quite new and original.

With dynamism, then, art climbs to an ideal, superior plane, creating a style and expressing our own age of speed and of simultaneity. When people tell us that the world has examples of both static and moving objects, and that not everything rushes around at speed, we reply that, in our painting it is the *conception* which dominates the *visual*, which perceives only fragmentarily, and therefore subdivides. Hence *Dynamism* is a general law of simultaneity and interpenetration dominating everything, in movement, that is appearance/exception/shading. We have called ourselves 'the primitives of a new and completely transformed sensitivity'. This frankly acknowledges a clear view of our creative potential.

Since we have to *re-create everything anew*, we Futurists are forced to make a far greater effort than any other revolutionaries who have appeared on the scene of Art.

With us Futurists, for the very first time, a sculptural simultaneity, analogous to pictorial simultaneity, has appeared in art.

An architectural construction in spiral form creates for the observer a continuity which allows him to understand, through the *force-form*, which is derived from *real form*, a new form defining objects and their driving force.

With this we have been able to maintain that *power-form* expresses the potential of the *living form*!

This unity within a given space provides us with a depth of volume, revealing each profile depth instead of a whole series of motionless profiles as we find in traditional statues.

For me, the things I am saying are not crazy abstractions, as many have thought who have laughed inanely at our experiments; instead it is the static qualities of the old masters which are abstractions, and unnatural abstractions at that – they are an outrage, a violation and a separation, a conception far removed from the law of the unity of universal motion. We are not, therefore, *anti-nature*, as many simpler-minded reactionary exponents of realism and naturalism like to think; we are ANTI-ART; in other words we are against the stasis which has reigned for centuries in art, except for a few rare attempts found in the most warm-blooded works and in the liveliest periods.

In fact, the static attitudes of Greece and Egypt are much more arbitrary than our ideas of dynamic continuity. It should never be forgotten that we are passing through a stage in a long progress towards interpenetration, simultaneity and fusion, on which humanity has been engaged for thousands of years.

As a result, sculpture as well, by means of an interpenetration of

planes, is bringing figures alive within their environment without their being mere slaves of artificial or fixed lights or pretty backgrounds. Such methods would destroy architectural laws and as a result the artist would have to run for help to painting, which was one of the fundamental mistakes of Impressionist sculpture.

We must, therefore, raise the concept of the object to that of a plastic whole: *object + environment*. In this way we shall have the object extended into the rays of light which shine on to it, by uniting atmospherical blocks with elements of a more concrete reality.

We exhort the young to forget the idea of figures enclosed within a traditional framework – a result of culture, academism and tradition! Instead Futurist sculpture will put the figure at the centre of a plastic orientation of space.

We must free ourselves from all the old formulas! We must destroy everything within us which is static, dead, everything in fact which is passéist! I shall never tire of repeating: no painting can exist outside our plastic dynamism!

Dynamism in painting and sculpture is, therefore, an evolutional concept of a plastic reality. It is the reflexion of a sensibility which conceives the world as an infinite prolonging of an evolutionary species. This is life itself. We Futurists have been able to create the model form – the form of forms – continuity.

12 December 1913
Lecture published in *Lacerba* (Florence), 15 December 1913
Translation RB

F. T. Marinetti
Destruction of Syntax - Imagination without Strings - Words-in-Freedom 1913

The Futurist sensibility
My Technical Manifesto of Futurist Literature (11 May 1912), with which I invented *essential and synthetic lyricism, imagination without strings*, and *words-in-freedom*, deals exclusively with poetic inspiration.

Philosophy, the exact sciences, politics, journalism, education, business, however much they may seek synthetic forms of expression,

will still need to use syntax and punctuation. I am obliged, for that matter, to use them myself in order to make myself clear to you.

Futurism is grounded in the complete renewal of human sensibility brought about by the great discoveries of science. Those people who today make use of the telegraph, the telephone, the phonograph, the train, the bicycle, the motorcycle, the automobile, the ocean liner, the dirigible, the aeroplane, the cinema, the great newspaper (synthesis of a day in the world's life) do not realize that these various means of communication, transportation and information have a decisive influence on their psyches.

An ordinary man can in a day's time travel by train from a little dead town of empty squares, where the sun, the dust, and the wind amuse themselves in silence, to a great capital city bristling with lights, gestures, and street cries. By reading a newspaper the inhabitant of a mountain village can tremble each day with anxiety, following insurrection in China, the London and New York suffragettes, Doctor Carrel, and the heroic dog-sleds of the polar explorers. The timid, sedentary inhabitant of any provincial town can indulge in the intoxication of danger by going to the movies and watching a great hunt in the Congo. He can admire Japanese athletes, Negro boxers, tireless American eccentrics, the most elegant Parisian women, by paying a franc to go to the variety theatre. Then, back in his bourgeois bed, he can enjoy the distant, expensive voice of a Caruso or a Burzio.

Having become commonplace, these opportunities arouse no curiosity in superficial minds who are as incapable of grasping any novel facts *as the Arabs who looked with indifference at the first aeroplanes in the sky of Tripoli*. For the keen observer, however, these facts are important modifiers of our sensibility because they have caused the following significant phenomena:

1. Acceleration of life to today's swift pace. Physical, intellectual, and sentimental equilibration on the cord of speed stretched between contrary magnetisms. Multiple and simultaneous awareness in a single ndividual.

2. Dread of the old and the known. Love of the new, the unexpected.

3. Dread of quiet living, love of danger, and an attitude of daily heroism.

4. Destruction of a sense of the Beyond and an increased value of the individual whose desire is *vivre sa vie*, in Bonnot's phrase.

5. The multiplication and unbridling of human desires and ambitions.

6. An exact awareness of everything inaccessible and unrealizable in every person.

7. Semi-equality of man and woman and a lessening of the disproportion in their social rights.

8. Disdain for *amore* (sentimentality or lechery) produced by the greater freedom and erotic ease of women and by the universal exaggeration of female luxury. Let me explain: Today's woman loves luxury more than love. A visit to a great dressmaker's establishment, escorted by a paunchy, gouty banker friend who pays the bills, is a perfect substitute for the most amorous rendezvous with an adored young man. The woman finds all the mystery of love in the selection of an amazing ensemble, the latest model, which her friends still do not have. Men do not love women who lack luxury. The lover has lost all his prestige Love has lost its absolute worth. A complex question; all I can do is to raise it.

9. A modification of patriotism, which now means a heroic idealization of the commercial, industrial, and artistic solidarity of a people.

10. A modification in the idea of war, which has become the necessary and bloody test of a people's force.

11. The passion, art, and idealism of Business. New financial sensibility.

12. Man multiplied by the machine. New mechanical sense, a fusion of instinct with the efficiency of motors and conquered forces.

13. The passion, art, and idealism of Sport. Idea and love of the 'record'.

14. New tourist sensibility bred by ocean liners and great hotels (annual synthesis of different races). Passion for the city. Negation of distances and nostalgic solitudes. Ridicule of the 'holy green silence' and the ineffable landscape.

15. The earth shrunk by speed. New sense of the world. To be precise: One after the other, man will gain the sense of his home, of the quarter where he lives, of his region, and finally of the continent. Today he is aware of the whole world. He little needs to know what his ancestors did, but he must assiduously discover what his contemporaries are doing all over the world. The single man, therefore, must communicate with every people on earth. He must feel himself to be the axis, judge, and motor of the explored and unexplored infinite. Vast increase of a sense of humanity and a momentary urgent need to establish relations with all mankind.

16. A loathing of curved lines, spirals, and the *tourniquet*. Love for the straight line and the tunnel. The habit of visual foreshortening and visual synthesis caused by the speed of trains and cars that look down on cities and countrysides. Dread of slowness, pettiness, analysis, and

detailed explanations. Love of speed, abbreviation, and the summary. 'Quick, give me the whole thing in two words!'

17. Love of depth and essence in every exercise of the spirit.

So these are some elements of the new Futurist sensibility that has generated our pictorial dynamism, our antigraceful music in its free, irregular rhythms, our noise-art and our words-in-freedom.

Words-in-freedom

Casting aside every stupid formula and all the confused verbalisms of the professors, I now declare that lyricism is the exquisite faculty of intoxicating oneself with life, of filling life with the inebriation of oneself. The faculty of changing into wine the muddy water of the life that swirls and engulfs us. The ability to colour the world with the unique colours of our changeable selves.

Now suppose that a friend of yours gifted with this faculty finds himself in a zone of intense life (revolution, war, shipwreck, earthquake, and so on) and starts right away to tell you his impressions. Do you know what this lyric, excited friend of yours will instinctively do?

He will begin by brutally destroying the syntax of his speech. He wastes no time in building sentences. Punctuation and the right adjectives will mean nothing to him. He will despise subtleties and nuances of language. Breathlessly he will assault your nerves with visual, auditory, olfactory sensations, just as they come to him. The rush of steam-emotion will burst the sentence's steampipe, the valves of punctuation, and the adjectival clamp. Fistfuls of essential words in no conventional order. Sole preoccupation of the narrator, to render every vibration of his being.

If the mind of this gifted lyrical narrator is also populated by general ideas, he will involuntarily bind up his sensations with the entire universe that he intuitively knows. And in order to render the true worth and dimensions of his lived life, he will cast immense nets of analogy across the world. In this way he will reveal the analogical foundation of life, telegraphically, with the same economical speed that the telegraph imposes on reporters and war correspondents in their swift reportings. This urgent laconism answers not only to the laws of speed that govern us but also to the rapport of centuries between poet and audience. Between poet and audience, in fact, the same rapport exists as between two old friends. They can make themselves understood with half a word, a gesture, a glance. So the poet's imagination must weave together distant things *with no connecting strings*, by means of essential *free* words.

Death of free verse

Free verse once had countless reasons for existing but now is destined to be replaced by *words-in-freedom*.

The evolution of poetry and human sensibility has shown us the two incurable defects of free verse.

1. Free verse fatally pushes the poet towards facile sound effects, banal double meanings, monotonous cadences, a foolish chiming, and an inevitable echo-play, internal and external.

2. Free verse artificially channels the flow of lyric emotion between the high walls of syntax and the weirs of grammar. The free intuitive inspiration that addresses itself directly to the intuition of the ideal reader finds itself imprisoned and distributed like purified water for the nourishment of all fussy, restless intelligences.

When I speak of destroying the canals of syntax, I am neither categorical nor systematic. Traces of conventional syntax and even of true logical sentences will be found here and there in the words-in-freedom of my unchained lyricism. This inequality in conciseness and freedom is natural and inevitable. Since poetry is in truth only a superior, more concentrated and intense life than what we live from day to day, like the latter it is composed of hyper-alive elements and moribund elements.

We ought not, therefore, to be too much preoccupied with these elements. But we should at all costs avoid rhetoric and banalities telegraphically expressed.

The imagination without strings

By the imagination without strings I mean the absolute freedom of images or analogies, expressed with unhampered words and with no connecting strings of syntax and with no punctuation.

'Up to now writers have been restricted to immediate analogies. For instance, they have compared an animal with a man or with another animal, which is almost the same as a kind of photography. (They have compared, for example, a fox terrier to a very small thoroughbred. Others, more advanced, might compare the same trembling fox terrier to a little Morse Code machine. I, on the other hand, compare it with gurgling water. In this there is an *ever vaster gradation of analogies*, there are ever deeper and more solid affinities, however remote.)

'Analogy is nothing more than the deep love that assembles distant, seemingly diverse and hostile things. An orchestral style, at once polychromatic, polyphonic, and polymorphous, can embrace the life of matter only by means of the most extensive analogies.

'When, in my *Battle of Tripoli*, I compared a trench bristling with bayonets to an orchestra, a machine gun to a *femme fatale*, I intuitively introduced a large part of the universe into a short episode of African battle.

'Images are not flowers to be chosen and picked with parsimony, as Voltaire said. They are the very lifeblood of poetry. Poetry should be an uninterrupted sequence of new images, or it is mere anaemia and greensickness.

'The broader their affinities, the longer will images keep their power to amaze.'

(Technical Manifesto of Futurist Literature)

The imagination without strings, and words-in-freedom, will bring us to the essence of material. As we discover new analogies between distant and apparently contrary things, we will endow them with an ever more intimate value. Instead of *humanizing* animals, vegetables, and minerals (an outmoded system) we will be able to *animalize, vegetize, mineralize, electrify, or liquefy our style*, making it live the life of material. For example, to represent the life of a blade of grass, I say, 'Tomorrow I'll be greener.'

With words-in-freedom we will have: CONDENSED METAPHORS. TELEGRAPHIC IMAGES. MAXIMUM VIBRATIONS. NODES OF THOUGHT. CLOSED OR OPEN FANS OF MOVEMENT. COMPRESSED ANALOGIES. COLOUR BALANCES. DIMENSIONS, WEIGHTS, MEASURES, AND THE SPEED OF SENSATIONS. THE PLUNGE OF THE ESSENTIAL WORD INTO THE WATER OF SENSIBILITY, MINUS THE CONCENTRIC CIRCLES THAT THE WORD PRODUCES. RESTFUL MOMENTS OF INTUITION. MOVEMENTS IN TWO, THREE, FOUR, FIVE DIFFERENT RHYTHMS. THE ANALYTIC, EXPLORATORY POLES THAT SUSTAIN THE BUNDLE OF INTUITIVE STRINGS.

Death of the literary I
Molecular life and material
My technical manifesto opposed the obsessive *I* that up to now the poets have described, sung, analysed, and vomited up. To rid ourselves of this obsessive *I*, we must abandon the habit of humanizing nature by attributing human passions and preoccupations to animals, plants, water, stone, and clouds. Instead we should express the infinite smallness that surrounds us, the imperceptible, the invisible, the agitation of atoms, the Brownian movements, all the passionate hypotheses and all the domains explored by the high-powered microscope. To explain: I

V Gino Severini *Tuscan Landscape* 1914

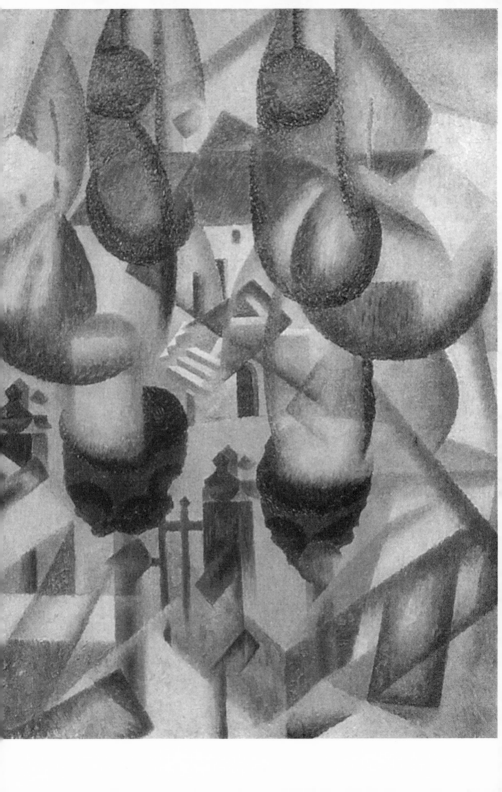

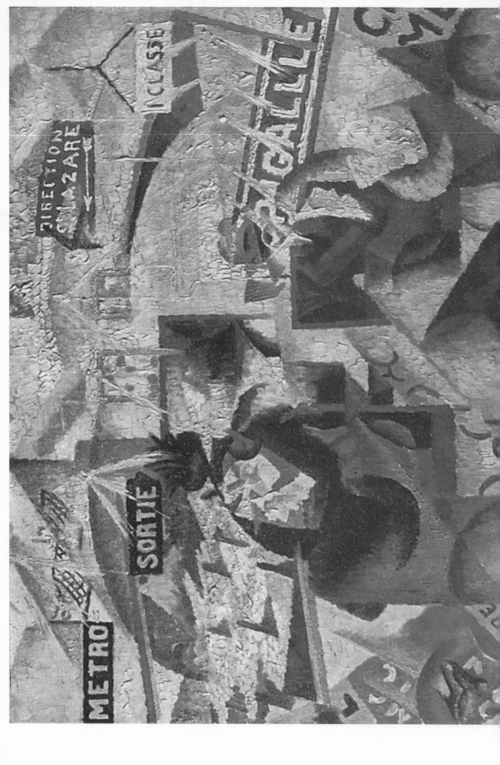

want to introduce the infinite molecular life into poetry not as a scientific document but as an intuitive element. It should mix, in the work of art, with the infinitely great spectacles and dramas, because this fusion constitutes the integral synthesis of life.

To give some aid to the intuition of my ideal reader I use italics for all words-in-freedom that express the infinitely small and the molecular life.

Semaphoric adjective
Lighthouse-adjective or atmosphere-adjective

Everywhere we tend to suppress the qualifying adjective because it presupposes an arrest in intuition, too minute a definition of the noun. None of this is categorical. I speak of a tendency. We must make use of the adjective as little as possible and in a manner completely different from its use hitherto. One should treat adjectives like railway signals of style, employ them to mark the tempo, the retards and pauses along the way. So, too, with analogies. As many as twenty of these semaphoric adjectives might accumulate in this way.

What I call a semaphoric adjective, lighthouse-adjective, or atmosphere-adjective is the adjective apart from nouns, isolated in parentheses. This makes it a kind of absolute noun, broader and more powerful than the noun proper.

The semaphoric adjective or lighthouse-adjective, suspended on high in its glassed-in parenthetical cage, throws its far-reaching, probing light on everything around it.

The profile of this adjective crumbles, spreads abroad, illuminating, impregnating, and enveloping a whole zone of words-in-freedom. If, for instance, in an agglomerate of words-in-freedom describing a sea voyage I place the following semaphoric adjectives between parentheses: (calm, blue, methodical, habitual) not only the sea is *calm, blue, methodical, habitual,* but the ship, its machinery, the passengers. What I do and my very spirit are *calm, blue, methodical, habitual.*

The infinitive verb

Here, too, my pronouncements are not categorical. I maintain, however, that in a violent and dynamic lyricism the infinitive verb might well be indispensable. Round as a wheel, like a wheel adaptable to every car in the train of analogies, it constitutes the very speed of the style.

The infinitive in itself denies the existence of the sentence and prevents the style from slowing and stopping at a definite point. While

VI Gino Severini *Nord-Sud* 1912

the infinitive is round and as mobile as a wheel, the other moods and tenses of the verb are either triangular, square, or oval.

Onomatopoeia and mathematical symbols

When I said that we must spit on the Altar of Art, I incited the Futurists to liberate lyricism from the solemn atmosphere of compunction and incense that one normally calls by the name of Art with a capital A. Art with a capital A constitutes the clericalism of the creative spirit. I used this approach to incite the Futurists to destroy and mock the garlands, the palms, the aureoles, the exquisite frames, the mantles and stoles, the whole historical wardrobe and the romantic bric-a-brac that comprise a large part of all poetry up to now. I proposed instead a swift, brutal, and immediate lyricism, a lyricism that must seem anti-poetic to all our predecessors, a telegraphic lyricism with no taste of the book about it but, rather, as much as possible of the taste of life. Beyond that the bold introduction of onomatopoetic harmonies to render all the sounds and noises of modern life, even the most cacophonic.

Onomatopoeia that vivifies lyricism with crude and brutal elements of reality was used in poetry (from Aristophanes to Pascoli) more or less timidly. We Futurists initiate the constant, audacious use of onomatopoeia. This should not be systematic. For instance, my *Adrianople Siege-Orchestra* and my *Battle Weight + Smell* required many onomatopoetic harmonies. Always with the aim of giving the greatest number of vibrations and a deeper synthesis of life, we abolish all stylistic bonds, all the bright buckles with which the traditional poets link images together in their prosody. Instead we employ the very brief or anonymous mathematical and musical symbols and we put between parentheses indications such as (fast) (faster) (slower) (two-beat time) to control the speed of the style. These parentheses can even cut into a word or an onomatopoetic harmony.

Typographical revolution

I initiate a typographical revolution aimed at the bestial, nauseating idea of the book of passéist and D'Annunzian verse, on seventeenth-century handmade paper bordered with helmets, Minervas, Apollos, elaborate red initials, vegetables, mythological missal ribbons, epigraphs, and roman numerals. The book must be the Futurist expression of our Futurist thought. Not only that. My revolution is aimed at the so-called typographical harmony of the page, which is contrary to the flux and reflux, the leaps and bursts of style that run through the page. On the

same page, therefore, we will use *three or four colours of ink,* or even twenty different typefaces if necessary. For example: italics for a series of similar or swift sensations, boldface for the violent onomatopoeias, and so on. With this typographical revolution and this multicoloured variety in the letters I mean to redouble the expressive force of words.

I oppose the decorative, precious aesthetic of Mallarmé and his search for the rare word, the one indispensable, elegant, suggestive, exquisite adjective. I do not want to suggest an idea or a sensation with passéist airs and graces. Instead I want to grasp them brutally and hurl them in the reader's face.

Moreover, I combat Mallarmé's static ideal with this typographical revolution that allows me to impress on the words (already free, dynamic, and torpedo-like) every velocity of the stars, the clouds, aeroplanes, trains, waves, explosives, globules of seafoam, molecules, and atoms.

Thus I realize the fourth principle of my First Futurist Manifesto (20 February 1909): 'We affirm that the world's beauty is enriched by a new beauty: the beauty of speed.'

Multilinear lyricism

In addition, I have conceived *multilinear lyricism,* with which I succeed in reaching that lyric simultaneity that obsessed the Futurist painters as well: multilinear lyricism by means of which I am sure to achieve the most complex lyric simultaneities.

On several parallel lines, the poet will throw out several chains of colour, sound, smell, noise, weight, thickness, analogy. One of these lines might, for instance, be olfactory, another musical, another pictorial.

Let us suppose that the chain of pictorial sensations and analogies dominates the others. In this case it will be printed in a heavier typeface than the second and third lines (one of them containing, for example, the chain of musical sensations and analogies, the other the chain of olfactory sensations and analogies).

Given a page that contains many bundles of sensations and analogies, each of which is composed of three or four lines, the chain of pictorial sensations and analogies (printed in boldface) will form the first line of the first bundle and will continue (always in the same type) on the first line of all the other bundles.

The chain of musical sensations and analogies, less important than the chain of pictorial sensations and analogies (first line) but more

important than that of the olfactory sensations and analogies (third line), will be printed in smaller type than that of the first line and larger than that of the third.

Free expressive orthography
The historical necessity of free expressive orthography is demonstrated by the successive revolutions that have continuously freed the lyric powers of the human race from shackles and rules.
1. In fact, the poets began by channelling their lyric intoxication into a series of equal breaths, with accents, echoes, assonances, or rhymes at pre-established intervals (*traditional metric*). Then the poets varied these different measured breaths of their predecessors' lungs with a certain freedom.
2. Later the poets realized that the different moments of their lyric intoxication had to create breaths suited to the most varied and surprising intervals, with absolute freedom of accentuation. Thus they arrived at *free verse*, but they still preserved the syntactic order of the words, so that the lyric intoxication could flow down to the listeners by the logical canal of syntax.
3. Today we no longer want the lyric intoxication to order the words syntactically before launching them forth with the breaths we have invented, and we have *words-in-freedom*. Moreover our lyric intoxication should freely deform, reflesh the words, cutting them short, stretching them out, reinforcing the centre or the extremities, augmenting or diminishing the number of vowels and consonants. Thus we will have the *new orthography* that I call *free expressive*. This instinctive deformation of words corresponds to our natural tendency towards onomatopoeia. It matters little if the deformed word becomes ambiguous. It will marry itself to the onomatopoetic harmonies, or the noise-summaries, and will permit us soon to reach the *onomatopoetic psychic harmony*, the sonorous but abstract expression of an emotion or a pure thought. But one may object that my words-in-freedom, my imagination without strings, demand special speakers if they are to be understood. Although I do not care for the comprehension of the multitude, I will reply that the number of Futurist public speakers is increasing and that any admired traditional poem, for that matter, requires a special speaker if it is to be understood.

<div align="right">

11 May 1913
Published in *Lacerba* (Florence), 15 June 1913
Translation R W F

</div>

Umberto Boccioni
Futurist Dynamism and French Painting 1913

From our first conversation in the Closerie des Lilas the day after the opening of the first exhibition of Futurist painting, I noticed that Fernand Léger was one of the most gifted and promising of the Cubists. But I could only think of him as *a Cubist*, that is a member of a school which seemed already to have been defined, and which, at the moment of that first exhibition of ours, was constantly contrasted with our work as something organic, square, *cubic*, in fact immovable.

In Italy, every half-educated idiot would talk about it in the usual ironical and witless grand manner which every Italian able to read feels entitled to assume when speaking about art. Meanwhile, we were working, exhibiting and selling with that same fine and scornful indifference which distinguishes us. Against this background, you will understand with what satisfaction I read today in *Montjoie!* an article by Fernand Léger, the continuation of another article subtitled 'Notes for a Lecture' ['Les Origines de la peinture et sa valeur représentative', *Montjoie!*, 29 May and 14–29 June 1913].

O asinine compatriots, do you not see that in France, too, painters write articles, give lectures, write books and go on painting? Well then? In Italy, any painter or sculptor who is not simply an effeminate snob with the mentality of a loathsome Greek pot or an Etruscan sarcophagus, is usually a mangy scoundrel deficient in ideas and in personal cleanliness, whose mind, although profoundly painterly, reaches no further than his stinking pipe.

Léger's article is a true act of Futurist faith which gives us great satisfaction (all the more so since the author is kind enough to mention us). But we cannot agree with him when he blurs all distinctions by jumping from Impressionism to formal Divisionism, colour Divisionism and dynamism. He ought to know that dynamism, as a definitive system, received its *first* statement from the Futurist painters. And he cannot be unaware that when we spoke of dynamism, we conceived it in its universal synthesis of form and colour. In fact, here is what we say in our Technical Manifesto of Futurist Painting:

On form: 'The gesture which we would reproduce on canvas shall no longer be a fixed *moment* in universal dynamism. It shall simply be the *dynamic sensation* itself.'

On colour: 'Painting cannot exist today without Divisionism. This is no process that can be learned and applied at will. Divisionism, for

the modern painter, must be *completely innate*, deemed by us to be essential and necessary'.

It is as well to recall that our manifesto, the preface to the catalogue and our paintings were attacked for being imperfect and retrogressive.

There were scandalized cries in Paris and elsewhere. We were called photographic, iconoclastic and cinematic, and worst of all, with the aim of insulting our use of colours, we were called Impressionists! And the Italian critics, through the mouth of Signor Henri des Pruraux, gave us the following:

'And it is from the snapshot that are derived the grotesque statements like the following: *A horse that is trotting has twenty pairs of legs*. The snapshot, and, even worse, the cinema which breaks up life, tossing it about in a monotonous, rushing rhythm – are these by any chance the two new classics in favour of which the Futurists proscribe the masters in the galleries?' (*La Voce*, no. 44, 31 October 1912.) It is a civil question, I agree, but mistaken. We must be indulgent. The poor old critics are only able to understand cut and dried works and periods. When the temporal limits have been established they start up and, if you like, begin to reason. But it is fatal if they are presented with a work or any historical movement still developing and veiled by the natural distortions of life.

These masterpiece-hounds soon lose the scent and start snapping wildly at anything which clashes with their last night's certainties!

But let us proceed. Since 1910 (and if you will allow us, some considerable time before, for a manifesto is not thought up and written in a single day or night), we, the Italian Futurist painters, have considered that the only *forward-looking* and *definitive* road for art lay in a dynamism of colour and form. We might add, indeed, that no one, either in France or in Italy, was aware of this. For when we were exhibiting in Paris, everyone turned to Picasso's magnificently gifted Divisionism for form, and to the darker colour schemes of Cézanne for colour; Cubism had already had its great baptism at the Salon d'Automne.

What we then said about Impressionism, in the manifesto-preface to our catalogue (5 February 1912), was heresy but is now, I think, generally accepted:

'While we repudiate Impressionism, at the same time we vigorously disapprove of the current reaction, which tries to kill the essence of Impressionism, that is the poetry of movement. It is impossible to combat the transience of Impressionism except by going beyond it. It is quite absurd to try and fight it by using the artistic laws that preceded it.'

As can be seen, we spoke out clearly. Cubism proclaimed the opposite – the static, *tradition française*, pure objectivity, etc. And this is what Roger Allard, one of the few critics who defended the Cubists with some courage, bellowed against us:

'The voluptuous serenity of Ingres should teach you, you who have a cinematograph in your bellies' (good grief!) 'that it is the height of stupidity to try and fix movement and narrate an analysis of such movement' (?!), 'that the artist's resources are lines and volumes, equations and equilibria and that no form of trickery can possibly give the illusion of rhythm!' (Wham!) (*Revue indepéndante*, no. 3, August 1911, p. 134.)

And since M. Allard, who is an intelligent critic, will soon also be talking about *dynamism*, forgetful perhaps of the Italian Futurists living down here in isolation, it is as well to recall what he wrote again in the *Revue indépendante:* 'I have in the past had a number of doubts about the Futurist dynamism of J. Metzinger, most of which I still entertain.'

I am of course quoting, as can be seen, young, intelligent critics who are aware of the importance of our discoveries. If I were to copy down here all that has been said about us by the illustrious donkeys of all nations, you would die laughing.

We are pleased and encouraged to learn of the continuous expansion of our 'plastic dynamism'. We want therefore to make clear our absolute priority for all dynamic experiments.

The position of Futurist painting is particularly unfavourable. It arose and is developing in Italy, a country of the blind, where there is no tradition at all of modern, artistic experiment. From this point of view Italy is held abroad to be the Boeotia of Europe. We feel violently that it is our duty to shout out the prime importance of our efforts. We demand the right to live! Our artistic productions never have the success that is guaranteed to those that bear the mark of Paris, when we present them in the intellectual centres of Europe. We have always praised and defended Impressionism, Matisse, Picasso and the Cubists with complete sincerity. We demand the same treatment for ourselves in Italy. Even if, according to Guillaume Apollinaire's poetic definition, dynamism based on complementary colours and simultaneous contrasts is to be called *Orphism*, even if Fernand Léger is always renewing his noble striving towards linear and planar dynamism, we the Futurists, from the beginning bearers of the universal Italian genius, have always proclaimed the indissoluble simultaneity of the dynamism of colour and form.

We were the first to proclaim that modern life is *fast and fragmented*

(words also used by F. Léger). It was we who said, amid the sarcasm and mistrust of the critics, that modern life is the only source of inspiration for a modern artist, and therefore for dynamism. So much the worse for the short-sighted who thought we were in love with the isolated incident – who thought we were amateurs of trajectories and mechanical movements.

We have always rejected with disgust and scorn even a distant relationship with photography, because it is outside art. Photography is valuable in one respect: it reproduces and imitates objectively, and, having perfected this, it has freed the artist from the obligation of reproducing reality exactly.

We are the only modern artists to have created an art in complete accord with the modern view of life. 'If our pictures are Futurist, it is because they are the result of absolutely Futurist conceptions, ethical, aesthetic, political and social.' (5 February 1912.)

Even this was thought to be unnecessary literary and philosophical phrase-mongering. On the subject of philosophy I will conclude with the words of a dear and courageous friend and brother-in-arms, Ardengo Soffici. *Paris-Journal* published an article from a daily paper entitled: 'Bergson and the Cubists'. Soffici correctly protested against anyone claiming to see similarities between the ideas of Bergson and the *static creations* of the Cubists. He ended his article deploring that: 'when he examined the Cubist theories which postulate immobility, objectivity and compactness and which came into being in reaction to Impressionist theories tending to lyricism, vibration and fluidity, he' (*Bergson*) 'did not notice at once that they are in open contradiction, in complete opposition to the conclusions of his own philosophy and therefore of his aesthetics – this is a grave oversight.' (*La Voce*, no. 52, 1911.)

My dear Soffici. You said then that Bergson distrusts artistic realizations. Very true. Do you not think that we Futurist painters have gone beyond that point and that some time soon someone will run along behind us – philosophically speaking – and will discover heaven knows what system in what is our, the only possible, the great *dynamic and evolutionary realization*?

You know that we are creating surrounded by the cowardice and despicable apathy of Italian artists!

Published in *Lacerba* (Florence), 1 August 1913
Translation JCH

Carlo Carrà
The Painting of Sounds, Noises and Smells 1913

Before the nineteenth century, painting was a silent art. Painters of antiquity, of the Renaissance, of the seventeenth and the eighteenth centuries, never envisaged the possibility of rendering sounds, noises and smells in painting, even when they chose flowers, stormy seas or wild skies as their themes.

The Impressionists in their bold revolution made some confused and hesitant attempts at sounds and noises in their pictures. Before them – nothing, absolutely nothing!

Nevertheless, we should point out at once, that between the Impressionist mumblings and our Futurist paintings of sounds, noises and smells there is an enormous difference, as great as that between a misty winter morning and a scorching summer afternoon, or – even better – between the first breath of life and an adult man in full development of his powers. In their canvases, sounds and noises are expressed in such a thin and faded way that they seem to have been perceived by the eardrum of a deaf man. Here we do not wish to present a detailed account of the principles and experiments of the Impressionists. There is no need to enquire minutely into all the reasons why the Impressionists never succeeded in painting sounds, noises and smells. We shall only mention here the kind of thing they would have had to destroy if they had wanted to obtain results:

1. The extremely vulgar perspectives of *trompe-l'oeil*, a game worthy of an academic of the Leonardo da Vinci sort or an idiot designer of *verismo* operas.

2. The concept of colour harmonies, a characteristic defect of the French which inevitably forced them into the elegant ways of Watteau and his like, and, as a result, led to the abuse of light blues, pale greens, violets and pinks. We have already said very many times how we regret this tendency towards the soft, the effeminate, the gentle.

3. Contemplative idealism, which I have defined as a *sentimental mimicry of apparent nature*. This contemplative idealism is contaminating the pictorial construction of the Expressionists, just as it contaminated those of their predecessors Corot and Delacroix.

4. All anecdote and detail, which (although it is a reaction, an antidote, to false academical construction) almost always demeans painting to the level of photography.

As for the Post- and Neo-Impressionists, such as Matisse, Signac and Seurat, we maintain that, far from perceiving the problem and facing up to the difficulties of sounds, noises and smells in their paintings, they have preferred to withdraw into static representations in order to obtain a greater synthesis of form and colour (Matisse) and a systematic application of light (Signac, Seurat).

We Futurists state, therefore, that in bringing the elements of sound, noise and smell to painting we are opening fresh paths.

We have already evolved, as artists, a love of modern life in its essential dynamism – its sounds, noises and smells – thereby destroying the stupid pattern for the solemn, the bombastic, the serene, the hieratic and the mummified: everything purely intellectual, in fact. IMAGINATION WITHOUT STRINGS, WORDS-IN-FREEDOM, THE SYSTEMATIC USE OF ONOMATOPOEIA, ANTIGRACEFUL MUSIC WITHOUT RHYTHMIC QUADRATURE, AND THE ART OF NOISES. These have derived from the same sensibility which has generated the painting of sounds, noises and smells.

It is indisputably true that (1) silence is static and sounds, noises and smells are dynamic, (2) sounds, noises and smells are none other than different forms and intensities of vibration, and (3) any continued series of sounds, noises and smells imprints on the mind an arabesque of form and colour.

We should therefore measure this intensity and perceive these arabesques.

THE PAINTING OF SOUNDS, NOISES AND SMELLS REJECTS:
1. All subdued colours, even those obtained directly and without the help of tricks such as patinas and glazes.
2. The banality of velvets, silks, flesh tints which are too human, too fine, too soft, along with flowers which are excessively pale and drooping.
3. Greys, browns and all mud colours.
4. The use of pure horizontal and vertical lines and all other dead lines.
5. The right angle which we consider passionless.
6. The cube, the pyramid and all other static shapes.
7. The unities of time and place.

THE PAINTING OF SOUNDS, NOISES AND SMELLS DESIRES:
1. Reds, rrrrreds, the rrrrrreddest rrrrrrreds that shouuuuuuut.
2. Greens, that can never be greener, greeeeeeeeeeeens, that screeeeeeeam, yellows, as violent as can be; polenta yellows, saffron yellows, brass yellows.
3. All the colours of speed, of joy, of carousings and fantastic carnivals,

fireworks, cafés and singing, of music-halls; all colours which are seen in movement, colours experienced in time and not in space.

4. The dynamic arabesque as the sole reality created by the artist from the depths of his sensibilities.

5. The clash of all acute angles, which we have already called the angles of will.

6. Oblique lines which affect the soul of the observer like so many bolts from the blue, along with lines of depth.

7. The sphere, ellipses which spin, upside-down cones, spirals and all those dynamic forms which the infinite powers of an artist's genius are able to uncover.

8. Perspectives obtained not as the objectivity of distances but as a subjective interpenetration of hard and soft, sharp and dull forms.

9. As a universal subject and as the sole reason for a painting's existence; the significance of its dynamic construction (polyphonic architectural whole).

When we talk of architecture, people usually think of something static; this is wrong. What we are thinking of is an architecture similar to the dynamic and musical architecture achieved by the Futurist musician Pratella. Architecture is found in the movement of colours, of smoke from a chimney, and in metallic structures, when they are expressed in states of mind which are violent and chaotic.

10. The inverted cone (the natural shape of an explosion), the slanting cylinder and cone.

11. The collision of two cones at their apexes (the natural shape of a water spout) with floating and curving lines (a clown jumping, dancers).

12. The zig-zag and the wavy line.

13. Ellipsoidal curves seen like nets in movement.

14. Lines and volumes as part of a plastic transcendentalism, that is according to their special kind of curving or obliqueness, determined by the painter's state of mind.

15. Echoes of lines and volumes in movement.

16. Plastic complementarism (for both forms and colours), based on the law of equivalent contrast and on the clash of the most contrasting colours of the rainbow.

This complementarism derives from a disequilibrium of form (therefore they are forced to keep moving). The consequent destruction of the *pendants* of volumes. We must reject these *pendants* since they are no more than a pair of crutches, allowing only a single movement, forward and then backward, that is, not a total movement, which we call the spherical expansion of space.

113

17. The continuity and simultaneity of the plastic transcendency of the animal, mineral, vegetable and mechanical kingdoms.

18. Abstract plastic wholes, that is those which correspond not to the artist's vision but to sensations which derive from sounds, noises and smells, and all the unknown forces involved in these. These plastic polyphonic, polyrhythmic and abstract wholes correspond to the necessity for an internal disharmony which we Futurist painters believe to be indispensable for pictorial sensibility.

These plastic wholes are, because of their mysterious fascination, much more suggestive than those created by our visual and tactile senses, because they are so much closer to our pure plastic spirit.

We Futurist painters maintain that sounds, noises and smells are incorporated in the expression of lines, volumes and colours just as lines, volumes and colours are incorporated in the architecture of a musical work.

Our canvases therefore express the plastic equivalent of the sounds, noises and smells found in theatres, music-halls, cinemas, brothels, railway stations, ports, garages, hospitals, workshops, etc., etc.

From the form point of view: there are sounds, noises and smells which are concave, convex, triangular, ellipsoidal, oblong, conical, spherical, spiral, etc.

From the colour point of view: there are sounds, noises and smells which are yellow, green, dark blue, light blue, violet.

In railway stations and garages, and throughout the mechanical or sporting world, sounds, noises and smells are predominantly red; in restaurants and cafés they are silver, yellow and violet. While the sounds, noises and smells of animals are yellow and blue, those of a woman are green, blue and violet.

We shall not exaggerate and claim that smell alone is enough to determine in our minds arabesques of form and colour which could be said to constitute the motive and justify the necessity of a painting.

But it is true in the sense that if we are shut up in a dark room (so that our sense of sight no longer works) with flowers, petrol or other things with a strong smell, our plastic spirit will gradually eliminate the memory sensation and construct a very special plastic whole which corresponds perfectly, in its quality of weight and movement with the smells found in the room.

These smells, through some kind of obscure process, have become environment-force, determining that state of mind which for us Futurist painters constitutes a pure plastic whole.

114

This bubbling and whirling of forms and light, composed of sounds, noises and smells has been partly achieved by me in my *Anarchical Funeral* and in my *Jolts of a Taxi-cab*, by Boccioni in *States of Mind* and *Forces of a Street*, by Russolo in *Revolt* and Severini in *Bang Bang*, paintings which were violently discussed at our first Paris Exhibition in 1912. This kind of bubbling over requires a great emotive effort, even delirium, on the part of the artist, who in order to achieve a vortex, must be a vortex of sensation himself, a pictorial force and not a cold multiple intellect.

Know therefore! In order to achieve this *total painting*, which requires the active cooperation of all the senses, *a painting which is a plastic state of mind of the universal*, you must paint, as drunkards sing and vomit, sounds, noises and smells!

11 August 1913
Published in *Lacerba* (Florence), 1 September 1913
Translation R B

Enrico Prampolini
Chromophony - the Colours of Sounds 1913

This study aims to explain a new state of perception concerning optical sensitivity in human beings.

If we conceive of painting as an aggregation of chromatic vibrations we should remember that the principles on which future painting must be established will be those of pure atmospheric visibility. The aim will be to encourage the optical appreciation of fine distinctions, atmospheric subtleties, and rhythmic influences of the atom, and to be able to express in chromatic terms the sound waves and the vibrations of all movements within the atmosphere.

Animals, like primitive peoples – including some still living in Australia – only distinguish dark from light colours, and have arrived, with some exceptions, at a third level of perception, which, however they are not in a position to categorize; they have developed their optical nerves far more than other beings as a means of perceiving objects at a great distance. Hence, they may be excessively long-sighted and have a great acuteness of vision, even distinguishing things through opaque bodies (lines).

We, on the other hand, have poorly developed optical organs, as far as perception of distant objects is concerned, a degree of presbyopia is general, and there are frequent cases of severe myopia; but (perhaps for physiological reasons connected with the polyhedric nature of our experience) as a compensation we have been able to develop our optical capacities in a chromatic or colouristic sense, so that we can perceive the whole chromatic gamut of bright objects.

Man, being superior to animals intellectually, must continue to progress. Since the perfection of our human senses is nothing less than a question of habit and education, and just as animals are able to perceive things through non-transparent bodies, we should be in a position to filter through our eyes all the constituent parts of the atmosphere in all its vibratory expressions.

As we have said before, it is known that humans have an optical awareness of the chromatic vibrations of sources of light; so we should also accept the scientific principle, which shows that the chromatic vibrations emitted by a source of sound *also* exist in the atmosphere and are susceptible to our optical sense. Both powers are able to influence the atmosphere, and hence the human senses. If we accept the maxim that a given atmospheric state changes the colours of objects, we should also accept the fact that it has a colour of its own, and that the atmospheric essence can be distinguished as a constituent of our optical perception.

We can distinguish between two notes – C and F, for example – because they send back different vibrational entities into the atmosphere. Therefore, it should be just as easy and just as credible to distinguish chromatically the value of this or that note, given the fact of the colour influence which the surrounding objects refract onto these vibrations.

Accepting as axiomatic Newton's principle that the atmosphere is permanently saturated by the seven colours of the solar spectrum, I shall give an example of the results of one of my experiments.

It is obvious that a motor horn, when it hoots, displaces the atmosphere, which then diffuses rhythmically in a special series of waves, rebounding from any obstacle it comes up against, and, therefore, refracting, breaking up into a myriad chromatic scales; and, in all these simultaneous rhythmic patterns, the atmospheric vibrations will take on as many lights and colours as there are, and not only the colours of the objects and bodies which these vibrations come up against, but also reflections from other objects and bodies around and about.

I stress the fact that these colorations are not, as people have mistakenly thought, mere abstract expressions or arbitrary factors, con-

ceived empirically by the artist or even the result of his wild fantasies; this would amount to academism or even worse.

Let us look at another example (the food of idiots): A is in one room, and a second person, Z, is in another; the latter begins to play, sing, gesticulate, make noises, etc. A will not be able to perceive any of the colours of the sounds, noises or atmospheric displacements taking place in the other room, because he is not there in person. As a result, the atmospheric vibrations produced by the various actions of Z will reach him in an infinitely disintegrated manner, and, consequently, will have only a very weak degree of chromatism, and they will lack the capacity to influence the atmospheric area which surrounds A, that is to say, the area in which the individual visual perception takes place.

I stress once again the statement that the perception of sound colours and any other displacement in the atmosphere is a manifestation of 'pure optical visuality' and needs no help from culture.

I hope I have managed to explain that when we speak of vibrations and atmospheric dynamism, the vibrations displaced by a single force cannot be equated with a single colour, but with a multitude of colours, since we know that the atmosphere is composed of seven primary colours and that the vibrations constitute a disintegration of it.

Let me conclude, therefore, by stating that it is neither true nor possible that a note, a sound, a noise, a gesture, a word, a smell, may have a corresponding colour; instead they will have several colours. Similarly, it is not true that just because the atmospheric vibrations are more violent, so then the colour will become more intense and, therefore, visible; it is the primal power, the type of vibration and the place of origin which determine value and aspect.

It is also essential to try to understand the potentiality of the atmosphere, the atmosphere in which we live and breathe; we should learn about the latent chromatic sources with which the atmosphere is saturated; but in order to acquire this knowledge we must have a painter's personality and an infinite knowledge of the atmosphere, the breathing and the slow death of colours.

Living corpses, cold souls, those beings dedicated to competence and hard work, those who have chosen the middle road and lack fire and passion: these are the people who will not understand or perceive results in this kind of enquiry. And since art involves enthusiasm and exaltation, souls that are enthusiastic and exalted have the faculty of attaining psychic or sensory virtues which others cannot hope to possess.

Why have I chosen sound in order to define the basis of Chromophony?

Because it is the fittest expression for classifying these new manifestations of mankind. Nevertheless, we should clearly remember that, by the term 'Chromophony', I intend to include any kind of atmospheric displacement, even those with non-sound sources. In this way we will easily be able to distinguish, in the chromatic vibrations expressed in a painting, whether the vibrations concerned were displaced by the voice of a person of one sex rather than the other.

Physiologically, this phenomenon of the optical sense reveals itself in the following way: 'a noise, a sound, a word, while arousing in the atmosphere a pure, dynamic vibration, arouses within the volatile imagination of the artist the intuitive chromatic stimulus.'

All modern manifestations of life, in order to be able to continue their existence and be discussed and approved, in spite of all the adverse criticism of morons, must have a positive character. Therefore, if we wish to enjoy this positivism in painting, all our expressions should be manifested purely with colours.

Look at the atmosphere and saturate your eyes with Nature, the inconceivable; launch the concrete into the abstract, so that from the reciprocal repercussions there will appear a violent irradiation of evolving vibrations.

Destroy, destroy, in order to rebuild consciousness and opinion, culture and the genesis of art.

These few words on Chromophony are for those who suffer from blindness of the mind and dumbness of the eyes.

Published in *Gazzetta Ferrarese*, 26 August 1913
Translation R B

Gino Severini
The Plastic Analogies of Dynamism - Futurist Manifesto 1913

We want to enclose the universe in the work of art. Individual objects do not exist any more.

We must forget exterior reality and our knowledge of it in order to *create* the new dimensions, the order and extent of which will be discovered by our artistic sensibility in relation to the world of plastic creation.

VII Giacomo Balla *Study of Ongoing Lines* (*Swallows*) 1913

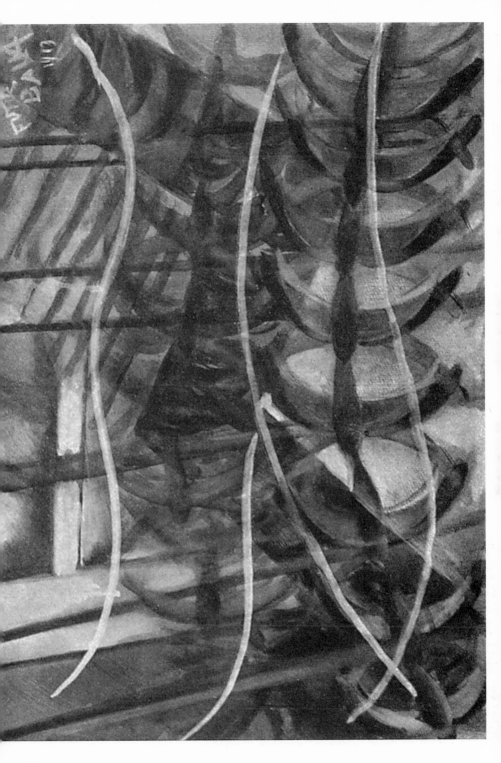

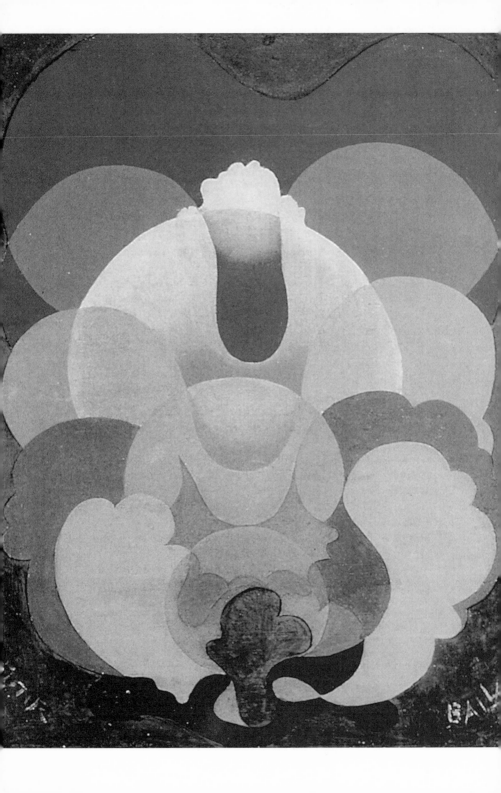

We will express in this way artistic emotions which are not only related to a particular emotional background, but united to the whole universe; for matter, considered in its effects, encloses the universe in an enormously vast circle of analogies, which start with affinities or resemblances and end with contrasts and specific differences.

Thus the sensation aroused in us by a real object of which we know the square shape and blue colour can be expressed artistically through its formal and chromatic complementaries, i.e. round shapes and yellow colours.

So now exterior reality and our knowledge of it no longer have any influence on our plastic expression, and, with regard to the action of the memory on our sensitivity, only the memory of the emotion remains and not that of the cause that produced it.

Memory then will act in the work of art as an *element of artistic intensification*, as a true emotive source independent of any unity of time or place, and as sole *raison d'être* of an artistic creation.

As early as 1911 in my painting *Memories of Travel* – first Futurist exhibition in Paris, February 1912 – I had realized the possibility of expanding *ad infinitum* the range of plastic expression, totally doing away with the unities of time and place with a painting of memory which brought together in a single plastic whole things perceived in Tuscany, in the Alps, in Paris, etc.

Today, in this epoch of dynamism and simultaneity, one cannot separate any event or object from the memories, the plastic preferences or aversions, which its *expansive action* calls up *simultaneously* in us, and which are so many abstract realities – *points de repère* for achieving the full effect of the event or object in question.

The spiralling shapes, and the beautiful contrasts of yellow and blue, that are intuitively felt one evening while *living the movements of a girl dancing* may be found again *later*, through a process of plastic preferences or aversions, or through a combination of both, *in the concentric circling of an aeroplane or in the onrush of an express train*.

In this way certain forms and colours expressing the sensations of noise, sound, smell, heat, speed, etc., connected with the experience of an *ocean liner*, can express by *plastic analogy* the same sensations evoked in us by a very different reality – the *Galeries Lafayette*.

The experience *ocean liner* is thus linked to the experience *Galeries Lafayette* (and every experience is linked to its specific but diverse correlative) by its *qualitative radiations* which permeate the universe on the electrical waves of our sensibility.

121

VIII Giacomo Balla *Futurballa* 1913

This is a complex form of realism which *totally* destroys the integrity of the subject-matter – henceforth taken by us only *at its greatest vitality*, which can be expressed thus:

Galeries Lafayette = *ocean liner*.

The abstract colours and forms that we portray belong to the Universe outside time and space.

Before us, analogies had only been used to a greater or lesser extent in literature, and the poet Marinetti, who was the first to use them systematically and to achieve an intense and specific realism, defines analogies in this way in his marvellous Technical Manifesto of Futurist Literature:

'Analogy is no more than the immense love which brings together distant objects which are on the surface different and hostile.

'By using vast analogies, this orchestrated style, which is at the same time polychromatic, polyphonic and polymorphous, can embrace the full life of the subject-matter.

'In order to give the successive movements of an object, one must give the chain of analogies which it arouses, condensed and gathered into a single quintessential word.

'In order to develop and gather up the most fleeting and intangible aspects of the subject-matter, tight nets of images and analogies must be woven so that we may cast them into the mysterious ocean of phenomena.'

So, using analogies, we can penetrate the most expressive part of reality and render *simultaneously* the *subject* and the *will* at their most *intensive* and *expansive*.

With the interpenetration of planes and the simultaneity of environment, we have been able to render the reciprocal influence of objects and the environmental vitality of the subject (intensity and expansion of object + environment); with plastic analogies we can *infinitely* enlarge the range of these influences, radiations and contrasts of the will, the unique form of which is *created* by our artistic sensibility and expresses the *absolute vitality* of matter, or *universal dynamism* (intensity and expansion of the object + environment through the entire universe, as far as its specific but diverse correlative).

In addition we are taking *artistic emotion* back to its *physical* and *spontaneous source* – *Nature* – from which anything philosophical or intellectual would tend to alienate it. Therefore, although our creations represent an inner life totally different from real life, the painting and sculpture that we base on artistic analogies can be called painting and sculpture after nature.

There are two kinds of analogy – *real analogies* and *apparent analogies*. For example:

Real analogies: the sea dancing, its zig-zag movements and contrasting silver and emerald, evokes within my plastic sensibility the distant vision of a dancer covered in sparkling sequins in her world of light, noise and sound.

Therefore *sea = dancer*.

Apparent analogies: the plastic expression of the same sea, which in a real analogy evokes in me a dancer, gives me by a process of apparent analogy a vision of a great bunch of flowers. These evident and superficial analogies help to intensify the expressive power of the work of art. Thus one comes to this result:

sea = dancer + bunch of flowers.

It is not possible to establish technical laws, which are especially relevant to the individuality of each artist. Nevertheless here are the bases of our means of expression, in part already used by us, but now intensified and systematically developed in accordance with our now universal plastic sensibility.

FORM

1. Simultaneous contrast of lines, planes and volumes, and of groups of analogous forms disposed in spherical expansion. – Constructive interpenetration.

2. Rhythmic arabesque-like construction, intentionally ordered in a new *qualitative architecture*, formed exclusively of qualitative quantities. ... (*The subject-matter, when its effect is considered, sacrifices its integrity, and therefore its integral quantities, in order to develop to the utmost its qualitative continuities.* Therefore our Futuristic artistic expression will be purely qualitative.)

3. Dynamic composition open in all directions towards space, vertically rectangular, or square and spherical.

4. Suppression of the straight line which is as static and formless as a colour without tonal gradations, and of parallel lines.

COLOUR

1. Exclusive use of the pure colours of the prism for areas in simultaneous contrast or for groups of analogous and divided colours. (*Complementarity in general or Divisionism of analogous colours makes up the technique of colour analogies. Plastic analogy is the destruction of a real difference between objects by a real analogy; using colour analogies one can obtain the greatest luminous intensity, heat, musicality, optical and constructional dynamism.*)

2. Use of pure black, pure white or the plain canvas for neutral areas or to obtain the greatest intensity from the colours.

3. Use, to heighten the realism, of onomatopoetic symbols, of isolated words, and of all possible types of materials.

4. *Our need for absolute realism makes us model in relief on our paintings and colour our plastic wholes with all the colours of the prism disposed in spherical expansion.*

All sensations, when they take artistic form, become immersed in the sensation *light*, and therefore can only be expressed with all the colours of the prism.

Painting and modelling forms, other than with the entire spectrum of colours, would mean suppressing one of the sources of life in the object, that of *irradiation.*

The coloured expression of the sensation *Light*, in accordance with our *spherical expansion in space*, can only be centrifugal or centripedal [*sic*] with relation to the organic structure of the work. Thus, for example, the artistic ensemble *Dancer = sea* should preferably have luminous irradiations (forms and colour-light) moving from the centre towards space (centrifugal). This is, in addition, dependent on the artistic sensibility of each artist; but it is *essential* to do away with the principle of light, local tone and shadows which painters before us have used to show the effect of light on bodies, and which goes together with a relativity of luminous, ephemeral and accidental phenomena.

We will call this new artistic expression of light *spherical expansion of light in space.*

In this way we will have a spherical expansion of colour in perfect accord with the spherical expansion of forms.

For example: If the centre of a group of forms is yellow, a series of colours will radiate towards space, from one colour analogy to the next as far as blue, its complementary colour, and if necessary as far as black, the absence of light, and vice versa.

It is clear that in one and the same picture or work of art there may be more than one *centrifugal and centripedal* [*sic*] nucleus in simultaneous and dynamic competition.

One of our most systematic Futurist characteristics, which can also be found amongst artists belonging to different races, is that of expressing *sensations of movement.*

Indeed, one of the effects of science, which has transformed our sensibility and which has led to the majority of our Futurist truths, is *speed.*

Speed has given us a new conception of space and time, and consequently of life itself; and so it is perfectly reasonable for our Futurist works to *characterize* the art of our epoch with the *stylization of movement* which is one of the most immediate manifestations of life.

Therefore we must *ban*, as we banned the *nude* in our first manifesto of Futurist painting, *the human body, still-lifes and rural landscapes considered as objects of feeling.*

These objects, taken individually, that is separated from the *qualitative associations* which express their *total effect* in the universe, *even if considered in conjunction with an emotional background,* can be of but slight interest to our artistic genius, and would allow it to moulder in pursuits unworthy of its creative strength.

On the other hand a complex of dynamic elements like an aeroplane in flight + man + landscape; a tram or an automobile travelling at speed + boulevard + passengers; or carriages in the Métro + stations + posters + light + crowd, etc., etc., and all the artistic analogies which they arouse in us, offer us sources of feeling and lyricism which are much deeper and more complex.

Also we must once and for all ban the time-honoured academic distinctions between *pictorial form* and *sculptural form.*

Plastic dynamism, the absolute vitality of matter, can be expressed only with *colourforms* at their *maximum* of profundity, intensity and luminous irradiation, that is, with painting and sculpture united in a single work of art.

I therefore foresee the *end of the painting and of the statue.* These forms of art, in spite of our innovatory spirit, curb our creative freedom and contain within them their own fates: museums, collectors' galleries, all equally bogged down in the past.

Instead, *our plastic creations must live in the open air and fit into architectural schemes, with which they will share the active intervention of the outside world, of which they represent the particular essence.*

<div align="right">

Ms. September–October 1913
Translation J C H

</div>

F. T. Marinetti
The Variety Theatre 1913

We are deeply disgusted with the contemporary theatre (verse, prose, and musical) because it vacillates stupidly between historical reconstruction (pastiche or plagiarism) and photographic reproduction of our daily life; a finicking, slow, analytic, and diluted theatre worthy, all in all, of the age of the oil lamp.

FUTURISM EXALTS THE VARIETY THEATRE because:

1. The Variety Theatre, born as we are from electricity, is lucky in having no tradition, no masters, no dogma, and it is fed by swift actuality.

2. The Variety Theatre is absolutely practical, because it proposes to distract and amuse the public with comic effects, erotic stimulation, or imaginative astonishment.

3. The authors, actors, and technicians of the Variety Theatre have only one reason for existing and triumphing: incessantly to invent new elements of astonishment. Hence the absolute impossibility of arresting or repeating oneself, hence an excited competition of brains and muscles to conquer the various records of agility, speed, force, complication, and elegance.

4. The Variety Theatre is unique today in its use of the cinema, which enriches it with an incalculable number of visions and otherwise unrealizable spectacles (battles, riots, horse races, automobile and aeroplane meets, trips, voyages, depths of the city, the countryside, oceans, and skies).

5. The Variety Theatre, being a profitable show window for countless inventive forces, naturally generates what I call 'the Futurist marvellous', produced by modern mechanics. Here are some of the elements of this 'marvellous': (a) powerful caricatures; (b) abysses of the ridiculous; (c) delicious, impalpable ironies; (d) all-embracing, definitive symbols; (e) cascades of uncontrollable hilarity; (f) profound analogies between humanity, the animal, vegetable, and mechanical worlds; (g) flashes of revealing cynicism; (h) plots full of the wit, repartee, and conundrums that aerate the intelligence; (i) the whole gamut of laughter and smiles, to flex the nerves; (j) the whole gamut of stupidity, imbecility, doltishness, and absurdity, insensibly pushing the intelligence to the very border of madness; (k) all the new significations of light, sound, noise, and language, with their mysterious and inexplicable extension into the least-explored part of our sensibility; (l) a cumulus of events unfolded

at great speed, of stage characters pushed from right to left in two minutes ('and now let's have a look at the Balkans': King Nicolas, Enver-Bey, Daneff, Venizelos, belly-blows and fistfights between Serbs and Bulgars, a *couplet*, and everything vanishes); (*m*) instructive satirical pantomimes; (*n*) caricatures of suffering and nostalgia, strongly impressed on the sensibility through gestures exasperating in their spasmodic, hesitant, weary slowness; grave words made ridiculous by funny gestures, bizarre disguises, mutilated words, ugly faces, pratfalls.

6. Today the Variety Theatre is the crucible in which the elements of an emergent new sensibility are seething. Here you find an ironic decomposition of all the worn-out prototypes of the Beautiful, the Grand, the Solemn, the Religious, the Ferocious, the Seductive, and the Terrifying, and also the abstract elaboration of the new prototypes that will succeed these.

The Variety Theatre is thus the synthesis of everything that humanity has up to now refined in its nerves to divert itself by laughing at material and moral grief; it is also the bubbling fusion of all the laughter, all the smiles, all the mocking grins, all the contortions and grimaces of future humanity. Here you sample the joy that will shake men for another century, their poetry, painting, philosophy, and the leaps of their architecture.

7. The Variety Theatre offers the healthiest of all spectacles in its dynamism of form and colour (simultaneous movement of jugglers, ballerinas, gymnasts, colourful riding masters, spiral cyclones of dancers spinning on the points of their feet). In its swift, overpowering dance rhythms the Variety Theatre forcibly drags the slowest souls out of their torpor and forces them to run and jump.

8. The Variety Theatre is alone in seeking the audience's collaboration. It doesn't remain static like a stupid voyeur, but joins noisily in the action, in the singing, accompanying the orchestra, communicating with the actors in surprising actions and bizarre dialogues. And the actors bicker clownishly with the musicians.

The Variety Theatre uses the smoke of cigars and cigarettes to join the atmosphere of the theatre to that of the stage. And because the audience cooperates in this way with the actors' fantasy, the action develops simultaneously on the stage, in the boxes, and in the orchestra. It continues to the end of the performance, among the battalions of fans, the honeyed dandies who crowd the stage door to fight over the star; double final victory: chic dinner and bed.

9. The Variety Theatre is a school of sincerity for man because it exalts his rapacious instincts and snatches every veil from woman, all

the phrases, all the sighs, all the romantic sobs that mask and deform her. On the other hand it brings to light all woman's marvellous animal qualities, her grasp, her powers of seduction, her faithlessness, and her resistance.

10. The Variety Theatre is a school of heroism in the difficulty of setting records and conquering resistances, and it creates on the stage the strong, sane atmosphere of danger. (E.g., death-diving, 'Looping the loop' on bicycles, in cars, and on horseback.)

11. The Variety Theatre is a school of subtlety, complication, and mental synthesis, in its clowns, magicians, mind readers, brilliant calculators, writers of skits, imitators and parodists, its musical jugglers and eccentric Americans, its fantastic pregnancies that give birth to objects and weird mechanisms.

12. The Variety Theatre is the only school that one can recommend to adolescents and to talented young men, because it explains, quickly and incisively, the most abstruse problems and most complicated political events. Example: A year ago at the Folies-Bergère, two dancers were acting out the meandering discussions between Cambon and Kinderlen-Watcher [sic] on the question of Morocco and the Congo in a revealing symbolic dance that was equivalent to at least three years' study of foreign affairs. Facing the audience, their arms entwined, glued together, they kept making mutual territorial concessions, jumping back and forth, to left and right, never separating, neither of them ever losing sight of his goal, which was to become more and more entangled. They gave an impression of extreme courtesy, of skilful, flawlessly diplomatic vacillation, ferocity, diffidence, stubbornness, meticulousness.

Furthermore the Variety Theatre luminously explains the governing laws of life:

(a) the necessity of complication and varying rhythms;

(b) the fatality of the lie and the contradiction (e.g., two-faced English *danseuses*: little shepherd girl and fearful soldier);

(c) the omnipotence of a methodical will that modifies human powers;

(d) a synthesis of speed + transformations.

13. The Variety Theatre systematically disparages ideal love and its romantic obsession that repeats the nostalgic languors of passion to satiety, with the robot-like monotony of a daily profession. It whimsically mechanizes sentiment, disparages and healthily tramples down the compulsion towards carnal possession, lowers lust to the natural function of coitus, deprives it of every mystery, every crippling anxiety, every unhealthy idealism.

Instead, the Variety Theatre gives a feeling and a taste for easy, light and ironic loves. Café-concert performances in the open air on the terraces of casinos offer a most amusing battle between spasmodic moonlight, tormented by infinite desperations, and the electric light that bounces off the fake jewellery, painted flesh, multicoloured petticoats, velvets, tinsel, the counterfeit colour of lips. Naturally the energetic electric light triumphs and the soft decadent moonlight is defeated.

14. The Variety Theatre is naturally anti-academic, primitive, and naive, hence the more significant for the unexpectedness of its discoveries and the simplicity of its means. (E.g., the systematic tour of the stage that he *chanteuses* make, like caged animals, at the end of every *couplet*.)

15. The Variety Theatre destroys the Solemn, the Sacred, the Serious, and the Sublime in Art with a capital A. It cooperates in the Futurist destruction of immortal masterworks, plagiarizing them, parodying them, making them look commonplace by stripping them of their solemn apparatus as if they were mere *attractions*. So we unconditionally endorse the performance of *Parsifal* in forty minutes, now in rehearsal in a great London music-hall.

16. The Variety Theatre destroys all our conceptions of perspective, proportion, time, and space. (E.g., a little doorway and gate, thirty centimetres high, alone in the middle of the stage, which certain eccentric Americans open and close as they pass and repass, very seriously as if they couldn't do otherwise.)

17. The Variety Theatre offers us all the records so far attained: the greatest speed and the finest gymnastics and acrobatics of the Japanese, the greatest muscular frenzy of the Negroes, the greatest development of animal intelligence (horses, elephants, seals, dogs, trained birds), the finest melodic inspiration of the Gulf of Naples and the Russian steppes, the best Parisian wit, the greatest competitive force of different races (boxing and wrestling), the greatest anatomical monstrosity, the greatest female beauty.

18. The conventional theatre exalts the inner life, professorial meditation, libraries, museums, monotonous crises of conscience, stupid analyses of feelings, in other words (dirty thing and dirty word), *psychology*, whereas, on the other hand, the Variety Theatre exalts action, heroism, life in the open air, dexterity, the authority of instinct and intuition. To psychology it opposes what I call 'body-madness' (*fisicofollia*).

19. Finally, the Variety Theatre offers to every country (like Italy) that has no great single capital city a brilliant résumé of Paris considered as the one magnetic centre of luxury and ultrarefined pleasure.

FUTURISM WANTS TO TRANSFORM THE VARIETY THEATRE INTO A THEATRE OF AMAZEMENT, RECORD-SETTING, AND BODY-MADNESS.

1. One must completely destroy all logic in Variety Theatre performances, exaggerate their luxuriousness in strange ways, multiply contrasts and make the absurd and the unlifelike complete masters of the stage. (Example: Oblige the *chanteuses* to dye their décolletage, their arms and especially their hair, in all the colours hitherto neglected as means of seduction. Green hair, violet arms, blue décolletage, orange chignon, etc. Interrupt a song and continue with a revolutionary speech. Spew out a *romanza* of insults and profanity, etc.).

2. Prevent a set of traditions from establishing itself in the Variety Theatre. Therefore oppose and abolish the stupid Parisian 'Revues', as tedious as Greek tragedy with their *Compère* and *Commère* playing the part of the ancient chorus, their parade of political personalities and events set off by wisecracks in a most irritating logical sequence. The Variety Theatre, in fact, must not be what it unfortunately still is today, nearly always a more or less amusing newspaper.

3. Introduce surprise and the need to move among the spectators of the orchestra, boxes, and balcony. Some random suggestions: spread a powerful glue on some of the seats, so that the male or female spectator will stay glued down and make everyone laugh (the damaged frock coat or toilette will naturally be paid for at the door). – Sell the same ticket to ten people: traffic jam, bickering, and wrangling. – Offer free tickets to gentlemen or ladies who are notoriously unbalanced, irritable, or eccentric and likely to provoke uproars with obscene gestures, pinching women, or other freakishness. Sprinkle the seats with dust to make people itch and sneeze, etc.

4. Systematically prostitute all of classic art on the stage, performing for example all the Greek, French, and Italian tragedies, condensed and comically mixed up, in a single evening. – Put life into the works of Beethoven, Wagner, Bach, Bellini, Chopin, introducing them with Neapolitan songs. – Put Duse, Sarah Bernhardt, Zacconi, Mayol, and Fregoli side by side on the stage. – Play a Beethoven symphony backwards, beginning with the last note. – Boil all of Shakespeare down to a single act. – Do the same with all the most venerated actors. – Have actors recite *Hernani* tied in sacks up to their necks. Soap the floorboards to cause amusing tumbles at the most tragic moments.

5. In every way encourage the *type* of the eccentric American, the impression he gives of exciting grotesquerie, of frightening dynamism; his crude jokes, his enormous brutalities, his trick weskits and pants as deep as a ship's hold out of which, with a thousand other things, will

come the great Futurist hilarity that should make the world's face young again.

Because, and don't forget it, we Futurists are YOUNG ARTILLERYMEN ON A TOOT, as we proclaimed in our manifesto, 'Let's Murder the Moonshine', fire + fire + light against moonshine and against old firmaments war every night great cities to blaze with electric signs. Immense black face (30 metres high + 150 metres height of the building = 180 metres) open close open close a golden eye 3 metres high SMOKE SMOKE MANOLI SMOKE MANOLI CIGARETTES woman in a blouse (50 metres + 120 metres of building = 170 metres) stretch relax a violet rosy lilac blue bust froth of electric light in a champagne glass (30 metres) sizzle evaporate in a mouthful of darkness electric signs dim die under a dark stiff hand come to life again continue stretch out in the night the human day's activity courage + folly never to die or cease or sleep electric signs = formation and disaggregation of mineral and vegetable centre of the earth circulation of blood in the ferrous faces of Futurist houses increases, empurples (joy anger more more still stronger) as soon as the negative pessimist sentimental nostalgic shadows besiege the city brilliant revival of streets that channel a smoky swarm of workers by day two horses (30 metres tall) rolling golden balls with their hoofs GIOCONDA PURGATIVE WATERS crisscross of *trrrr trrrrr* Elevated *trrrr trrrrr* overhead trrrombone whissstle ambulance sirens and firetrucks transformation of the streets into splendid corridors to guide, push logic necessity the crowd towards trepidation + laughter + music-hall uproar FOLIES-BERGÈRE EMPIRE CRÈME-ÉCLIPSE tubes of mercury red red red blue violet huge letter-eels of gold purple diamond fire Futurist defiance to the weepy night the stars' defeat warmth enthusiasm faith conviction will power penetration of an electric sign into the house across the street *yellow slaps* for that gouty, dozy bibliophile in slippers 3 mirrors watch him the sign plunges to 3 redgold abysses open close open close 3 thousand metres deep horror quick go out out hat stick steps taximeter push shove *zuu zuoeu* here we are dazzle of the promenade solemnity of the panther-cocottes in their comic-opera tropics fat warm smell of music-hall gaiety = tireless ventilation of the world's Futurist brain.

<div style="text-align:right">

29 September 1913
Published in *Lacerba* (Florence), 1 October 1913
and *Daily Mail* (London), 21 November 1913
(shorter text, different translation)
Translation R W F

</div>

Giacomo Balla
Futurist Manifesto of Men's Clothing 1913

We Futurists, in those brief gaps between our great struggles for renewal, have spent the time discussing, as is our wont, very many subjects. For quite some time now we have been convinced that today's clothes, while they may be somewhat simplified to suit certain modern requirements, are still atrociously passéist.

WE MUST DESTROY ALL PASSÉIST CLOTHES, and everything about them which is tight-fitting, colourless, funereal, decadent, boring and unhygienic. As far as *materials* are concerned, we must *abolish*: wishy-washy, pretty-pretty, gloomy, and neutral colours, along with patterns composed of lines, checks and spots. *In cut and design*: the abolition of static lines, all uniformities such as ridiculous turn-ups, vents, etc. *Let us finish with the humiliating and hypocritical custom of wearing mourning.* Our crowded streets, our theatres and cafés are all imbued with a depressingly funereal tonality, because clothes are made only to reflect the gloomy and dismal moods of today's passéists.

WE MUST INVENT FUTURIST CLOTHES, hap-hap-hap-hap-happy clothes, daring clothes with brilliant colours and dynamic lines. They must be simple, and above all they must be made to last for a short time only in order to encourage industrial activity and to provide constant and novel enjoyment for our bodies. USE materials with forceful MUSCULAR colours – the reddest of reds, the most purple of purples, the greenest of greens, intense yellows, orange, vermilion – and SKELETON tones of white, grey and black. And we must invent dynamic designs to go with them and express them in equally dynamic shapes: triangles, cones, spirals, ellipses, circles, etc. The cut must incorporate dynamic and asymmetrical lines, with the left-hand sleeve and left side of a jacket in circles and the right in squares. And the same for waistcoats, stockings, topcoats, etc. The consequent merry dazzle produced by our clothes in the noisy streets, which we shall have transformed with our FUTURIST architecture, will mean that everything will begin to sparkle like the glorious prism of a jeweller's gigantic glass-front, and all around us we shall find acrobatic blocks of colours set out like the following word-shapes:

Coffeecornhou Rosegreebastocap transpomotocar legcutshop blueblackwhitehouses aerocigarend skyroofliftyellight anomoviesphot barbebbenpurp.

Human beings, until now, have dressed (more or less) in black mourning.

We are fighting against:

(a) *the timidity and symmetry* of colours, colours which are arranged in wishy-washy patterns of idiotic spots and stripes;
(b) all forms of *lifeless* attire which make man feel tired, depressed, miserable and sad, and which restrict movement producing a triste wanness;
(c) so-called 'good taste' and harmony, which weaken the soul and take the spring out of the step.

We want Futurist clothes to be comfortable and practical
Dynamic
Aggressive
Shocking
Energetic
Violent
Flying (i.e. giving the idea of flying, rising and running)
Peppy
Joyful
Illuminating (in order to have light even in the rain)
Phosphorescent
Lit by electric lamps.

Pattern changes should be available by pneumatic dispatch; in this way anyone may change his clothes according to the needs of mood.

Available modifications will include:
Loving
Arrogant
Persuasive
Diplomatic
Unitonal
Multitonal
Shaded
Polychrome
Perfumed.

As a result we shall have the necessary variety of clothes, even if the people of a given city lack the imagination themselves.

The happiness of our *Futurist clothes* will help to spread the kind of good humour aimed at by my great friend Palazzeschi in his manifesto *against sadness*.

Shortly to appear: a Futurist manifesto on Women's Clothing.

Ms. 1913
(First draft of the Manifesto for a Futurist Costume.
Contemporary with the Palazzeschi manifesto,
which is dated 29 December 1913. *Ed.*)
Translation R B

Ardengo Soffici
The Subject in Futurist Painting 1914

If we consider the thing from a conceptual point of view, we are obviously led to conclusions of the following nature: 'Whatever art tries to represent, its object is always man. A landscape, a still-life, are no more than the hieroglyphics into which someone's personality has been injected, and through which the artist presents his own spiritual being.' If, on the other hand, we were to set aside such aesthetic truisms, along with all the subtleties that could be found concerning subjectivism and objectivism and their inevitable connection within the work of art, and pay attention solely to the practice of pictorial art as it in fact appears to those who are engaged in it – or to those who wish to study its development in its concrete forms – then the problem of the subject immediately assumes very great importance.

I have said over and over again, *ad nauseam*, what pictorial art should mean today; I think I may venture, therefore, to assume that no one will believe that I attach value to the subject in accordance with the old criteria of nobility or grandeur, or in relation to any literary, dramatic or sentimental qualities. Its importance for me resides entirely in the fact that each new subject demands from the painter a new plastic sense and hence a new style. I mean by this that an unaccustomed collection of forms, lines and colours requires, in order to be expressed, a different treatment of the materials, as well as a different way of conceiving the arrangement and composition of the different parts, in view of attaining the essential quality of every work of art: unity.

It is a fact that the painting of the old masters, which is founded on the study of human and animal forms and, to some degree, of landscape, has imposed on the concepts of 'style' and 'plastic art' a meaning which is a far cry from our modern ideas.

The virtually unexpected appearance of new forms modified our sensibilities, and must also inevitably modify our means of expression. Who can fail to understand, for example, that an aeroplane, a train, any machine, a café-concert, a circus scene, inevitably give an absolutely new interpretation of the fusion of lines and the complementarity of colours and light, when used as elements in a painting, as opposed to the old one of persons seated round a table, a group of nude bathers, a pair of plough-oxen or a collection of fruit and china on a table?

Now there is something more vibrant, more fragmentary, more abrupt, more chaotic and more nervous in these new subjects, which the calm lines, harmonious colours and balanced chiaroscuro of the old ones could never convey.

There is a profound and intimate difference in the poetic stimulus; and therefore there must be a difference in the expressive plastic texture. It is only in this sense, as the factor which imposes the necessity of appropriate plastic rhythms, that the Futurist painter attaches importance to his subject. This is why modernity is the indispensable condition for all the arts, as far as subject is concerned.

<div align="right">

Published in *Lacerba* (Florence), 1 January 1914
Translation RB

</div>

Bruno Corradini, Emilio Settimelli
Weights, Measures and Prices of Artistic Genius - Futurist Manifesto 1914

Criticism has never existed, and does not exist. The passéist pseudo-criticism which has been nauseating us up to the present has never been more than the solitary vice of the impotent, the peevish outbursts of failed artists, fatuous prattle, arrogant dogmatism in the name of non-existent authorities. We Futurists have always said that this amphibious, uterine and imbecile activity has no right to make judgments. Today sees the birth in Italy of the first real criticism, through the work of Futurism. But since the words critic and criticism have already been besmirched by the foul use that has been made of them, we Futurists are abolishing them, once and for all, and will use in their place the terms MEASUREMENT and MEASURER.

OBSERVATION NO. 1. Every human activity is a projection of nervous energy. This energy, which is one of physical constitution and of action, undergoes various transformations and assumes various aspects according to the material chosen to manifest it. A human being assumes greater or lesser importance according to the quantity of energy at his disposal, and according to his power and ability to modify his surroundings.

OBSERVATION NO. 2. There is no essential difference between a human brain and a machine. It is mechanically more complicated, that is all. For example, a typewriter is a primitive organism governed by a logic imposed on it by its construction. It reasons thus: if one key is pressed it must write in lower case; if the shift and another key are pressed, it follows that it must write in upper case; when the space-bar is pressed, it must advance; when the back-space is pressed, it must go back. For a typewriter to have its E pressed and to write an X would be nonsensical. A broken key is an attack of violent insanity.

A human brain is a much more complicated machine. The logical relationships which govern it are numerous. They are imposed on it by the environment in which it is formed. Reasoning is the habit of linking ideas in a particular way. It is useful because it coincides with the way in which the phenomena of our reality develop. But they coincide because our reasoning is drawn from the reality which surrounds us. If our world were different, we would reason differently: if chairs falling over usually caused deafness of the left ear in all cavalry officers, this relationship would be true for us. Thus, most notions are arranged in every brain in a definite pattern. For example, snow-white-cold-winter, fire-red-hot, dance-rhythm-happiness. Everyone is capable of associating blue and sky. While on the other hand there are pieces of knowledge between which it is difficult to establish a relationship, because they have never been associated together, because there are no obvious similarities between them.

OBSERVATION NO. 3. Nervous energy, in the act of applying itself to a cerebral task, finds before itself a combination of elements arranged in a particular order. Some united, close, like and similar, others distant, unconnected, extraneous, dissimilar. The energy acting on these particles of knowledge can only discover affinities and establish relationships between them by mixing and separating them and by forming combinations.

From this springs FUTURIST MEASUREMENT, which is based on the following incontrovertible principles:

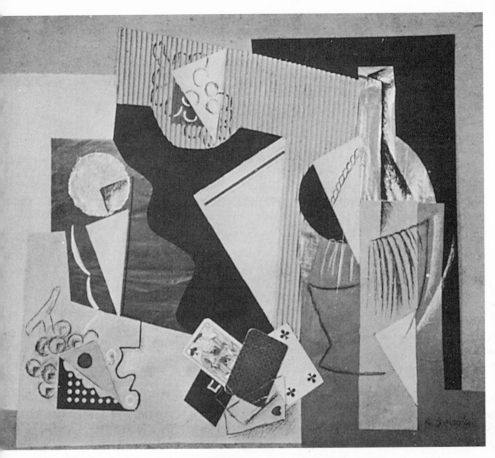

ino Severini *Still-life. with Flask and Playing-cards* 1912

ino Severini
Bear's Dance 1912

49 Gino Severini at the Marlborough Gallery, London, 1913

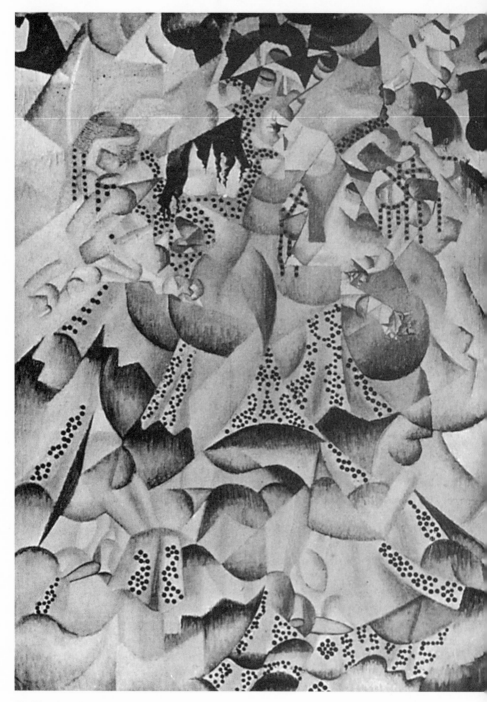

50 Gino Severini *The Dancer in Blue* 1912

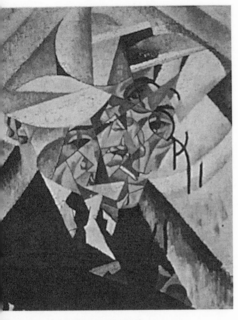

Gino Severini *Self-portrait* 1912

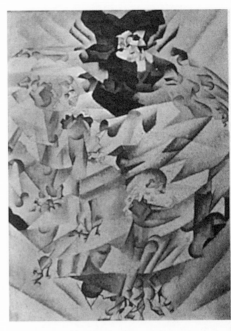

52 Gino Severini *Dancer at Bal Tabarin* 1912

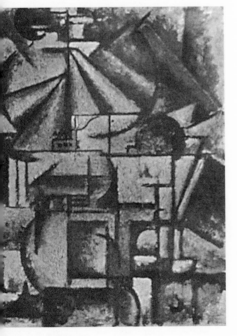

Ardengo Soffici
Composition of the Planes of a Lamp 1912

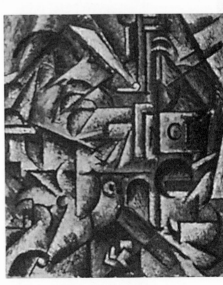

54 Ardengo Soffici
Lines and Volumes of a Street 1912

55 Luigi Russolo *Self-portrait*

56 Luigi Russolo *Self-portrait* 1912

57 Luigi Russolo *Self-portrait* 1912

58 Luigi Russolo *Self-portrait* 1913

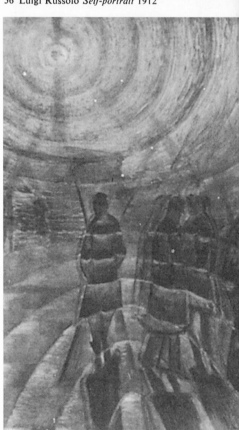

59 Luigi Russolo *Solidity of Fog* 1912

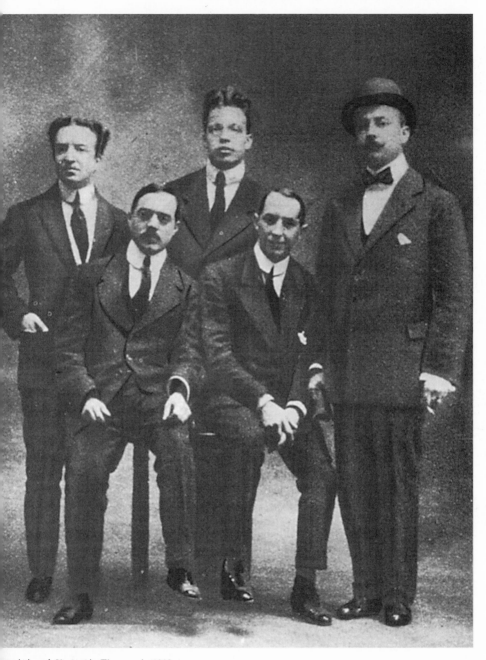

...turists and *Vociani* in Florence in 1912.
 the left:
...zeschi, Carrà, Papini, Boccioni and Marinetti

61 Giacomo Balla
Study for 'Iridescent Interpenetration' 1912

62 Giacomo Balla
Study for 'Iridescent Interpenetration' 1912

63 Giacomo Balla *Iridescent Interpenetration No. 4* 1912–13

Giacomo Balla
Iridescent Interpenetration 1912

Giacomo Balla with his daughters Elica and Luce

Giacomo Balla
Velocity of Lights + Speed 1913

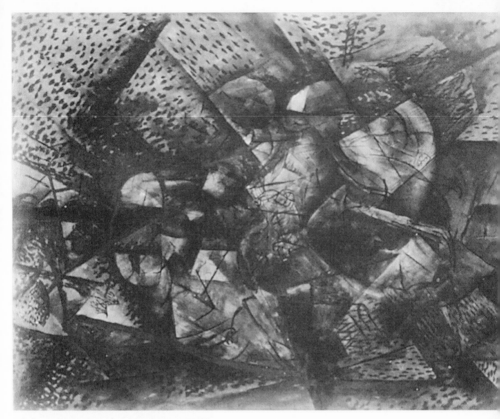

67 Carlo Carrà *Interpenetration of Planes* 1913

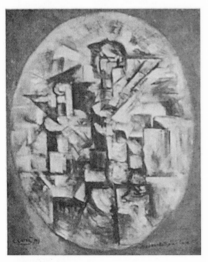

68 Carlo Carrà
Woman + Bottle + House 1913

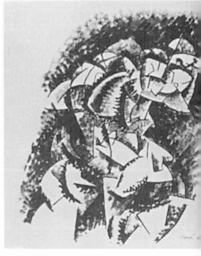

69 Carlo Carrà *Interpenetration of Prisms
– Centres of Force of a Boxer* 1913

1. Beauty has nothing to do with art. DISCUSSING A PAINTING OR A POEM, BY STARTING WITH THE EMOTION THAT IT GIVES ONE, IS LIKE STUDYING ASTRONOMY BY CHOOSING AS ONE'S POINT OF DEPARTURE THE SHAPE OF ONE'S NAVEL. Emotion is an accessory factor in a work of art. Whether it is there or not, varies from individual to individual and from moment to moment – it cannot establish an objective value. 'Beautiful' or 'ugly', 'I like it' or 'I don't like it', this is all subjective, gratuitous, uninteresting and unverifiable.

2. THE SOLE UNIVERSAL CONCEPT: VALUE, DETERMINED BY NATURAL RARITY. For example, it is not true for everyone that the sea is beautiful, but all must recognize that a diamond has great value. Its value is determined by its rarity, which is not a matter of opinion.

3. In the intellectual field THE ESSENTIAL (not casual) RARITY OF A CREATION IS IN DIRECT PROPORTION TO THE QUALITY OR ENERGY NEEDED TO PRODUCE IT.

4. The combination of elements (drawn from experience) more or less dissimilar is the necessary and sufficient raw material for any intellectual creation. The quantity of energy necessary to discover affinities and establish relationships between a given number of elements is greater when the elements to be combined are more distant, more unlike each other, and when the relationships discovered are more complex and more numerous. That is: THE QUANTITY OF CEREBRAL ENERGY NECESSARY TO PRODUCE A WORK IS DIRECTLY PROPORTIONAL TO THE RESISTANCE WHICH SEPARATES THE ELEMENTS BEFORE ITS ACTION IS FELT AND TO THE COHESION WHICH UNITES THEM AFTERWARDS.

5. THE FUTURIST MEASUREMENT OF A WORK OF ART MEANS AN EXACT SCIENTIFIC DETERMINATION EXPRESSED IN FORMULAE OF THE QUALITY OF CEREBRAL ENERGY REPRESENTED BY THE WORK ITSELF, INDEPENDENTLY OF THE GOOD, BAD OR NON-EXISTENT IMPRESSION WHICH PEOPLE MAY HAVE OF THE WORK.

All this brings about a completely Futurist conception of art, that is to say essentially modern, without preconceived ideas and brutal. This resolute surgery will complete the destruction of the traditionalist view of Art with a capital A. Here in the meantime are a few immediate consequences:

1. IMMEDIATE DISAPPEARANCE OF ALL INTELLECTUAL SENTIMENTALITY (corresponding to an amorous sentimentality in the field of sensuality) WHICH FORMS AROUND THE WORD 'INSPIRATION'. Having demonstrated the puerility of the idea that a work of art should move us, it is more than justified to work lucidly, coldly, even with indifference and laugh-

ingly on a particular theme – e.g., given 43 nouns, 12 atmospheric adjectives, 9 verbs in the infinitive, 3 prepositions, 13 articles and 25 mathematical or musical signs, to create a masterpiece in words-in-freedom using only these.

2. Logical abolition of all kinds of illusion about one's own value, of vainglory and modesty, for which there will no longer be any reason, given the possibility of an exact and unchallengeable evaluation. Right to proclaim and affirm one's own superiority and one's genius. The Futurist measurer will be able to issue certificates of imbecility, mediocrity or genius to be appended to personal identity papers.

3. BECAUSE ALL THAT MATTERS IS THE QUANTITY OF ENERGY MANIFESTED, THE ARTIST WILL BE PERMITTED ALL FORMS OF ECCENTRICITY, LUNACY OR ILLOGICALITY.

4. For the same reason, the concept of art will have to be enormously widened in another direction too. There is no reason why every activity must of necessity be confined to one or other of those ridiculous limitations which we call music, literature, painting, etc. And why one should not for example dedicate oneself to creating objects out of pieces of wood, canvas, paper, feathers and nails, which, dropped from a tower 37 metres 3 centimetres in height, would describe, falling to the ground, a line of more or less complexity, more or less difficult to obtain and more or less rare. Therefore EVERY ARTIST WILL BE ABLE TO INVENT A NEW FORM OF ART, which would be the free expression of the particular idiosyncrasies of his cerebral make-up, with its modern madness and complication, and in which would be found mixed in accordance with a new measure and scale, the most diverse means of expression – words, colours, notes, indications of shape, of scent, of facts, noises, movements and of physical sensations; I.E. THE CHAOTIC, UNAESTHETIC AND HEEDLESS MIXING OF ALL THE ARTS ALREADY IN EXISTENCE AND OF ALL THOSE WHICH ARE AND WILL BE CREATED BY THE INEXHAUSTIBLE WILL FOR RENEWAL WHICH FUTURISM WILL BE ABLE TO INFUSE INTO MANKIND.

In addition Futurist measurement will clear away from our civilization, which will be full of the new 'geometric and mechanical splendour', the stinking dungheap of long hair, romantic neckties, asceti-cultural pride and of idiotic poverty which delighted former generations. The work of the Futurist measurer will have as its immediate effect the definitive placing of the artist in society. The artist of genius has been and is still today a social outcast. Now genius has a social, economic and financial value. Intelligence is a commodity in vigorous demand in all the markets in the world. Its value is determined, as with every other

product, by its essential rarity. A given quantity of a commodity known to be saleable acquires, in a certain market, a fixed value; however, it rarely happens that one manages to establish a fixed value for a certain quantity of artistic energy, determined by an objective state of affairs which can be verified by anyone. A piece of gold, or a precious stone, has in the world at a given moment a well-defined rarity value on the basis of which the buyer's price is determined. THE FUTURIST MEASURER WILL HAVE THEREFORE TO ANALYSE THE WORK OF ART INTO THE INDIVIDUAL DISCOVERIES OF RELATIONSHIPS OF WHICH IT CONSISTS, DETERMINE BY MEANS OF CALCULATIONS THE RARITY OF EACH DISCOVERY, THAT IS THE QUANTITY OF ENERGY NECESSARY TO PRODUCE THEM, FIX ON THE BASIS OF THIS RARITY A FIXED PRICE FOR EACH ONE OF THEM, ADD UP THE INDIVIDUAL VALUES, AND GIVE THE OVERALL PRICE OF THE WORK. Naturally the price must always be justified by a formula of measurement which would indicate the quantity of artistic energy represented by the work and the higher or lower quotation for artistic energy on the market at that moment.

Thus, having destroyed the snobbish passéism of art-as-ideal, of art-as-sublime-holy-inaccessible, of art-as-torment-purity-vow-solitude-disdain for reality – the anaemic melancholy of the spineless who cut themselves off from real life because they are unable to face it – the artist will finally find his place in life, along with the butcher and the tyre-manufacturer, the grave-digger and the speculator, the engineer and the farmer. This is the basis of a new universal financial organization through which a whole series of activities, formidable in their development, completeness and importance, which have remained up to the present time in the grip of barbarism, will be fitted into modern civilization. We Futurists affirm that a whiff of steam from a locomotive and the febrile, crowded pulsation of modern life, passed across the bloodless body of art, will have as their immediate effect the production and selection of works a thousand times better than we now have. It is in addition a violent purgative and remedial cure which art needs to eliminate the last elements of traditionalist infection circulating about its body.

While on one side Futurist measurement will give the artist unchallengeable rights, on the other it must impose on him precise duties and responsibilities. For example, a painter who has attributed to his painting formulae of value indicating, let us suppose, that it contains 10 discoveries of the first quality (30 lire each), 20 of the second (18 lire each), 8 of the third (10 lire each) and fixes the price at 740 lire, if by chance it happens that this is checked and that some of the discoveries

147

have a lower value than indicated or indeed have no value, he must be put on trial for fraud and fined or sent to prison. WE THEREFORE ASK THE STATE TO CREATE A BODY OF LAW FOR THE PURPOSE OF GUARDING AND REGULATING THE SALE OF GENIUS. One is astonished to see that in the field of intellectual activity fraud is still perfectly legal. It is really a relic of barbarism which survives anachronistically in the midst of modern progress. In this field Futurist fists are logical and necessary – they fill the functions which in a civilized society are carried out by the law. Being absolutely certain that the laws for which we are calling will be given to us in the very near future, we demand at once that D'AN-NUNZIO, PUCCINI AND LEONCAVALLO BE THE FIRST TO BE TRIED ON THE ACCUSATION OF PERSISTENT FRAUD CONTRARY TO THE PUBLIC GOOD. These gentlemen in fact sell for thousands of lire works whose value varies from a minimum of thirty-five centimes to a maximum of forty francs.

Until these laws are enacted, we should regard ourselves as inhabitants of a barbarous country. And so be it. But where barbarism rules, the fist and the bullet are arguments which count. Let us therefore conduct the discussion in this way.

As can be seen, the Futurist evaluator will exercise an effect totally different from that exercised today by the traditionalist critic. He will be a true professional, doctor and psychologist, fulfilling an office made valid and practical by the law. The same for the artist. TOMORROW WE SHOULD FIX ON TO OUR FRONT DOORS PLATES READING – MENSURATOR, FANTASTICATOR, PHILOSOPHER, SPECIALIST IN ASTRONOMICAL POETRY, GENIUS, MADMAN. Yes, Madman, because it is time for madness (the upsetting of logical relationships) to be made into a conscious and evolved art. An individual who is able to construct in his own mind a complicated lunacy assumes a value. A GOOD MADMAN MAY BE WORTH THOUSANDS OF FRANCS. Another activity which will be purged and regulated by Futurist evaluation is prostitution. For here too there are often forced victims of deplorable frauds.

And now affirming: (1) that INTUITION IS NO MORE THAN RAPID AND FRAGMENTARY REASONING, that between reasoning and intuition there is no essential difference and that therefore any product of the latter may be controlled by the former; (2) that reasoning and intuition are cerebral functions explicable and traceable down to their smallest details, using a Futurist analysis of the contents of knowledge down to its mediumistic depths; (3) that Futurist measurement will be made in accordance with logic (together with the relationships which govern material reality, reflected in the human brain), with the physical laws

of energy and with the circumstances, independent of all subjective considerations (we have valued at 12,000 lire a picture by the painter Boccioni which makes us feel indescribably sick; and we are forced to admit the enormous value of an onomatopoeia by the poet Marinetti, which is hideously ugly, anti-aesthetic and repulsive); we formulate the following absolute

FUTURIST CONCLUSIONS:

1. ART IS A CEREBRAL SECRETION CAPABLE OF EXACT CALIBRATION.
2. THOUGHT MUST BE WEIGHED AND SOLD LIKE ANY OTHER COMMODITY.
3. THE WORK OF ART IS NOTHING BUT AN ACCUMULATOR OF CEREBRAL ENERGY; CREATING A SYMPHONY OR POEM MEANS TAKING A CERTAIN NUMBER OF SOUNDS OR WORDS, SMEARING THEM WITH INTELLECT AND STICKING THEM TOGETHER.
4. THE KIND OF WORK HAS IN ITSELF NO VALUE; IT MAY ACQUIRE A VALUE THROUGH THE CONDITIONS IN WHICH IT IS PRODUCED – POLEMIC VALUE, VALUE OF ABSTRACTION, ETC.
5. THE PRODUCER OF ARTISTIC CREATIVITY MUST JOIN THE COMMERCIAL ORGANIZATION WHICH IS THE MUSCLE OF MODERN LIFE. MONEY IS ONE OF THE MOST FORMIDABLY AND BRUTALLY SOLID POINTS OF THE REALITY IN WHICH WE LIVE. IT IS ENOUGH TO TURN TO IT TO ELIMINATE ALL POSSI-BILITY OF ERROR AND UNPUNISHED INJUSTICE. IN ADDITION A GOOD IN-JECTION OF FINANCIAL SERUM WILL INTRODUCE DIRECTLY INTO THE BLOODSTREAM OF THE INTELLECTUAL CREATOR AN EXACT AWARENESS OF HIS RIGHTS AND RESPONSIBILITIES.
6. IN ADDITION TO THE WORDS 'CRITICISM' AND 'CRITIC' THE FOLLOWING TERMS MUST BE ABOLISHED: SOUL, SPIRIT, ARTIST AND ANY OTHER WORD WHICH LIKE THESE IS IRREMEDIABLY INFECTED WITH TRADITIONALIST SNOBBERY; THESE MUST BE REPLACED BY EXACT DENOMINATIONS LIKE: BRAIN, DISCOVERY, ENERGY, CEREBRATOR, FANTASTICATOR, ETC.
7. ALL PAST ART MUST BE RESOLUTELY THROWN OVERBOARD, ART WHICH DOES NOT INTEREST US AND WHICH BESIDES WE ARE UNABLE TO MEASURE GIVEN OUR ABSOLUTE AND NECESSARY IGNORANCE OF ALL THE DETAILS AND CIRCUMSTANCES WHICH CONSTITUTE THE FRAMEWORK OF LIFE IN WHICH IT WAS CREATED.
8. THE STUPENDOUS IMPORTANCE OF OUR AFFIRMATIONS REGARDING THE WILL OF GENIUS AND OF FUTURIST RENEWAL MUST BE EXALTED.

We are extremely pleased to see that Futurism, born in Milan, the industrial and commercial capital of Italy, and launched five years ago

for the whole world by the poet Marinetti in the columns of *Le Figaro*, having triumphed in the field of art with WORDS-IN-FREEDOM, PLASTIC DYNAMISM, ANTIGRACEFUL, POLYTONAL MUSIC WITHOUT QUADRATURE and the ART OF NOISES, is about to burst into the laboratories and schools of passéist science, the museums and cemeteries of mummified syllogisms and torture-chambers of free creative madness.

Milan, 11 March 1914
Translation JCH

Umberto Boccioni
Absolute Motion + Relative Motion = Dynamism
1914

Absolute motion is a dynamic law inherent in an object. The plastic construction of the object must here concern itself with the motion which an object has within itself, whether it be at rest or in movement. I have made this distinction between rest and movement so that I may make myself clear, although, in fact, there is no such thing as rest, only motion (rest being merely relative, a matter of appearance). This plastic construction obeys a law of motion which characterizes the body in question. It is the plastic power which the object contains within itself, closely bound up with its own organic substance, determined by its particular characteristics: colour, temperature, consistency, form (flat, concave, convex, cubic, conic, spiral, elliptical, spherical, etc.).

The plastic power with which an object is endowed is its force, that is, its primordial psychology. This power, this primordial psychology, enables us to create in our paintings new subjects which do not aim at narrative or episodic representation; instead it coordinates different plastic values of reality, a coordination which is purely architectural, freed of all literary and sentimental influences.

In this initial state of motion, which I envisage as a thing apart – although in fact it is not – the object is not seen with its relative motion but is conceived according to its living outlines, which reveal how its motion would be broken up according to the tendencies of its forces. In this way we obtain a decomposition of the object, which is a method

far removed from the intellectual schemas of the Cubists. Instead it presents the *appearance* of an object, interpreting it through a sensation which is infinitely refined and superior to those of past times.

This is how we consider the motion of an object, what one might call its breathing or heartbeat. A hesitant, unconscious hint of this breathing can be discerned in Italian art from its beginnings. This is what plastic art is all about

When, rather tardily, some of the Cubists began to concern themselves with these matters, they revealed what I have called their Gothicism, and, at the same time, again made obeisance to the plastic primacy of the Italians.

Therefore, it is clear that two objects, of different shapes, can influence each other and be characterized by the power of their respective absolute motions. The weaker, whether it has a static or a dynamic temperament, will always feel the effects of the power of the stronger, which can again be either static or dynamic.

For example, if you place next to each other a sphere and a cone, you will find in the former a sensation of dynamic thrust and in the latter one of static indifference. The sphere shows a tendency to move while the cone tends to take root.

The atmospheric zone around the edges of the cone, as opposed to the one around the sphere, will be an *empty zone* and will give the cone a brilliant outline.

The other zone, which is affected by the motion of the sphere, will have a denser atmosphere and cause the edges of the cone to acquire a shading of attraction, a melting of its outline towards the expanding curves and ellipses of the sphere.

Moreover, while the sphere creates horizontal dilations and suggests an expansive potential, the cone creates descending thrusts and angular limitations at the apex.

If we look at the sloping planes of a pyramid, they appear to attract a cylinder which is standing beside it in a vertical position. And while the cylinder reveals spiral dilations within itself, the pyramid has a tendency to take root along the lines of the angle of the sloping planes. In a pyramid the convergence of these planes overwhelms the spherical soaring dynamism of the cylinder. The cylinder has an action upon itself, while the other has an action of attraction or contact.

In the case of a cube observed alongside a sphere, the horizontal and perpendicular stasis of the cube does battle with the ideal global rotation (force-lines) of the sphere, since a cube and a sphere are equal as far as their potential is concerned.

Here I limit myself to observing these simple bodies, which are geometrically definable and have a primordial plastic structure. The reader should imagine this method of study applied to life, to the infinite combinations of light and forms in the animal, mineral and vegetable, as well as mechanical, worlds, and then he will begin to grasp the thrills, the visions of plastic poetry which have remained undiscovered till today, and which are the prerogative of Futurist painters and future generations.

Relative motion is a dynamic law which depends on the object's movement.

It is quite incidental whether we are talking about moving objects or the relationship between moving objects and non-moving objects. In fact, there is no such thing as a non-moving object in our modern perception of life.

What I have said is based on the following truth: *a horse in movement is not a motionless horse which is moving, but a horse in movement, which makes it another sort of thing altogether, and it should be conceived and expressed as something simply varied.*

It is a matter of conceiving the object in movement quite apart from the motion which it contains within itself. That is to say, we must try to find a form which will be able to express a new absolute – *speed*, which any true modern spirit cannot ignore. It is a matter of studying the different aspects assumed by the life of speed and its consequent simultaneousness.

Until today men have observed changes produced by the wind in the trees, the countryside, drapes, etc. They have not, so far, looked at the way that trains, cars, bicycles and aeroplanes have upset the contemplative concept of the landscape. We might say that, in as far as it has become normal to view objects from the vantage-point of speed, to restrict oneself to a perspectival and anatomical observation of a landscape, or any other natural element, is totally against nature.

In order to depict a wheel in motion, it no longer occurs to anyone to observe it at rest, counting the number of spokes and measuring its curves, and then draw it in movement. This would be impossible. Nevertheless, the very same procedure, while obviously absurd for a wheel, is still used for the human body which lives through the movements of its arms and legs and the whole of its being.

This state of affairs has come to pass because, according to ancient tradition, plants and objects interest us much less, psychologically, than animals and men.

That is why it is so much easier to apply to natural forms innovations suggested by the necessities of life, which change our sensibilities.

Everyone is prepared to try out a new kind of structure or technique in a landscape painting, but hardly experiment at all when they draw a horse, much less when they draw a man, and even less with the figure of a woman, since here nobility, the sublime and the poetic have all been given precedence over plastic values.

Today modernity is using – in advertisements, newspapers, sketches and caricatures – a new kind of basic dynamic norm which corresponds much more to the truth.

Yet even in these humble and barbarous forms less courage has been shown in the treatment of living beings than in that of so-called inanimate objects – cars, moving trains and trams, etc. You may more easily find the dynamic approach in a comic paper, in the form of a thief escaping with a hen, than in the painting of a battle scene by an artist who is considered a credit to the nation.

The reason for this is that in all the museums of the world we do not have a single painting or drawing by an old master which shows a man running or a man in flight as he should look.

Our great national painters and those of other countries, if they don't feel in accord with the past, come out in a cold sweat. At first in the early days of Impressionism violet was accepted for fields, skies and trees; but heaven help us if it appeared on the face, arms or breasts of a beautiful woman. It was the same with the Pointillists: a face covered with dots or stripes would enrage the public who, conversely, were quite happy to see a sky treated in this way, even a horse, possibly a peasant.

But in the portrait of a gentleman or a lady, what an idea!

The concept of motion in the study and representation of life has always remained outside art proper, outside this odious temple which we would willingly set alight if only it were tangible.

It is true that the wheels of a carriage, the propeller of an aeroplane, have much swifter movements than those of the legs of a human being or a horse. Nevertheless it is still a question of a simple variation of form and rhythm. It is a matter of gradations of movement, and above all a matter of tempo.

When, one day, a critic – much quoted and esteemed – writes in one of the principal daily papers, for the sake of his own self-preservation, and does us the honour of calling us geniuses, by saying that one of our masterpieces approaches a Michelangelo or a Rembrandt, etc., then Dynamism will have made its mark, will progress, and be applied. But

if he really thinks that by doing this he will make money and sleep comfortably, lots of painters will see through him.

Advance extract from *Pittura scultura futuriste*, Milan 1914
Published in *Lacerba* (Florence), 15 March 1914
Translation R B

F. T. Marinetti
Geometric and Mechanical Splendour and the Numerical Sensibility 1914

We are hastening the grotesque funeral of passéist Beauty (romantic, symbolist, and decadent) whose essential elements were memory, nostalgia, the fog of legend produced by remoteness in time, the exotic fascination produced by remotenesses in space, the picturesque, the imprecise, rusticity, wild solitude, multicoloured disorder, twilight shadows, corrosion, weariness, the soiled traces of the years, the crumbling of ruins, mould, the taste of decay, pessimism, phthisis, suicide, the blandishments of pain, the aesthetics of failure, the adoration of death.

A new beauty is born today from the chaos of the new contradictory sensibilities that we Futurists will substitute for the former beauty, and that I call Geometric and Mechanical Splendour.

Its essential elements are: hygienic forgetfulness, hope, desire, controlled force, speed, light, willpower, order, discipline, method; a feeling for the great city; the aggressive optimism that results from the cult of muscles and sport; the imagination without strings, ubiquity, laconism and the simultaneity that derives from tourism, business, and journalism; the passion for success, the keenest instinct for setting records, the enthusiastic imitation of electricity and the machine; essential concision and synthesis; the happy precision of gears and well-oiled thoughts; the concurrence of energies as they converge into a single victorious trajectory.

My Futurist senses perceived this splendour for the first time on the bridge of a dreadnought. The ship's speed, its trajectories of fire

154

determined from the height of the quarterdeck in the cool ventilation of warlike probabilities, the strange vitality of orders sent down from the admiral and suddenly become autonomous, human no longer, in the whims, impatiences, and illnesses of steel and copper. All of this radiated geometric and mechanical splendour. I listened to the lyric initiative of electricity flowing through the sheaths of the quadruple turrets, descending through sheathed pipes to the magazine, drawing the howitzers [sic] out to the breeches, out to the projecting chases of the guns. Up sights, aim, lift, fire, automatic recoil, the projectile's very personal path, hit, smash, smell of rotten eggs, mephitic gases, rust, ammonia, and so on. This new drama full of Futurist surprise and geometric splendour is a thousand times more interesting to us than human psychology with its very limited combinations.

Sometimes the great human collectivities, tides of faces and howling arms, can make us feel a slight emotion. To them we prefer the great solidarity of preoccupied motors, arrayed and eager. Nothing is more beautiful than a great humming central electric station that holds the hydraulic pressure of a mountain chain and the electric power of a vast horizon, synthesized in marble distribution panels bristling with dials, keyboards, and shining commutators. These panels are our only models for the writing of poetry. For precursors we have gymnasts and high-wire artists who, in their evolutions, their rests, and the cadences of their musculature, realize the sparkling perfection of precise gears, and the geometric splendour that we want to achieve in poetry with words-in-freedom.

1. We systematically destroy the literary 'I' in order to scatter it into the universal vibration and reach the point of expressing the infinitely small and the vibrations of molecules. E.g. lightning movements of molecules in the hole made by a howitzer [sic] (last part of 'Fort Cheittam-Tépé' in my *Zang tumb tumb*). Thus the poetry of cosmic forces supplants the poetry of the human.

The traditional narrative proportions (romantic, sentimental, and Christian) are abolished, according to which a battle wound would have a greatly exaggerated importance in respect to the instruments of destruction, the strategic positions, and atmospheric conditions. In my poem *Zang tumb tumb* I describe the shooting of a Bulgarian traitor with a few words-in-freedom, but I prolong a discussion between two Turkish generals about the line of fire and the enemy cannon. In fact I observed in the battery of Suni, at Sidi-Messri, in October 1911, how the shining, aggressive flight of a cannonball, red hot in the sun and

speeded by fire, makes the sight of flayed and dying human flesh almost negligible.

2. Many times I have demonstrated how the noun, enfeebled by multiple contacts or the weight of Parnassian and decadent adjectives, regains its absolute value and its expressive force when it is denuded and set apart. Among naked nouns I distinguish *the elementary noun* and *the motion-synthesis noun* (or node of nouns). This distinction is not absolute and it comes from almost ungraspable intuitions. According to an elastic and comprehensive analogy, I see every noun as a vehicle or belt set in motion by the verb in the infinitive.

3. Except for needed contrast or a change of rhythm, the different moods and tenses of the verb should be abolished, because they make the verb into a stagecoach's loose wheel adapting itself to rough country roads, but unable to turn swiftly on a smooth road. *The infinitive verb,* on the other hand, *is the very movement of the new lyricism,* having the fluency of a train's wheel or an aeroplane's propeller.

The different moods and tenses of the verb express a prudent and reassuring pessimism, a clenched, episodic, accidental egotism, a high and low of force and tiredness, of desire and delusion, of pauses, in other words, in the trajectory of hope and will. The infinitive verb expresses optimism itself, the absolute generosity of the folly of Becoming. When I say *to run,* what is that verb's subject? Everyone and everything: that is, the universal irradiation of life that runs and of which we are a conscious particle. E.g. the finale of *Tavern Parlour* by the free-wordist Folgore. The infinitive is the passion of the *I* that abandons itself to the becoming of *all,* the heroic disinterested continuity of the joy and effort of acting. Infinitive verb = the divinity of action.

4. By means of one or more adjectives isolated between parentheses or set next to words-in-freedom behind a perpendicular line (in clefs) one can give the different atmospheres of the story and the tones that govern it. *These atmosphere-adjectives or tone-adjectives cannot be replaced by nouns.* They are intuitive convictions difficult to explain. I nevertheless believe that by isolating, for example, the noun *ferocity* (or putting it in brackets, describing a slaughter), one will create a mental state of ferocity, firmly enclosed within a clean profile. Whereas, if I put between parentheses or brackets the adjective *ferocious,* I make it into an atmosphere-adjective or tone-adjective that will envelop the whole description of the slaughter without arresting the current of the words-in-freedom.

5. Despite the most skilful deformations, the syntactic sentence always

contains a scientific and photographic perspective absolutely contrary to the rights of emotion. *With words-in-freedom this photographic perspective is destroyed* and one arrives naturally at the multiform emotional perspective. (E.g. *Man + mountain + valley* of the free-wordist Boccioni.)

6. Sometimes we make *synoptic tables of lyric values* with our words-in-freedom, which allow us as we read to follow many currents of intertwined or parallel sensations at the same time. These synoptic tables should not be a goal but a means of increasing the expressive forces of the lyricism. One must therefore avoid any pictorial preoccupation, taking no satisfaction in a play of lines or in curious typographic disproportions.

Everything in words-in-freedom that does not contribute towards the expression of the fugitive, mysterious Futurist sensibility with the newest geometric-mechanical splendour must be resolutely banned. The free-wordist Cangiullo, in *2nd-class Smoker*, had the happy thought of rendering with this *designed analogy*:

ᴛᴏ SMOKE

the long and monotonous reveries and self-expansion of the boredom-smoke of a long train trip.

The words-in-freedom, in this continuous effort to express with the greatest force and profundity, naturally transform themselves into *self-illustrations*, by means of free, expressive orthography and typography, the synoptic tables of lyric values and designed analogies. (E.g. the military balloon I designed typographically in my *Zang tumb tumb*.) As soon as this greater expression is reached, the words-in-freedom return to their normal flow. The synoptic tables of values are in addition the basis of criticism in words-in-freedom. (E.g. *Balance 1910–1914* by the free-wordist Carrà.)

7. *Free expressive orthography and typography also serve to express the facial mimicry and the gesticulation of the narrator.*

Thus the words-in-freedom manage to make use of (rendering it completely) that part of communicative exuberance and epidermic geniality that is one of the characteristics of the southern races. This energy of accent, voice, and mimicry that has shown up hitherto only in moving tenors and brilliant talkers finds its natural expression in the disproportions of typographic characters that reproduce the facial grimaces and the chiseling, sculptural force of gestures. In this way words-in-freedom become the lyric and transfigured prolongation of our animal magnetism.

8. Our growing love for matter, the will to penetrate it and know its vibrations, the physical sympathy that links us to motors push us to the *use of onomatopoeia.*

Since noise is the result of rubbing or striking rapidly moving solids, liquids, or gases, onomatopoeia, which reproduces noise, is necessarily one of the most dynamic elements of poetry. As such, onomatopoeia can replace the infinitive verb, especially if it is set against one or more other onomatopoeias. (E.g.: the onomatopoeia *tatatata* of the machine guns, set against the *Hoooraaaah* of the Turks at the end of the chapter 'Bridge' in my *Zang tumb tumb.*)

The brevity of the onomatopoeias in this case permits the most skilful combination of different rhythms. These would lose a part of their velocity if expressed more abstractly, with greater development, that is, without the help of the onomatopoeias. There are different kinds of onomatopoeias:

(a) *Direct, imitative, elementary, realistic onomatopoeia*, which serves to enrich lyricism with brute reality, which keeps it from becoming too abstract or *artistic.* (E.g. Ratta-tat-tata gunfire.) In my 'Contraband of War' in *Zang tumb tumb*, the strident onomatopoeia *ssiiiiii* gives the whistle of a towboat on the Meuse River and is followed by the veiled onomatopoeia *ffiiiii ffiiiiii*, echo from the opposite bank. The two onomatopoeias saved me from needing to describe the width of the river, which is defined by the contrast between the two consonants *s* and *f.*

(b) *Indirect, complex, and analogical onomatopoeia.* E.g. in my poem *Dunes* the onomatopoeia *dum-dum-dum-dum* expresses the circling sound of the African sun and the orange weight of the sun, creating a rapport between sensations of weight, heat, colour, smell, and noise. Another example: the onomatopoeia *stridionla stridionla stridionlaire* that repeats itself in the first canto of my epic poem *The Conquest of the Stars* forms an analogy between the clashing of great swords and the furious action of the waves, just before a great battle of stormy waters.

(c) *Abstract onomatopoeia*, noisy, unconscious expression of the most complex and mysterious motions of our sensibility. (E.g. in my poem *Dunes*, the abstract onomatopoeia *ran ran ran* corresponds to no natural or mechanical sound, but expresses a state of mind.)

(d) *Psychic onomatopoetic harmony*, that is the fusion of 2 or 3 abstract onomatopoeias.

9. My love of precision and essential brevity has naturally given me a taste for numbers, which live and breathe on the paper like living

beings in our new *numerical sensibility*. E.g. instead of saying, like the ordinary traditional writer, 'A vast and deep boom of bells' (an imprecise, hence inefficient denotation), or else, like an intelligent peasant, 'this bell can be heard from such or such a village' (a more precise and efficient denotation), I grasp the force of the reverberation with intuitive precision and determine its extent, saying: 'Bell boom breadth 20 square kilometres.' In this way I give the whole vibrating horizon and a number of distant beings stretching their ears to the same bell sound. I escape imprecision and dullness, and I take hold of reality with an act of will that subjects and deforms the very vibration of the metal in an original manner.

The mathematical signs $+ - \times =$ serve to achieve marvellous syntheses and share, with their abstract simplicity of anonymous gears, in expressing the geometric and mechanical splendours. For example, it would have needed at least an entire page of description to render this vast and complex battle horizon, when I found this definitive lyric equation: 'horizon $=$ sharp bore of the sun $+$ 5 triangular shadows (1 kilometre wide) $+$ 3 lozenges of rosy light $+$ 5 fragments of hills $+$ 30 columns of smoke $+$ 23 flames.'

I make use of x to indicate interrogative pauses in my thought. I thereby eliminate the question mark, which too arbitrarily localizes its atmosphere of doubt on a single point of awareness. With the mathematical x, the doubting suspension suddenly spreads itself over the entire agglomeration of words-in-freedom.

Always intuitively, I introduce members that have no direct significance or value between the words-in-freedom, but that (addressing themselves phonically and optically to the numerical sensibility) express the various transcendental intensities of matter and the indestructible correspondences of sensibility.

I create true theorems or lyric equations, introducing numbers chosen intuitively and placed in the very middle of a word, with a certain quantity of $+ - \times =$. I give the thicknesses, the relief, the volume of the thing the words should express. The placement $+ - + - + + \times$ serves to render, for example, the changes and acceleration of an automobile's speed. The placement $+ + + + +$ serves to render the clustering of equal sensations. (E.g. *faecal odour of dysentery* $+$ *the honeyed stench of plague sweats* $+$ *smell of ammonia*, etc., in 'Train Full of Sick Soldiers' in my *Zang tumb tumb*.)

Thus for the '*ciel antérieur où fleurit la beauté*' of Mallarmé we substitute geometric and mechanical splendour and the numerical sensibility of words-in-freedom.

Published in two parts in *Lacerba* (Florence), 15 March 1914
and 1 April 1914, with two different titles,
and as a leaflet
by Direzione del Movimento Futurista, 18 March
1914
Translation R W F

Antonio Sant'Elia
Manifesto of Futurist Architecture 1914

No architecture has existed since 1700. A moronic mixture of the most
various stylistic elements used to mask the skeletons of modern houses
is called modern architecture. The new beauty of cement and iron are
profaned by the superimposition of motley decorative incrustations
that cannot be justified either by constructive necessity or by our
(modern) taste, and whose origins are in Egyptian, Indian or Byzantine
antiquity and in that idiotic flowering of stupidity and impotence that
took the name of NEOCLASSICISM.

These architectonic prostitutions are welcomed in Italy, and rapa-
cious alien ineptitude is passed off as talented invention and as extremely
up-to-date architecture. Young Italian architects (those who borrow
originality from clandestine and compulsive devouring of art journals)
flaunt their talents in the new quarters of our towns, where a hilarious
salad of little ogival columns, seventeenth-century foliation, Gothic
pointed arches, Egyptian pilasters, rococo scrolls, fifteenth-century
cherubs, swollen caryatids, take the place of style in all seriousness, and
presumptuously put on monumental airs. The kaleidoscopic appearance
and reappearance of forms, the multiplying of machinery, the daily
increasing needs imposed by the speed of communications, by the
concentration of population, by hygiene, and by a hundred other
phenomena of modern life, never cause these self-styled renovators of
architecture a moment's perplexity or hesitation. They persevere
obstinately with the rules of Vitruvius, Vignola and Sansovino plus
gleanings from any published scrap of information on German architec-
ture that happens to be at hand. Using these, they continue to stamp
the image of imbecility on our cities, our cities which should be the
immediate and faithful projection of ourselves.

And so this expressive and synthetic art has become in their hands a

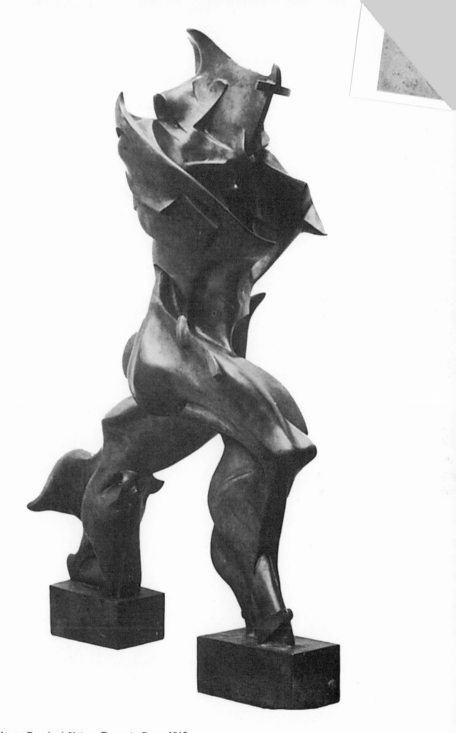

70 Umberto Boccioni *Unique Forms in Space* 1913

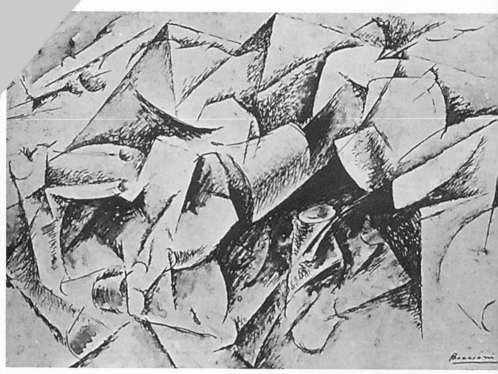

71 Umberto Boccioni
Study No. 1 for 'Horse + Houses' 1913–14

72 Umberto Boccioni
Dynamism of a Cyclist 1913

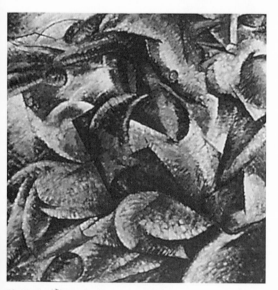

73 Umberto Boccioni
Dynamism of a Human Body 1913

74 Umberto Boccioni *Dynamism* 1913

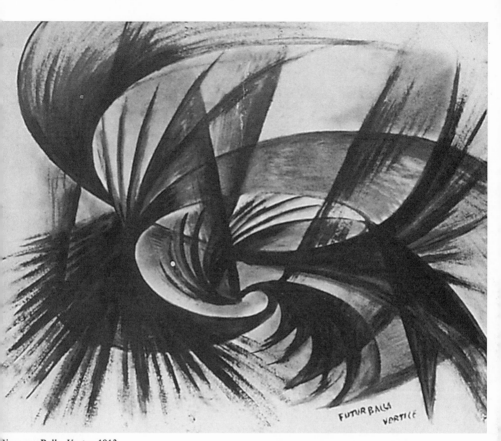

Giacomo Balla *Vortex* 1913

Giacomo Balla *Atmospheric Densities* 1913

77 Mario Sironi *Self-portrait* 1913

78 Enrico Prampolini *Futurist Portrait* 1913

79 Enrico Prampolini *Spatial Rhythms* 1913

80 Anton Giulio Bragaglia

rdengo Soffici
osition with Ashtray 1913

82 Ardengo Soffici
Lines and Vibrations of a Person 1913

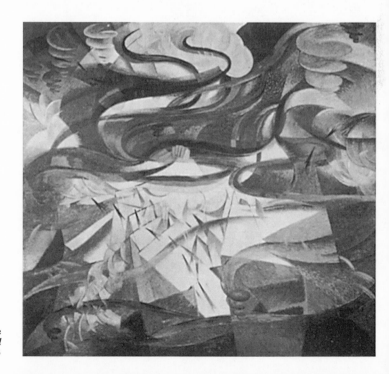

83 Leonardo Dudreville
veryday Domestic Quarrel
1913

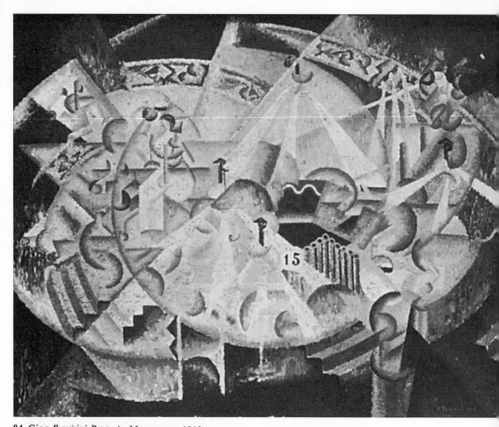

84 Gino Severini *Party in Montmartre* 1913

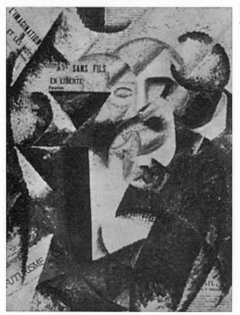

85 Gino Severini
Portrait of Marinetti 1913

86 Gino Severini
From Nothing to the Real 1913

Ugo Giannattasio *The Turnstile* 1913

88 Depero, Balla and Jannelli

Umberto Boccioni *Muscles in Speed* 1913

90 Boccioni and Sironi in Paris

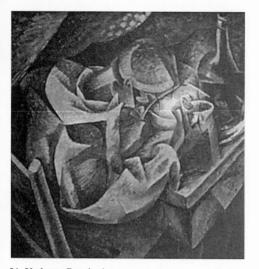

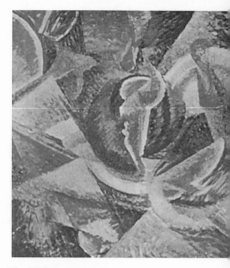

91 Umberto Boccioni
Drinker 1914

92 Umberto Boccioni
Still-life with Watermelon 1914

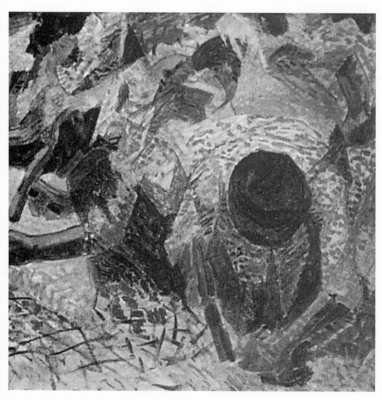

93 Umberto Boccioni *Pavers* 1914

vacuous stylistic exercise, a jumble of ill-mixed formulae to disguise a run-of-the-mill traditionalist box of bricks and stone as a modern building. As if we who are accumulators and generators of movement, with all our added mechanical limbs, with all the noise and speed of our life, could live in streets built for the needs of men four, five or six centuries ago.

This is the supreme imbecility of modern architecture, perpetuated by the venal complicity of the academies, the internment camps of the intelligentsia, where the young are forced into the onanistic recopying of classical models instead of throwing their minds open in the search for new frontiers and in the solution of the new and pressing problem: THE FUTURIST HOUSE AND CITY. The house and the city that are ours both spiritually and materially, in which our tumult can rage without seeming a grotesque anachronism.

The problem posed in *Futurist* architecture is not one of linear rearrangement. It is not a question of finding new mouldings and frames for windows and doors, of replacing columns, pilasters and corbels with caryatids, flies and frogs. Neither has it anything to do with leaving a façade in bare brick, or plastering it, or facing it with stone or in determining formal differences between the new building and the old one. It is a question of tending the healthy growth of the Futurist house, of constructing it with all the resources of technology and science, satisfying magisterially all the demands of our habits and our spirit, trampling down all that is grotesque and antithetical (tradition, style, aesthetics, proportion), determining new forms, new lines, a new harmony of profiles and volumes, an architecture whose reason for existence can be found solely in the unique conditions of modern life, and in its correspondence with the aesthetic values of our sensibilities. This architecture cannot be subjected to any law of historical continuity. It must be new, just as our state of mind is new.

The art of construction has been able to evolve with time, and to pass from one style to another, while maintaining unaltered the general characteristics of architecture, because in the course of history changes of fashion are frequent and are determined by the alternations of religious conviction and political disposition. But profound changes in the state of the environment are extremely rare, changes that unhinge and renew, such as the discovery of natural laws, the perfecting of mechanical means, the rational and scientific use of material. In modern life the process of stylistic development in architecture has been brought to a halt. ARCHITECTURE NOW MAKES A BREAK WITH TRADITION. IT MUST PERFORCE MAKE A FRESH START.

Calculations based on the resistance of materials, on the use of reinforced concrete and steel, exclude 'architecture' in the classical and traditional sense. Modern constructional materials and scientific concepts are absolutely incompatible with the disciplines of historical styles, and are the principal cause of the grotesque appearance of 'fashionable' buildings in which attempts are made to employ the lightness, the superb grace of the steel beam, the delicacy of reinforced concrete, in order to obtain the heavy curve of the arch and the bulkiness of marble.

The utter antithesis between the modern world and the old is determined by all those things that formerly did not exist. Our lives have been enriched by elements the possibility of whose existence the ancients did not even suspect. Men have identified material contingencies, and revealed spiritual attitudes, whose repercussions are felt in a thousand ways. Principal among these is the formation of a new ideal of beauty that is still obscure and embryonic, but whose fascination is already felt even by the masses. We have lost our predilection for the monumental, the heavy, the static, and we have enriched our sensibility with a *taste for the light, the practical, the ephemeral and the swift*. We no longer feel ourselves to be the men of the cathedrals, the palaces and the podiums. We are the men of the great hotels, the railway stations, the immense streets, colossal ports, covered markets, luminous arcades, straight roads and beneficial demolitions.

We must invent and rebuild the Futurist city like an immense and tumultuous shipyard, agile, mobile and dynamic in every detail; and the Futurist house must be like a gigantic machine. The lifts must no longer be hidden away like tapeworms in the niches of stairwells; the stairwells themselves, rendered useless, must be abolished, and the lifts must scale the lengths of the façades like serpents of steel and glass. The house of concrete, glass and steel, stripped of paintings and sculpture, rich only in the innate beauty of its lines and relief, extraordinarily 'ugly' in its mechanical simplicity, higher and wider according to need rather than the specifications of municipal laws. It must soar up on the brink of a tumultuous abyss: the street will no longer lie like a doormat at ground level, but will plunge many storeys down into the earth, embracing the metropolitan traffic, and will be linked up for necessary interconnections by metal gangways and swift-moving pavements.

THE DECORATIVE MUST BE ABOLISHED. The problem of Futurist architecture must be resolved, not by continuing to pilfer from Chinese, Persian or Japanese photographs or fooling around with the rules of Vitruvius, but through flashes of genius and through scientific and

technical expertise. Everything must be revolutionized. Roofs and underground spaces must be used; the importance of the façade must be diminished; issues of taste must be transplanted from the field of fussy mouldings, finicky capitals and flimsy doorways to the broader concerns of BOLD GROUPINGS AND MASSES, and LARGE-SCALE DISPOSITION OF PLANES. Let us make an end of monumental, funereal and commemorative architecture. Let us overturn monuments, pavements, arcades and flights of steps; let us sink the streets and squares; let us raise the level of the city.

I COMBAT AND DESPISE:

1. All the pseudo-architecture of the avant-garde, Austrian, Hungarian, German and American;

2. All classical architecture, solemn, hieratic, scenographic, decorative, monumental, pretty and pleasing;

3. The embalming, reconstruction and reproduction of ancient monuments and palaces;

4. Perpendicular and horizontal lines, cubical and pyramidical forms that are static, solemn, aggressive and absolutely excluded from our utterly new sensibility;

5. The use of massive, voluminous, durable, antiquated and costly materials.

AND PROCLAIM:

1. That Futurist architecture is the architecture of calculation, of audacious temerity and of simplicity; the architecture of reinforced concrete, of steel, glass, cardboard, textile fibre, and of all those substitutes for wood, stone and brick that enable us to obtain maximum elasticity and lightness;

2. That Futurist architecture is not because of this an arid combination of practicality and usefulness, but remains art, i.e. synthesis and expression;

3. That oblique and elliptic lines are dynamic, and by their very nature possess an emotive power a thousand times stronger than perpendiculars and horizontals, and that no integral, dynamic architecture can exist that does not include these;

4. That decoration as an element superimposed on architecture is absurd, and that THE DECORATIVE VALUE OF FUTURIST ARCHITECTURE DEPENDS SOLELY ON THE USE AND ORIGINAL ARRANGEMENT OF RAW OR BARE OR VIOLENTLY COLOURED MATERIALS;

5. That, just as the ancients drew inspiration for their art from the

elements of nature, we – who are materially and spiritually artificial – must find that inspiration in the elements of the utterly new mechanical world we have created, and of which architecture must be the most beautiful expression, the most complete synthesis, the most efficacious integration;

6. That architecture as the art of arranging forms according to pre-established criteria is finished;

7. That by the term architecture is meant the endeavour to harmonize the environment with Man with freedom and great audacity, that is to transform the world of things into a direct projection of the world of the spirit;

8. From an architecture conceived in this way no formal or linear habit can grow, since the fundamental characteristics of Futurist architecture will be its impermanence and transience. THINGS WILL ENDURE LESS THAN US. EVERY GENERATION MUST BUILD ITS OWN CITY. This constant renewal of the architectonic environment will contribute to the victory of Futurism which has already been affirmed by WORDS-IN-FREEDOM, PLASTIC DYNAMISM, MUSIC WITHOUT QUADRATURE AND THE ART OF NOISES, and for which we fight without respite against tradition-alist cowardice.

Milan, 11 July 1914
Amplified from catalogue introduction
'Nuove Tendenze', Milan, 1914
Published in *Lacerba* (Florence), 1 August 1914
Translation CT

Umberto Boccioni
Futurist Painting and Sculpture (extracts) 1914

What divides us from Cubism

Picasso represents the furthest point of the Impressionist renewal. And as is the case with all furthest points, he is already preparing the negation of it, but a negation which cannot manage to organize itself. In this artist we can see developed as far as possible the artistic values initiated by Cézanne. In the works of the latest period the study of form moves ever closer to a concept based fundamentally on the objective

knowledge of reality. Having got over the initial surprise, however, you notice that this concept of form is the result of dispassionate, scientific measurement, which kills the dynamic warmth, the violent action and the marginal variation which are precisely the qualities that allow the form to live outside the intellect, so that it can be projected into infinity.

This is a result of plastic emotion, of the delirious feeling of intuition. The scientific measurement of which I spoke requires a circular viewpoint, which turns the artist into an analyst of immobility, an intellectual impressionist of pure form.

In fact Picasso copies the object in its formal complexity, taking it to pieces and numbering its various aspects. In this way he prevents himself from experiencing it in *action*. And he would not be able to do so, because the way he proceeds, the enumeration which I mentioned, freezes the life of the object (motion), detaches the constituent parts, and distributes them about the picture in accordance with an incidental harmony inherent in the object.

However, the analysis of the object is always at the expense of the object itself – it kills it. Consequently dead parts are extracted from it, but it will be quite impossible to *build up something living* out of them. For all the talk there is of 'living arabesques', and of the abstract individuality of a composition seen as a simple evocative combination of planes, volumes and lines, we Futurists proclaim that painting is moving towards a more synthetic and meaningful understanding of the object.

So, when Picasso removes life from the object, he kills the emotion. The Impressionists did the same with light. They killed it by dissecting it into its spectral parts. This scientific analysis is necessary for renewal but should not be an end in itself.

A painting by Picasso has no law, no lyricism, no will. It presents, unrolls, upsets, gives facets to, multiplies the details of the object *ad infinitum*. The vertical section of an object and the fantastic variety of aspects that a violin, a guitar, a glass, etc., can assume in his paintings, are a marvel similar to that of the scientific enumeration of the components of an object hitherto considered, out of ignorance or because of tradition, an indivisible whole. It was a historic discovery, necessary for art. It is the precious result of a long preparation, but it is still without emotion, or at least gives only one side of emotion. This is a scientific analysis which studies life by looking at a corpse, dissecting the muscles, arteries and veins, in order to study their functions and discover the laws of creation. But art *is* creation in itself, not an accumulation of

knowledge. Emotion in art needs drama. Emotion, in modern painting and sculpture, sings of gravitation, displacement, reciprocal attraction of forms, of masses and colours, sings of *movement*, the interpenetration of forces.

Picasso has tried to observe and portray several sides of the object and arrange them on the canvas, so that the forms of the object-environment do not participate merely as accidental elements round about. To do this, he has thought up a system whose framework of ideas it is extremely difficult to clothe in mystery, because it wobbles on the very edge of what is art.

The greater immobility caused by this analysis deprives Picasso of the sense of volume, which was one of the principal aims of Cézanne. The thorough analysis of volume has led him, as his work proceeds, to abbreviate the representation of objects. He has ended up by giving a mere sign, an indication of the form. Instead of the volume he gives the equivalent formula. So, given the transparency and malleability of these forms or sketches of forms, it is possible to make infinite variations. Hence the intricacy of the Picassian arabesque.

It is true that volume understood as some Cubists understand it leads to the monumental, to the 'grandeur' of the past, to classical painting, to Michelangelo, to Raphael, to Poussin, to David, to Ingres, etc.; and Picasso hates the *grande machine*, as he told me, and despises it in the Cubists. He is both right and wrong. He is right because if one must fall into the old composition of pictures, it is better to *limit oneself* to form for its own sake; wrong because it is inevitable that with elements of form and colour made more abstract by the ancients, the artist will try to construct a drama even more abstract than the antique. I will go further: form and colour cannot live except if they achieve identity in drama – in the plastic state of mind. . . .

Although we have, therefore, in Picasso an attempt to go beyond conventional art (and in this he is helped by thirty years and more of French painting), the Cubists on the contrary take part in it.

In Picasso we find abstraction that has gone on to the point of aridity, typical of the Spanish race to which he belongs (the Spaniards have always been, in the past, the great masters of analytical stylization); we Futurists, true Italians in our serenity and equilibrium, find in the Cubists the cold and academic good taste of the French. . . .

When the great French artists produce a painting or sculpture that is deeply felt, it is sweet, shy, almost tentative, but often elegant. Such is the character of the painters who are truly French, i.e. realistic and un-Italian, until the nineteenth century, the period when, with the

Barbizon school and the Impressionists, the apogee of French painting is reached.

France owes to Courbet and Manet the struggle for a radical transformation which leaves no doubt about the influences from the past – indicating at least a desire for change.

Impressionism, the final development of centuries of naturalism, is also the first page of the epic poem that will sing of the forces of matter in a way that transcends the accidental and episodic detail.

The Impressionists' *motif* is no more than the first step towards the creation of a plastic whole based on the poetic interplay (of masses, lines and light) between object and surroundings. It has become, one must not forget, the only word to describe – whatever one may think – the modern European plastic sensibility. Impressionism is a lyrical art which spells the end of the reproduction of an image for its own sake.

So it seemed that with Impressionism French painting had finally reached a solution of continuity, an outlet into the new universal and definitive formula of which I was speaking above. The opposite happened. With Cézanne's search for volume and immobility, weight, tone, etc., which is right in principle but wrong in its consequences, with Cubism and its *a priori* concepts which are the logical and systematic development of the paintings – and not of the ideas – of Cézanne, the French academic tradition has come back into its own.

As to the influence of sensibilities other than French, Cézanne's teachings are entirely Old Italian.

Cézanne ran the risk run by all intellectual artists, that of the temptation of tradition. In Cézanne you see constant attempts to follow the old masters. The Cubists, falling for this temptation, exaggerated Cézanne's well-known statements on the return to the cube, the sphere, the cylinder. They took literally the idea of Cézanne already referred to: *Il faut faire le musée devant la nature* ('Make the museum in the presence of nature'). In fact they forgot nature and made the museum. In their dislike of Impressionist chromatics, they exaggerated Cézanne's colouring by accentuating pure chiaroscuro, seasoning it with greys and other lifeless touches of a typical Frenchness and worthy of Girodet, Prud'hon or Ingres. With their exaggerated fear of the episodic they have generalized forms and have fallen into an overall generalization which is quite without life. They have tried to ascend to the concept in form by following the French academic tradition, but forget that this concept should emerge freely as a purification of naturalistic objectivity, and should not be a process of imitation and of moving towards the ancients.

We modern Italians have no past.

We Futurists are the only *primitives of a new and completely trans-formed sensibility.*

The Cubists go no further than the construction of the painting, the composition and the distribution of masses and colours. They upset the traditional elements of a painting and invent new rhythms for new combinations of straight line and curve. But this is not enough. This is still only a readjustment of the surface – and not a new abstract inter-pretation of depth.

The study and therefore the influence of the archaic art of antiquity, of the Negroes, of wood carvings, of Byzantine art, etc., has saturated the paintings of our young friends in France with the archaism which is another evil brought about by this obsession with the past, a cultural phenomenon related to the influence of the classical world. Even if these influences from rudimentary arts are accepted for what they have that is new, and even if they have helped to free us from classicism, they are still harmful to the development of a completely modern plastic out-look. That is why we call ourselves primitives. None of the Futurists, whether painters or sculptors, is tainted by that archaism which brings with it a hieratic immobility and an antique solemnity which repel us. I repeat – there is a *barbaric* element in modern life in which we find inspiration.

We Futurists deny that Cubism has been able to create an abstract code, a kind of plastic conceptualism, which can with its characteristic calculation in practice be a substitute for the artist's intuition. To pass in art to the concept, as the Cubists want, when we still lack an identity of external and internal reality, is very dangerous, and the lifeless images produced by some Cubists prove this.

We say that the line and the outline do not exist, if they are thought of as the fixed boundaries of the planes which determine them. This is a true return to the antique. Lines and outlines must only exist as forces bursting forth from the dynamic action of the bodies.

Therefore we do not draw accidental artistic concepts from the object, as Picasso does. We do not superimpose concepts on to the object like the Cubists. We Futurists are right inside the object, and we live out its evolutionary concept.

We shall put the spectator in the centre of the picture

In painting, which till now has obeyed static laws and thought of objects in terms of circumscribed contours, perspective is considered as a

scientific measurement of what is seen. This conception, purely external and panoramic in nature, runs counter to pure sensation, which obeys entirely contrary laws. Commonly held notions on perspective constitute a definite error in terms of true painting.

Pure sensation cannot be reconciled to the age-old habit of separating inspiration from execution, as I have already demonstrated when I described the disjunction between a study of the *body* and the study of *force*, between the study of *quantity* and the study of *quality*. Inspiration – the act in which the artist totally immerses himself in the object, living out its characteristic motion – tells us that in nature there can be no absolutely perpendicular lines and no absolutely horizontal lines.

The only thing that is perpendicular or horizontal is a single point, situated at eye level; since the others – above, below and alongside this point – all *lead off* around us in lines converging at infinity. One can therefore say that, as far as sensation is concerned, the artist finds himself at the centre of spherical currents which surround him on every side.

For us the picture is no longer an exterior scene, a stage for the depiction of a fact. A picture is not an irradiating architectural structure in which the artist, *rather than the object*, forms a central core. It is an emotive architectural environment which creates sensation and completely involves the observer. A Futurist painting is a *minimal vastness* in which depth has been substituted for the old idea of area. It means the destruction of monumentality, as typified by such things as pyramids, parthenons, colosseums, in order to express extreme complexity in minimal terms. *Quality* now replaces *quantity*. Hence, all the laws of *composition*, of *light and shade*, of *design and colour*, have been turned upside down, as I showed when I talked of complementarism.

We live out the object in the motion of its inner forces; we do not depict its incidental appearance. Through the style of the Impressionists, as I have already pointed out, this incidental aspect becomes defined in the form which is its law of succession.

We therefore maintain, unlike Cézanne, that *the boundaries of the object tend to retreat towards a periphery (the environment) of which we are the centre.*

Looking at it in another way, dynamism would be killed if we were to fix, within realistic, constructive lines which are coldly traditional, literary and objective, checking the lyrical line of the body, its force-line, its absolute motion.

Simultaneity

For us simultaneity is a lyrical exaltation, a plastic manifestation of a new absolute, speed; a new and marvellous spectacle, modern life; a new fever, scientific discovery.

Simultaneity is a condition in which the various elements which constitute *dynamism* are present. It is therefore an effect of that great cause which is *universal dynamism*. It is the lyrical manifestation of modern ways of looking at life, based on speed and contemporaneity in knowledge and communication....

We want emotions to provide the supreme laws behind the architectural components of a painting (objects); we also want the interpretation of the object to provide a correct equilibrium between *sensation* (appearances) and *structure* (science).

Physical transcendentalism and plastic states of mind

In German painting, pictorial themes always play safe and seek out subjects which have nothing to do with plastic concepts: these themes may be philosophical, sentimental, demonstrative.

The freedom given us by revolutionary French ideas on plastic art, in Germany has degenerated into an infantile frenzy for *Expressionistic exaggeration* of schematic values of form.

In Russian painting, Kandinsky's experiments reveal interesting musical tendencies. But even here the plastic sense hardly plays any part. Plastic music, as elaborated by Kandinsky, derives from an obsessive influence of symphonic poems, symphonies and sonatas, etc., which is as good as saying a museum of sounds. Consequently we end up with a picture which is a surface coloured with chromatic waves, violent and agreeable ones, but there is no development of plastic themes. Colours are still colours, forms have but a single dimension, arabesques are often merely borrowings from the Japanese – the painting has remained a kind of fabric or tapestry, a piece of decoration. Kandinsky, along with the others, is concerned with *content*, and this outweighs his concern for a refinement of sensibilities which might have achieved the creation of a new plastic perception of life.

The plastic arts, in all their infinite possibilities, cannot make progress along lines such as these.

In one of his books, Kandinsky wrote: 'The voice of the soul tells the artist the kind of form he needs', and also, 'Every form, every colour, has a mystical value'; he speaks too of 'contrapuntal designs'.

This whole obsession with spiritual and musical things may turn out to be harmful, if – as is the case with Kandinsky – they are based on a transcription of musical, literary or philosophical culture.

Instead we should forget everything which the external mechanisms of painting have demanded up till now. We should look on a painting or a piece of sculpture as constructions of a fresh inner reality in which elements of external reality contribute to setting up a law of plastic analogy, which till now the world has been completely unaware of.

It is these analogies that we arrive at in our *plastic states of mind.* . . .

That is why I am convinced that from reciprocal influences of the environment on the object, from indications of an object's plastic potential, from this strength – which I have called *primordial psychology* – will be born a coordinating organization of a plastic state of mind, and all this could be achieved without in any way diminishing the plastic force of the sculpture or painting.

A state of mind implies organization, hence creation. An organizing ability has always characterized the Italian genius.

We are working towards the creation of a transmissible synthesis which will act as a guideline for our perceptions and make possible a construction which will be freed from the heavy burden of analytical researches. We want to have done with those laboratories of art, and to start an era of creation which will correspond to an evolving formula of dynamism.

If we look at an object – even in the mirror of our inner memories – and then paint it or sculpt it, this still does not mean creation. This kind of procedure, even though it makes use of distortion, is still nothing but subjective Impressionism.

That is why we Futurists must go further than this. We must free the object from all relative resemblances. In this way we will arrive at a new synthesis, which will bring all the elements of a work of art together and contribute to the formation of a model type.

Everything I have so far perceived concerning states of mind involves this kind of synthesis, an endeavour to bring to life those plastic elements which have been brought up to date by the currents of a renewed plastic emotion.

Our sensibilities have been altered, developed and refined by the new

ferment of modern life; as a result we want to bring to painting and sculpture, elements of this reality which till now have been obligatorily treated as plastically non-existent and hence invisible, through a fear of offending tradition and because of our own lack of maturity.

Hence: the creation of an atmosphere as a new kind of material body existing between one object and another (the solidification of the Impressionists); the creation of a new form which derives from the dynamic strength of the object (force-lines); the creation of a new subject plus environment (the interpenetration of planes); the creation of a new emotive structure outside all unities of time or place (memory, sensation, simultaneity).

We do not, therefore, present an abstract formula external to ourselves, but a formula which shall be part of us, within ourselves, and conceived through *sensation*.

This formula, which should be the complete integration of what I have called PHYSICAL TRANSCENDENTALISM, derives from a perception of reality which has been conceived as motion. So, if the plastic potentialities of bodies excite emotions which we interpret through their motions, it is these *pure motions* that we shall hold fast.

There are rare emotive elements which can be *brought together* in an emotive plastic composition. These sentimental elements are strictly related to an object's form, as are the same plastic elements of reality.

In the motion of the material there are elements of excitability which cause the lines of a plastic drama to converge towards an inevitable catastrophe. The composition of a plastic state of mind, therefore, is not based on the arrangement of the gestures of a figure, nor on the expression of eyes, faces, stance (all old literary debris which we scorn). It consists of a rhythmic distribution of forces and objects, dominated and guided by the energy of the state of mind to combine emotions.

In my theory of the 'plastic states of mind', presented for the first time in a lecture to the Circolo Internazionale Artistico in Rome, in 1911, I said that 'colours and forms should express themselves, without the need of any objective representation, and should create in the picture both *states of form* and *states of colour*.'

Plastic states of mind should be the final culmination of all the plastic and expressionist experiments which have been going on since the beginning of time. It should be the perfect fusion of an impassive plastic

station, as cut up into cells as a monastery, as moss-grown as an abandoned house. In other words it is a pacifistic, neutralist th... the antithesis of the fierce, overwhelming, synthesizing velocity o... war.

Our Futurist Theatre will be:

Synthetic. That is, very brief. To compress into a few minutes, into a few words and gestures, innumerable situations, sensibilities, ideas, sensations, facts, and symbols.

The writers who wanted to renew the theatre (Ibsen, Maeterlinck, Andreyev, Claudel, Shaw) never thought of arriving at a true synthesis, of freeing themselves from a technique that involves prolixity, meticulous analysis, drawn-out preparation. Before the works of these authors, the audience is in the indignant attitude of a circle of bystanders who swallow their anguish and pity as they watch the slow agony of a horse who has collapsed on the pavement. The sigh of applause that finally breaks out frees the audience's stomach from all the indigestible time it has swallowed. Each act is as painful as having to wait patiently in an antechamber for the minister (*coup de théâtre:* kiss, pistol shot, verbal revelation, etc.) to receive you. All this passéist or semi-Futurist theatre, instead of synthesizing fact and idea in the smallest number of words and gestures, savagely destroys the variety of place (source of dynamism and amazement), stuffs many city squares, landscapes, streets, into the sausage of a single room. For this reason this theatre is entirely static.

We are convinced that mechanically, by force of brevity, we can achieve an entirely new theatre perfectly in tune with our swift and laconic Futurist sensibility. Our acts can also be moments [*atti – attimi*] only a few seconds long. With this essential and synthetic brevity the theatre can bear and even overcome competition from the *cinema.*

Atechnical. The passéist theatre is the literary form that most distorts and diminishes an author's talent. This form, much more than lyric poetry or the novel, is subject to *the demands of technique:* (1) to omit every notion that doesn't conform to public taste; (2) once a theatrical idea has been found (expressible in a few pages), to stretch it out over two, three or four acts; (3) to surround an interesting character with many pointless types: coat-holders, door-openers, all sorts of bizarre comic turns; (4) to make the length of each act vary between half and

power (which derives from the anonymous formal arabesques of pure painting) and the expression of the lyrical problem of a consciousness which has been completely renewed and *interpreted as an absolute example of MODERNOLATRY.*

Aesthetically, these states of mind are a way of escaping from sceptical and analytical negations; it is the thrilling inspiration for a future *distinction* and authority, far beyond the depressing sameness of emotive and plastic values which encumbers our excessively rationalistic minds. It is the creation of a new *order*, a new *clarity*, completely inimical to the classical ideas of people like Puvis de Chavannes; ideas which have sprung from the Futurists' hatred for the old laws and for the recent slavery of democratic realism.

Such is our faith in the future that we can afford to ignore the morrow. Have we perhaps begun to understand man's aspiration to travel at 300 kilometres an hour? Do we know why he is prepared to risk his life climbing to 5,000, 10,000, 20,000 metres – to infinity? There is only one desire, only one necessity: to go on CLIMBING.

From *Pittura scultura futuriste*, Milan, 1914
Translations JCH and RB

Enrico Prampolini
The Futurist 'Atmosphere-structure' – Basis for an Architecture 1914–15

No artistic activity has shown such a disdainfully anachronistic character as architecture.

This first manifestation of human skill, one of absolute necessity, if not actually anticipating the needs of man, should at least have paralleled the demands of his development. Instead it has always lagged behind and with steps of lead has followed the incessant evolution of human expression, letting the distance between them grow ever greater, and establishing a criminal gulf between the demands of man's life and the essential reciprocal aims of architecture.

Just as painting is an abstract consequence of sculpture, and sculpture an abstract consequence of architecture, so architecture was an

abstract consequence of the vegetable elements of nature, originating because of the evolution of the intrinsic necessities of primitive human life.

Just as the habitation and architecture of primitive man were vegetable in origin, because they mirrored the primitive, aboriginal, lake-borne life of man, so future dwellings, and Futurist architecture, will be an abstract consequence of the atmospheric elements of the forms of space originated by the revolutionary needs intrinsic to Futurist human life. Futurist architecture must have an atmospheric genesis since it mirrors the intense life of *motion*, *light* and *air* which nourishes Futurist man.

To defend himself from nature, the caveman felt the need, and had the genius, to create thatched huts raised on piles, combining vegetable elements and forming an architectonic whole which met his own needs and those of his time; and we now, who do *not* live in the same era, absolutely must not and cannot put up with the very same architectonic elements to which, from that time to this, our dwellings have been tied, and which have reduced architecture to impotence.

II

We know in fact that all the architecture that has ever been built has been a timid derivation from the lake and marsh dwellings of the Bronze Age. The same architectonic mouldings, the same foundations, the vegetable *elements* used by primitive man to build his own dwelling, have been *repeated* by every generation of all the different civilizations with an increasing devaluation of architectonic forms in relation to practical needs. By accepting *a priori* intrinsic values in this way, and by using the essential structure of the hut raised on piles, indiscriminately and in intoxicated ignorance, this generation will, by deduction and with an idiotic conception of hypothetical reform, succeed in scattering everywhere that monotonous expression of architectonic styles. This constitutes the clumsiest display of reciprocal plagiarism ever manifested by any civilization.

III

Primordial civilizations (Babylonia, Assyria, Egypt, Chaldea, etc.) utilized and materialized the natural elements that primitive man used rudimentally in their natural state, transforming the piles into columns, distorting the instinctive character of the thatched huts into temples, etc., thus muffling in hypocrisy the genius, the practical spontaneity, of the original population. The Greeks and the Romans, with scant

riginality, continued to render the natural forms already r y generations more abstract and synthetic. Then the Chr n the obscurity of mysticism, mistook the practical ess dwelling for the meaning of the symbolic idea. After thes others are bastardized derivations of disquieting resear exponents were such unknowns as Brunelleschi, Braman angelo, Bernini, etc.

Published in *Noi* (Rome), Fel
Tra

F. T. Marinetti, Emilio Settimelli, Bruno Corra
The Futurist Synthetic Theatre 1915

As we await our much prayed-for great war, we Futurist violent antineutralist action from city square to universit again, using our art to prepare the Italian sensibility fo hour of maximum danger. Italy must be fearless, eager, elastic as a fencer, as indifferent to blows as a boxer, as the news of a victory that may have cost fifty thousand de news of a defeat.

For Italy to learn to make up its mind with lightnir hurl itself into battle, to sustain every undertaking and ev calamity, books and reviews are unnecessary. They inter cern only a minority, are more or less tedious, obstruct laxing. They cannot help chilling enthusiasm, aborting in poisoning with doubt a people at war. War – Futurism obliges us to march and not to rot [*marciare, non marcire* and reading rooms. THEREFORE WE THINK THAT THE ON INSPIRE ITALY WITH THE WARLIKE SPIRIT TODAY IS THROUGH T In fact ninety percent of Italians go to the theatre, wher percent read books and reviews. But what is needed is THEATRE, completely opposed to the passéist theatre th monotonous, depressing processions around the sleepy It

Not to dwell on this historical theatre, a sickening g abandoned by the passéist public, we condemn the whole c theatre because it is too prolix, analytic, pedantically ps explanatory, diluted, finicking, static, as full of prohibitio

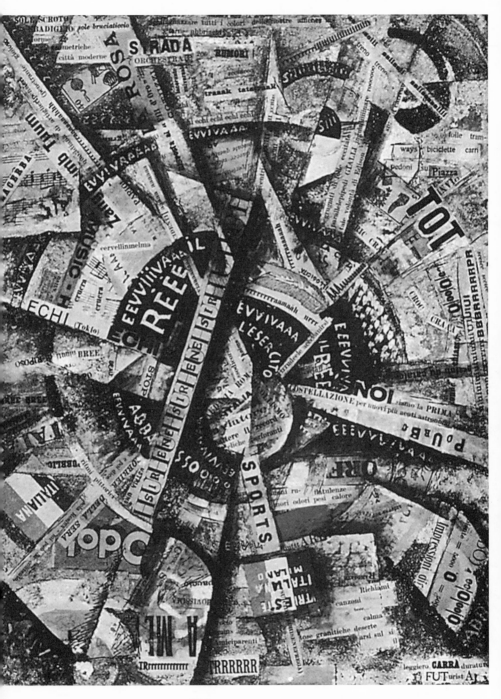

Carlo Carrà *Interventionist Demonstration* 1914

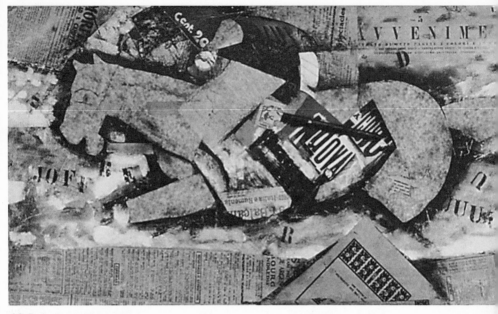

95 Carlo Carrà *Chase* 1914

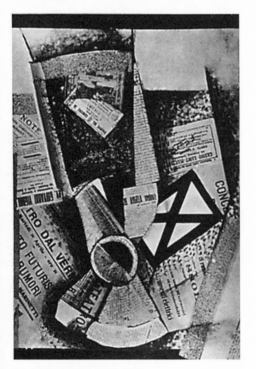

96 Carlo Carrà *Still-life* 1914

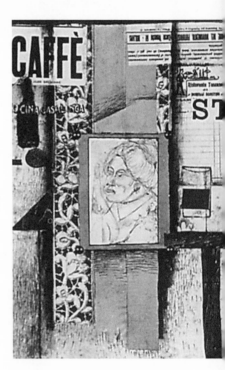

97 Carlo Carrà *Suburban Café* 1914

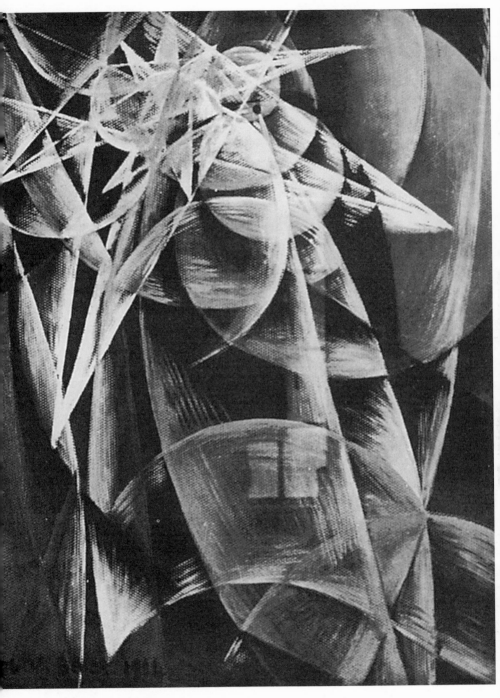

Giacomo Balla *Study for 'Mercury Passing in Front of the Sun'* 1914

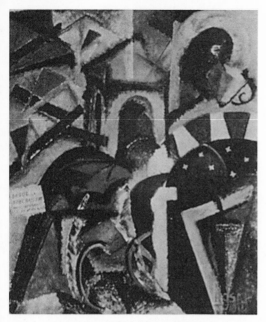

99 Ottone Rosai *Decomposition of a Street* 1914

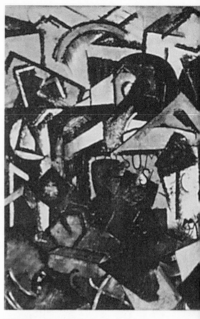

100 Ottone Rosai *Landscape* 1914

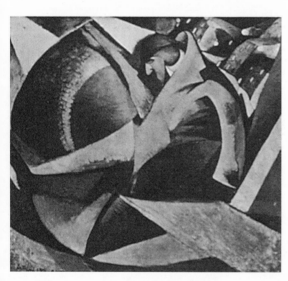

101 Achille Funi *Man Getting Off a Tram* 1914

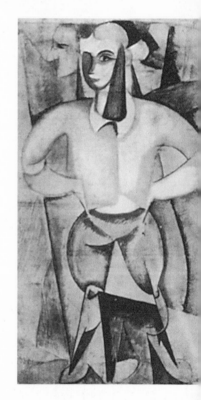

102 Achille Funi *Self-portrait* 1914

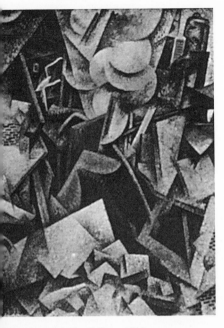

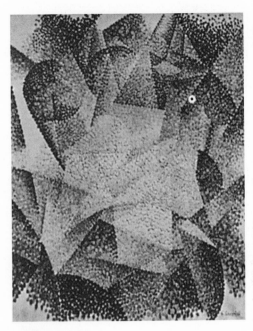

Gino Severini *The Collapse* 1914

104 Gino Severini
Spherical Expansion of Centrifugal Light 1914

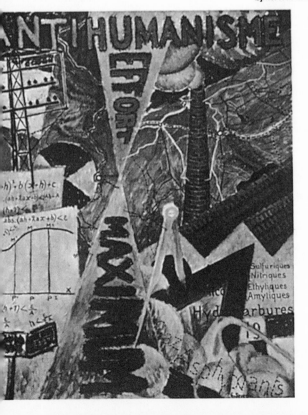

105 Gino Severini *War* 1914–15

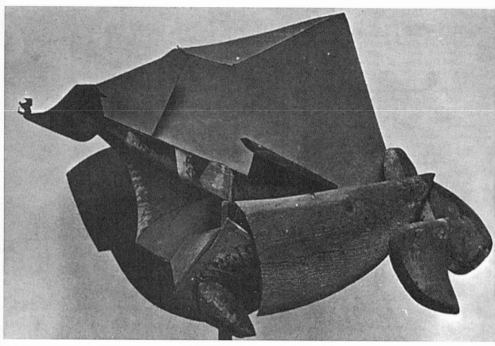

106 Umberto Boccioni *Horse + Rider + Houses* 1914

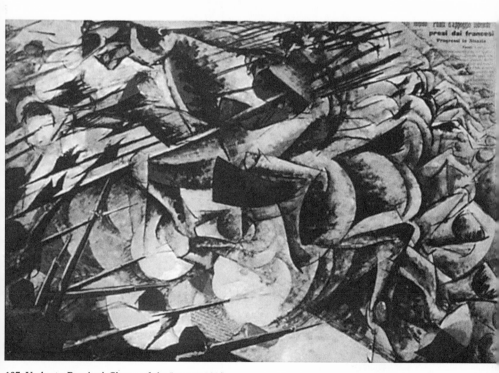

107 Umberto Boccioni *Charge of the Lancers* 1915

108 Giorgio Morandi
Still-life
1914

109 Giorgio Morandi
Still-life
1915

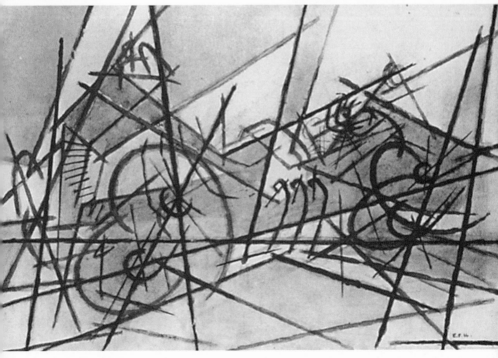

110 Enrico Prampolini *Mechanical Rhythms* 1914

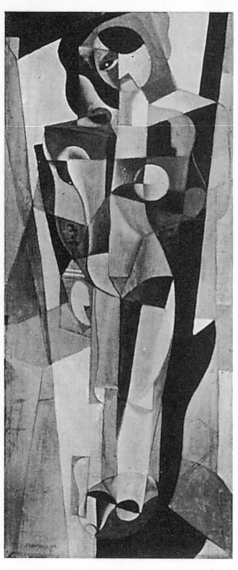

111 Enrico Prampolini
Woman + Surroundings 1915

112 Carlo Carrà
The Dancer of San Martino 1915

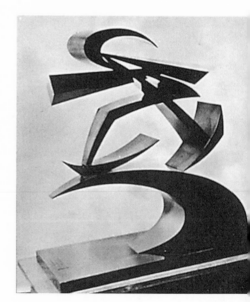

113 Giacomo Balla
Boccioni's Fist 1915

three-quarters of an hour; (5) to construct each act taking care to (a) begin with seven or eight absolutely useless pages, (b) introduce a tenth of your idea in the first act, five-tenths in the second, four-tenths in the third, (c) shape your acts for rising excitement, each act being no more than a preparation for the finale, (d) always make the first act *a little boring* so that the second can be *amusing* and the third *devouring*; (6) to set off every *essential* line with a hundred or more insignificant *preparatory* lines; (7) never to devote less than a page to explaining an entrance or an exit minutely; (8) to apply systematically to the whole play *the rule of a superficial variety*, to the acts, scenes, and lines. For instance, to make one act a day, another an evening, another deep night; to make one act pathetic, another anguished, another sublime; when you have to prolong a dialogue between two actors, make something happen to interrupt it, a falling vase, a passing mandolin player. ... Or else have the actors constantly move around from sitting to standing, from right to left, and meanwhile vary the dialogue to make it seem as if a bomb might explode outside at any moment (e.g., the betrayed husband might catch his wife red-handed) when actually nothing is going to explode until the end of the act; (9) to be enormously careful about *the verisimilitude of the plot*; (10) to write your play in such a manner that *the audience understands in the finest detail the how and why of everything that takes place on the stage, above all that it knows by the last act how the protagonists will end up.*

With our synthetist movement in the theatre, we want to destroy the Technique that from the Greeks until now, instead of simplifying itself, has become more and more dogmatic, stupid, logical, meticulous, pedantic, strangling. Therefore:

1. *It's stupid to write one hundred pages where one would do*, only because the audience through habit and infantile instinct wants to see character in a play result from a series of events, wants to fool itself into thinking that the character really exists in order to admire the beauties of Art, meanwhile refusing to acknowledge any art if the author limits himself to sketching out a few of the character's traits.

2. *It's stupid* not to rebel against the prejudice of theatricality when life itself (which consists *of actions vastly more awkward, uniform, and predictable* than those that unfold in the world of art) is for the most part *antitheatrical* and even in this offers *innumerable possibilities for the stage.* Everything of any value is theatrical.

3. *It's stupid* to pander to the primitivism of the crowd, which, in the last analysis, wants to see the bad guy lose and the good guy win.

4. *It's stupid* to worry about verisimilitude (absurd because talent and worth have little to do with it).

5. *It's stupid* to want to explain with logical minuteness everything taking place on the stage, when even in life one never grasps an event entirely, in all its causes and consequences, because reality throbs around us, bombards us *with squalls of fragments of inter-connected events, mortised and tenoned together, confused, mixed up, chaotic.* E.g. it's stupid to act out a contest between two persons *always* in an orderly, clear, and logical way, since in daily life we nearly always encounter mere *flashes of argument* made *momentary* by our modern experience, in a tram, a café, a railway station, which remain cinematic in our minds like fragmentary dynamic symphonies of gestures, words, lights, and sounds.

6. *It's stupid* to submit to obligatory *crescendi, prepared effects,* and *postponed climaxes.*

7. *It's stupid* to allow one's talent to be burdened with the weight of a technique that *anyone* (even imbeciles) *can acquire by study, practice, and patience.*

8. It's stupid to renounce the dynamic leap in the void of total creation, beyond the range of territory previously explored.

Dynamic, simultaneous. That is, born of improvisation, lightning-like intuition, from suggestive and revealing actuality. We believe that a thing is valuable to the extent that it is improvised (hours, minutes, seconds), not extensively prepared (months, years, centuries).

We feel an unconquerable repugnance for desk work, *a priori*, that fails to respect the ambience of the theatre itself. The greater number of our works have been written in the theatre. The theatrical ambience is our inexhaustible reservoir of inspirations: the magnetic circular sensation invading our tired brains during morning rehearsal in an empty gilded theatre; an actor's intonation that suggests the possibility of constructing a cluster of paradoxical thoughts on top of it; a movement of scenery that hints at a symphony of lights; an actress's fleshiness that fills our minds with genially full-bodied notions.

We overran Italy at the head of a heroic battalion of comedians who imposed on audiences *Elettricità* and other Futurist syntheses (alive yesterday, today surpassed and condemned by us) that were revolutions imprisoned in auditoriums. – From the Politeama Garibaldi of Palermo to the Dal Verme of Milan. The Italian theatres smoothed the wrinkles in the raging massage of the crowd and rocked with bursts

194

of volcanic laughter. We fraternized with the actors. Then, on sleepless nights in trains, we argued, goading each other to heights of genius to the rhythm of tunnels and stations. Our Futurist theatre jeers at Shakespeare but pays attention to the gossip of actors, is put to sleep by a line from Ibsen but is inspired by red or green reflections from the stalls. WE ACHIEVE AN ABSOLUTE DYNAMISM THROUGH THE INTERPENETRATION OF DIFFERENT ATMOSPHERES AND TIMES. E.g., whereas in a drama like *Più che L'Amore* [D'Annunzio], the important events (for instance, the murder of the gambling-house keeper) don't take place on the stage but are narrated with a complete lack of dynamism; and in the first act of *La Figlia di Jorio* [D'Annunzio] the events take place against a simple background with no jumps in space or time; in the Futurist synthesis, *Simultaneità*, there are two ambiences that interpenetrate and many different times put into action simultaneously.

Autonomous, alogical, unreal. The Futurist theatrical synthesis will not be subject to logic, will pay no attention to photography; it will be *autonomous*, will resemble nothing but itself, although it will take elements from reality and combine them as its whim dictates. Above all, just as the painter and composer discover, scattered through the outside world, a narrower but more intense life, made up of colours, forms, sounds, and noises, the same is true *for the man gifted with theatrical sensibility, for whom a specialized reality exists that violently assaults his nerves:* it consists of what is called THE THEATRICAL WORLD.

THE FUTURIST THEATRE IS BORN OF THE TWO MOST VITAL CURRENTS in the Futurist sensibility, defined in the two manifestos 'The Variety Theatre' and 'Weights, Measures, and Prices of Artistic Genius', which are: (1) our frenzied passion for real, swift, elegant, complicated, cynical, muscular, fugitive, Futurist life; (2) our very modern cerebral definition of art according to which no logic, no tradition, no aesthetic, no technique, no opportunity can be imposed on the artist's natural talent; he must be preoccupied only with creating synthetic expressions of cerebral energy that have THE ABSOLUTE VALUE OF NOVELTY.

The *Futurist theatre* will be able to excite its audience, that is make it forget the monotony of daily life, by sweeping it through *a labyrinth of sensations imprinted on the most exacerbated originality and combined in unpredictable ways.*

Every night the *Futurist theatre* will be a gymnasium to train our race's spirit to the swift, dangerous enthusiasms made necessary by this Futurist year.

CONCLUSIONS

1. TOTALLY ABOLISH THE TECHNIQUE THAT IS KILLING THE PASSÉIST THEATRE.

2. DRAMATIZE ALL THE DISCOVERIES (no matter how unlikely, weird, and antitheatrical) THAT OUR TALENT IS DISCOVERING IN THE SUBCONSCIOUS, IN ILL-DEFINED FORCES, IN PURE ABSTRACTION, IN THE PURELY CEREBRAL, THE PURELY FANTASTIC, IN RECORD-SETTING AND BODY-MADNESS. (E.g. *Vengono*, F. T. Marinetti's first drama of objects, a new vein of theatrical sensibility discovered by Futurism.)

3. SYMPHONIZE THE AUDIENCE'S SENSIBILITY BY EXPLORING IT, STIRRING UP ITS LAZIEST LAYERS WITH EVERY MEANS POSSIBLE; ELIMINATE THE PRECONCEPTION OF THE FOOTLIGHTS BY THROWING NETS OF SENSATION BETWEEN STAGE AND AUDIENCE; THE STAGE ACTION WILL INVADE THE ORCHESTRA SEATS, THE AUDIENCE.

4. FRATERNIZE WARMLY WITH THE ACTORS WHO ARE AMONG THE FEW THINKERS WHO FLEE FROM EVERY DEFORMING CULTURAL ENTERPRISE.

5. ABOLISH THE FARCE, THE VAUDEVILLE, THE SKETCH, THE COMEDY, THE SERIOUS DRAMA, AND TRAGEDY, AND CREATE IN THEIR PLACE THE MANY FORMS OF FUTURIST THEATRE, SUCH AS: LINES WRITTEN IN FREE WORDS, SIMULTANEITY, INTERPENETRATION, THE SHORT, ACTED-OUT POEM, THE DRAMATIZED SENSATION, COMIC DIALOGUE, THE NEGATIVE ACT, THE REECHOING LINE, 'EXTRA-LOGICAL' DISCUSSION, SYNTHETIC DEFORMATION, THE SCIENTIFIC OUTBURST THAT CLEARS THE AIR.

6. THROUGH UNBROKEN CONTACT, CREATE BETWEEN US AND THE CROWD A CURRENT OF CONFIDENCE RATHER THAN RESPECTFULNESS, IN ORDER TO INSTILL IN OUR AUDIENCES THE DYNAMIC VIVACITY OF A NEW FUTURIST THEATRICALITY.

These are the *first* words on the theatre. Our first eleven theatrical syntheses (by Marinetti, Settimelli, Bruno Corra, R. Chiti, Balilla Pratella) were victoriously imposed on crowded theatres in Ancona, Bologna, Padua, Naples, Venice, Verona, Florence, and Rome, by Ettore Berti, Zoncada, and Petrolini. In Milan we soon shall have the great metal building, enlivened by all the electro-mechanical inventions, that alone will permit us to realize our freest conceptions on the stage.

Milan, 11 January 1915; 18 February 1915
Published by Istituto Editoriale Italiano,
Milan, 1915
Translation R W F

Giacomo Balla, Fortunato Depero
Futurist Reconstruction of the Universe 1915

With the Technical Manifesto of Futurist Painting and the preface to the catalogue of the Futurist Exhibition in Paris (signed by Boccioni, Carrà, Russolo, Balla, Severini), with the manifesto of Futurist Sculpture (signed by Boccioni), the manifesto of the Painting of Sounds, Noises and Smells (signed by Carrà), with the volume *Pittura scultura futuriste* [Futurist Painting and Sculpture] by Boccioni and Carrà's *Guerrapittura* [Warpainting], pictorial Futurism has succeeded in the course of six years in progressing beyond Impressionism and in solidifying it, in proposing plastic dynamism and the moulding of the atmosphere, interpenetration of planes and states of mind. The lyrical appreciation of the universe, by means of Marinetti's Words-in-Freedom, and Russolo's Art of Noises, relies on plastic dynamism to provide a dynamic, simultaneous, plastic and noisy expression of universal vibration.

We Futurists, Balla and Depero, seek to realize this total fusion in order to reconstruct the universe by making it more joyful, in other words by an integral re-creation. We will give skeleton and flesh to the invisible, the impalpable, the imponderable and the imperceptible. We will find abstract equivalents for all the forms and elements of the universe, and then we will combine them according to the caprice of our inspiration, to shape plastic complexes which we will set in motion.

Balla started by studying the speed of automobiles, and in so doing discovered the laws and essential force-lines of speed. After more than twenty paintings exploring this, he understood that the flat plane of the canvas prevented him from reproducing the dynamic volume of speed in depth. Balla felt the need to construct, with strands of wire, cardboard planes, material, tissue paper, etc., the first plastic-dynamic complex:

1. ABSTRACT. 2. DYNAMIC. Relative movement (cinematographic) + absolute movement. 3. EXTREMELY TRANSPARENT. For the speed and volatility of the plastic complex which must appear and disappear, light and impalpable. 4. HIGHLY COLOURED AND EXTREMELY LUMINOUS (through the use of internal lights). 5. AUTONOMOUS, that is, resembling itself alone. 6. TRANSFORMABLE. 7. DRAMATIC. 8. VOLATILE. 9. ODOROUS. 10. NOISE-CREATING. Simultaneous plastic noisiness with plastic expression. 11. EXPLOSIVE, elements that appear and vanish simultaneously with a bang.

The free-wordist Marinetti, to whom we showed our first plastic complexes, said with enthusiasm: 'Before us, art consisted of memory, anguished re-evocation of the lost Object (happiness, love, landscape), and therefore nostalgia, immobility, pain, distance. With Futurism art has become action-art, that is, energy of will, aggression, possession, penetration, joy, brutal reality in art (e.g. onomatopoeia; e.g. noise-attuner [*intonarumori*] = motors), geometric splendour of forces, forward projection. Consequently art became the Present, the new Object, the new reality created with the abstract elements of the universe. The hands of the traditionalist artist ached for the lost Object; our hands suffered agonies for a new object to create. That is why the new object (plastic complex) appears miraculously in yours.'

THE MATERIAL CONSTRUCTION OF THE PLASTIC COMPLEX
NECESSARY MEANS: Strands of wire, cotton, wool, silk of every thickness and coloured glass, tissue paper, celluloid, metal netting, every sort of transparent and highly coloured material. Fabrics, mirrors, sheets of metal, coloured tin foil, every sort of gaudy substance. Mechanical and electrical devices; musical and noise-making elements, chemically luminous liquids of variable colours; springs, levers, tubes, etc. With these means we will construct –

Rotations

1. *Plastic complexes rotating on one axis* (horizontal, vertical, oblique).
2. *Plastic complexes rotating on more than one axis:*
 (a) in the *same* direction but with varying speeds;
 (b) in *opposite* directions;
 (c) in the *same and opposite* directions.

Decompositions

3. *Plastic complexes which decompose:*
 (a) in volume; (b) in layers;
 (c) in successive transformations (taking the shape of cones, pyramids, spheres, etc.).
4. *Plastic complexes which decompose, talk, produce noises and play music simultaneously.*

 Decomposition ⎫
 ⎬ Form+Expansion ⎧ Onomatopoeias
 ⎬ ⎨ Sounds
 Transformation ⎭ ⎩ Noises

Miracle Magic

5. *Plastic complexes which appear and disappear:*
 (a) slowly; (b) in repeated bursts (in scales);
 (c) with unexpected explosions.
 Pyrotechnics – Water – Fire – Rivers.

Using complex, constructive, noise-producing abstraction, that is, the Futurist style. Any action developed in space, any emotion felt, will represent for us the intuition of a discovery.

EXAMPLES: Watching an aeroplane swiftly climbing while a band played in the square, we had the idea of PLASTIC-MOTOR-NOISE MUSIC IN SPACE and the LAUNCHING OF AERIAL CONCERTS above the city. The need to vary the environment very frequently, together with sport, led us to the concept of TRANSFORMABLE CLOTHES (mechanical trimmings, surprises, tricks, disappearance of individuals). The simultaneity of speed and noises have led us to the idea of the ROTOPLASTIC NOISE FOUNTAIN. Tearing up a book and throwing it down into a courtyard resulted in PHONO-MOTO-PLASTIC ADVERTISEMENT and PYROTECHNIC-PLASTIC-ABSTRACT CONTESTS. A spring garden blown by the wind led to the concept of the MAGICAL TRANSFORMABLE MOTO-NOISY FLOWER. – The clouds flying in a storm made us perceive the BUILDING IN THE NOISY TRANSFORMABLE STYLE.

THE FUTURIST TOY

In games and toys, as in all traditionalist manifestations, there is nothing but grotesque imitation, timidity (little trains, little carriages, puppets), immobile objects, stupid caricatures of domestic objects, *antigymnastic and monotonous, fit only to cretinize and degrade a child.*

With plastic complexes we will construct toys which will accustom the child:

(1) TO COMPLETELY SPONTANEOUS LAUGHTER (with exaggerated and comical tricks);

(2) TO MAXIMUM ELASTICITY (without resorting to the throwing of projectiles, whip cracking, pin pricks, etc.);

(3) TO IMAGINATIVE IMPULSES (by using fantastic toys to be looked at through magnifying glasses, small boxes to be opened up at night to reveal pyrotechnic marvels, transforming devices, etc.);

(4) TO THE INFINITE STRETCHING AND ANIMATION OF THE SENSIBILITY (in the unbounded realms of the most acute and exciting noises, smells and colours);

(5) TO PHYSICAL COURAGE, TO FIGHTING AND TO WAR (with enormous dangerous and aggressive toys that will work outdoors).

The Futurist toy will be of great use to adults too, since it will keep them young, agile, jubilant, spontaneous, ready for anything, inexhaustible, instinctive and intuitive.

199

By developing the initial synthesis of the speed of an automobile, Balla arrived at the first plastic complex. This revealed an abstract landscape composed of cones, pyramids, polyhedrons, and the spirals of mountains, rivers, lights and shadows. It follows that a profound analogy exists between the essential force-lines of speed and the essential force-lines of a landscape. We have reached the profound essence of the universe, and we are masters of the elements. Following this course we will succeed in constructing

THE METALLIC ANIMAL

Fusion of art and science, chemistry, physics, continuous and unexpected pyrotechnics all incorporated into a new creature, a creature that will speak, shout and dance automatically. We Futurists, Balla and Depero, will construct millions of metallic animals for the vastest war (conflagration of all the creative forces of Europe, Asia, Africa and America, which will undoubtedly follow the current marvellous little human conflagration).

The inventions contained in this manifesto are absolute creations, integrally generated by Italian Futurism. No artist in France, Russia, England or Germany anticipated us in perceiving anything similar or analogous. Only the Italian genius, which is the most constructive and architectural, could perceive the abstract plastic complex. With this, Futurism has determined its style, which will inevitably dominate the sensibility of many centuries to come.

Milan, 11 March 1915
Published as a leaflet
by Direzione del Movimento Futurista
Translation CT

Enrico Prampolini
The Futurist Stage (Manifesto) 1915

We must rebel and assert our views and say to our friends the poets and musicians: this action needs to be staged this way rather than that.

We too wish to be artists and no longer mere executants. We must set the scene, bring the play to life with the full evocative power of our art.

It goes without saying that we need plays in tune with our sensibility, which means a more intense and more complete conception of staging subjects.

Let us renew the stage.

What will be completely new in the theatre as a result of our innovations is the *banning of painted scenery.* The stage will no longer have a coloured back-drop, *but a colourless electromechanical architectural structure, enlivened by chromatic emanations from a source of light,* produced by electric reflectors with coloured filters arranged and coordinated in accordance with the spirit of the action on stage.

The luminous radiation of these sheaves and walls of coloured lights and the dynamic combinations will give beautiful effects of interpenetration and intersection of light and shade. It will give birth to forlorn voids and exultant, almost corporeal, blocks of light. Additions, unreal clashes, an exuberance of sensations as well as the dynamic architectural structures on the stage, which will move, letting loose metallic arms and overturning the sculptural planes, together with fundamentally new and modern noises – all these will heighten the intensity and vitality of the stage action.

On a stage lit in such a way, actors will produce unforeseen dynamic effects, which are neglected or used very little in the theatre today, mainly because of the ancient prejudice that one must imitate and represent reality.

What's the point?

Do directors think that it is absolutely necessary to represent reality? Fools! Don't you realize that your efforts and unnecessary preoccupation with realism only diminish the intensity and decrease the emotional content, which one can attain using equivalents which interpret these realities, that is to say *abstractions.*

Let us create the stage.

In the foregoing lines we have defended the idea of a *dynamic stage* as opposed to the static stage of the past; with the fundamental principle that we are about to reveal we intend not only to take the stage to its highest point of expression, but to give it the basic values which are proper to it and which nobody has previously thought of giving it.

Let us reverse the roles.

Instead of the illuminated stage *let us create the stage that illuminates:*

expressive light radiating with great emotional intensity the colours appropriate to the action on stage.

April–May 1915
First published in French in *Der Futurismus*
(Berlin), no. 4, August 1922
Translation JCH

Carlo Carrà
Warpainting (extracts) 1915

*La peinture lâche est
la peinture d'un lâche.*
Delacroix

Illustrationism in Plastic Art

We Futurists have long meditated on many things (and we can do this very well indeed, even in the company of tarts and to the merry sound of night revellers, so please do not credit us with solemn Mazzini-like posturing) and we have come to the conclusion that the Great and Famous Art of the Past is, in fact, a very trivial thing.

Its major defect is a kind of *illustrationism* which has dominated all art, without exception, from antiquity to our own days.

By the word 'illustrationism' I do not wish to refer to what commonly goes under the name of 'illustration' (as in newspapers, novels, stories, etc.).

A painter who is affected by illustrationism never achieves, or even tries for, the expression of his feelings in the plastic world of form and colour, since for him lines, planes, colours express nothing in themselves. He accepts anything (and sometimes this amounts to very little) which serves to materialize his own vision, his own allegorical, symbolic or philosophic themes, which are *never purely pictorial*, and he is content to reproduce scenes of an eternal life, though he may see his subject within a contemporary framework.

He relies on a kind of traditional, conventional ideography, and he has an absolute horror of the humanized arabesque, that arabesque which encourages us to feel and to add greater value to expressions of light, of objects and beings in their attitudes of movement and stillness.

The painter who is basically an illustrator or decorator is content to make do with an explanatory tradition limited to purely external images, narrated on a single plane with the aid of colours.

202

So, the architectural and musical lyricism of form and colour, together with laws of tone and light and shade, have no significance for him. For us, on the other hand, *painting is just this*, and this is the only reason for its existence.

The error with which all plastic art, until now, has been affected, is not only found in Western art (although it is true that, from Courbet onwards, a few people have tried to wipe it out by timidly considering the painter's problem in relation to the search for pure plastic expression) but also is a notable failing in Oriental painting (the Chinese, Japanese, etc.), which is still completely fettered by it.

It is only this non-sense of illustrationism that has persuaded so many people that the Sistine Chapel and even Raphael's Loggia are works which are unsurpassed and unsurpassable.

They are all just stupid dictators, the literati, the philosophers, the journalists and those other people who fail to understand one iota of this and who refuse to see the basic difference between yesterday's painting and the painting of today.

With essential synthetic lyricism, with *imagination without strings* and *words-in-freedom, true poetry is born*, which never existed before.

With our pictorial Dynamism true painting is born, which also never existed before.

Unblinkered, as always, we Futurists will continue to demolish and to re-create, convinced that reason, as well as truth, is on our side.

The art of the past should be looked upon as a great joke based on moral, religious, ethical and political foundations. *It is only with us Futurists that true ART will be born.*

Distortion in Painting

One of the most characteristic signs, common to all the trends in painting today – and one which makes the greatness of contemporary works of art – is without doubt the element of *distortion* which is the predominant factor in the construction of a painting. Anyone who takes an intelligent interest in modern painting will know, anyway, that without the presence of this distorting element a work of art cannot exist.

The objective representation of things, so dear to the hearts of naturalists with their artistic *collectivism*, is henceforth confined to its legitimate field: photography.

The search for dynamic-plastic distortion in painting. The search for polytonal music without quadrature. The search for the art of sounds. The search for words-in-freedom.

We are happy to leave the job of explaining the meaning of these

words to pedagogues; they are obscure only to idiots; they are crystal clear to anyone who has any familiarity with art.

Distortion is an *altimeter* which registers the degrees of plastic expression which a work of art can attain.

Adjectives like 'primitive', 'great', etc., are too vague, indeterminate and elastic to be used unequivocally.

With such vague, amorphous terminology, anyone can call the most moronic and bourgeois painting in the world 'primitive' or 'great'.

As usual the Italians do not know what has been happening in other countries for the past thirty years.

In the works of the old masters, including Giotto and Titian, any plastic element was the result of accidental intuition.

The plastic elements of their *pictorial illustrations* are to be found in the minor, unimportant sections of their paintings and have little significance for the artist; they are generally found only in the drapes, landscape backgrounds, etc.

And don't throw in our faces the works of old stay-at-home Rembrandt, or El Greco, both of whom attempted some kind of formal distortion, which, however, was ruined by filthy literary psychology.

Such attempts at formal and psychological-literary distortion must be disowned by us Futurists with vigour. Forms executed in an inert and static way, derived from concepts far remote from any real feeling for life, the works of these old painters should be completely struck off our list of objects worthy of preservation; they should be removed from the sight of everyone still uncontaminated by stupid idolatry, everyone who wants to become a real art lover.

Once more we must return to the miraculous Bruno [*sic*] Courbet – the first plastic artist to refuse to have any truck with millenarian moralism or romantic sentimentalism in his painting.

The three major Post-Impressionist painters, Matisse, Derain and Picasso, have continued the traditions of their three great predecessors Manet, Renoir and Cézanne, and the distortionist aspect of the problem of plasticity in painting came to be applied with courage and greater awareness.

To this group of artists is due the great credit of having brought to painting an anti-episodic constructional synthesis which was entirely unknown among the old painters.

They have broken with perspective schemes, they have broadened and deepened their experiments with space and the plasticity of bodies and light, *distorting* all apparent reality; in this way these great precursors prepared the way for Futurist painting.

The need for more and more architectural distortion of objects and things made the painter Courbet take a stand against:

The pictorial distortion of the kind practised in a linear-static way by the Egyptians, the Ancient Greeks, Michelangelo and El Greco.

With Courbet, for the first time, we have plastic distortion accompanied by the principles of dynamism. We must give him the honour of being the first innovator of modern painting.

All these things have been discussed at great length by myself, Soffici and our friend Picasso in the latter's studio. Expounding our Futurist principles, we convinced Picasso of the necessity of starting – as far as distortion is concerned – with a passionate acceptance of modernity, as well as of popular art. We also showed him the absurdity of the kind of distortion which can take inspiration from a bygone sensibility inevitably static and false. This kind of distortion can only create works which have merely the appearance of modernity, where the life is merely illusory.

Our dynamic distortion in painting will be used to fight:
Any tendency towards the 'pretty', the 'tender', the 'sentimental' (BOTTICELLI, WATTEAU)

Any tendency towards 'literary heroicism' (DELACROIX)

Any tendency towards the 'bourgeois' or the 'academic' (RAPHAEL, LEONARDO DA VINCI)

Any tendency towards 'harmony', 'equilibrium', 'symmetry', the 'decorative', 'pure illustrationism' (VERONESE)

Any tendency towards the 'analytical', towards 'scientific or rationalist perspective', towards 'objectivism and natural probability' (SEURAT, SIGNAC, GROS)

While the paintings of our glorious predecessors, Courbet, Manet, Cézanne and Renoir, exhibit a certain fragmentariness, nevertheless their work was the *signal for a rebellion* against all gangrenous, millenarian, artistic traditionalism.

The artistic revolt begun by these painters will be brought to full fruit by us Futurist painters, and this new art, barely glimpsed by them, will be realized by *US* for our own pleasure and for the pleasure of a few like-minded people who find themselves capable of enjoying it.

From Carlo Carrà, *Guerrapittura*, Milan, 1915
Translation RB

Giacomo Balla
The Late Balla - Futurist Balla 1915

With the perfecting of photography, static traditionalist painting has completely fallen from repute; photography kills static contemplation. Watching a cinematographic performance we find ourselves in front of a painting in movement that consecutively transforms itself to reproduce a given action.

Static traditionalist painting was vanquished because it was obliged to transfix one single point among the infinite variety of aspects of nature. Mechanics have overtaken the traditionalist painter and forced him into becoming a pitiable imitator of static and exterior forms. It is imperative therefore not to halt and contemplate the corpse of tradition, but to renew ourselves by creating an art that no machine can imitate, that only the artistic Creative Genius can conceive. Futurism, predestined force of progress and not of fashion, creates the style of flowing abstract forms that are synthetic and inspired by the dynamic forces of the universe.

GIACOMO BALLA OF TURIN

Temperament: daring, intuitive.

Art – 1st Period: Objective personal realist – rebel against the academic schools – Analysis of our life – solution in Divisionist researches (light, environment, psyche, objects, people) – Struggles toils enjoyments – achievement of glorious career with recognition from public, artists, critics.

2nd Period: FUTURISM. *Evolution:* Total repudiation of own work-career. Public, artists, critics dismayed – incomprehensibility – accusations – madness – bad faith – derision – pity – Received with smiling indifference – First plastic researches in movement (speeding automobiles people in movement) – public curiosity – laughs, insults, derision, incredulity – violent arguments (Italians, poverty and grandeur, brimful of a great indigestion – Germanophilia!!!)

Continuation researches. Analysis reality abandoned definitively. Creation new Futurist style: synthetic abstract subjective dynamic forms.

Still research more struggle.

ON WITH FUTURISM ...

Published in exhibition catalogue 'Fu Balla – Balla Futurista', Sala d'Arte Angelelli, Rome, December 1915
Translation C T

F. T. Marinetti, Bruno Corra, Emilio Settimelli, Arnaldo Ginna, Giacomo Balla, Remo Chiti
The Futurist Cinema 1916

The book, a wholly passéist means of preserving and communicating thought, has for a long time been fated to disappear like cathedrals, towers, crenellated walls, museums, and the pacifist ideal. The book, static companion of the sedentary, the nostalgic, the neutralist, cannot entertain or exalt the new Futurist generations intoxicated with revolutionary and bellicose dynamism.

The conflagration is steadily enlivening the European sensibility. Our great hygienic war, which should satisfy *all* our national aspirations, centuples the renewing power of the Italian race. The Futurist cinema, which we are preparing, a joyful deformation of the universe, an alogical, fleeting synthesis of life in the world, will become the best school for boys: a school of joy, of speed, of force, of courage, and heroism. The Futurist cinema will sharpen, develop the sensibility, will quicken the creative imagination, will give the intelligence a prodigious sense of simultaneity and omnipresence. The Futurist cinema will thus cooperate in the general renewal, taking the place of the literary review (always pedantic) and the drama (always predictable), and killing the book (always tedious and oppressive). The necessities of propaganda will force us to publish a book once in a while. But we prefer to express ourselves through the cinema, through great tables of words-in-freedom and mobile illuminated signs.

With our manifesto 'The Futurist Synthetic Theatre', with the victorious tours of the theatre companies of Gualtiero Tumiati, Ettore Berti, Annibale Ninchi, Luigi Zoncada, with the two volumes of *Futurist Synthetic Theatre* containing eighty theatrical syntheses, we have begun the revolution in the Italian prose theatre. An earlier Futurist manifesto had rehabilitated, glorified, and perfected the Variety Theatre. It is logical therefore for us to carry our vivifying energies into a new theatrical zone: the *cinema*.

At first look the cinema, born only a few years ago, may seem to be Futurist already, lacking a past and free from traditions. Actually, by appearing in the guise of *theatre without words*, it has inherited all the most traditional sweepings of the literary theatre. Consequently, everything we have said and done about the stage applies to the cinema. Our action is legitimate and necessary in so far as the cinema up to now *has been and tends to remain profoundly passéist*, whereas we see in it

the possibility of an eminently Futurist art and *the expressive medium most adapted to the complex sensibility of a Futurist artist.*

Except for interesting films of travel, hunting, wars, and so on, the film-makers have done no more than inflict on us the most backward-looking dramas, great and small. The same scenario whose brevity and variety may make it seem advanced is, in most cases, nothing but the most trite and pious *analysis*. Therefore all the immense *artistic* possibilities of the cinema still rest entirely in the future.

The cinema is an autonomous art. The cinema must therefore never copy the stage. The cinema, being essentially visual, must above all fulfil the evolution of painting, detach itself from reality, from photography, from the graceful and solemn. It must become antigraceful, deforming, impressionistic, synthetic, dynamic, free-wording.

ONE MUST FREE THE CINEMA AS AN EXPRESSIVE MEDIUM in order to make it the ideal instrument *of a new art*, immensely vaster and lighter than all the existing arts. We are convinced that only in this way can one reach that *polyexpressiveness* towards which all the most modern artistic researches are moving. Today the *Futurist cinema* creates precisely the POLYEXPRESSIVE SYMPHONY that just a year ago we announced in our manifesto 'Weights, Measures, and Prices of Artistic Genius'. The most varied elements will enter into the Futurist film as expressive means: from the slice of life to the streak of colour, from the conventional line to words-in-freedom, from chromatic and plastic music to the music of objects. In other words it will be painting, architecture, sculpture, words-in-freedom, music of colours, lines, and forms, a jumble of objects and reality thrown together at random. We shall offer new inspirations for the researches of painters, which will tend to break out of the limits of the frame. We shall set in motion the words-in-freedom that smash the boundaries of literature as they march towards painting, music, noise-art, and throw a marvellous bridge between the word and the real object.

Our films will be:

1. CINEMATIC ANALOGIES that use reality directly as one of the two elements of the analogy. Example: If we should want to express the anguished state of one of our protagonists, instead of describing it in its various phases of suffering, we would give an equivalent impression with the sight of a jagged and cavernous mountain.

The mountains, seas, woods, cities, crowds, armies, squadrons, aeroplanes will often be our formidable expressive words: THE UNIVERSE WILL BE OUR VOCABULARY. Example: We want to give a sensation of strange cheerfulness: we show a chair cover flying comically around

Gallarate 1915

Marinetti, Boccioni, Sant'Elia and Sironi at
arate in 1915

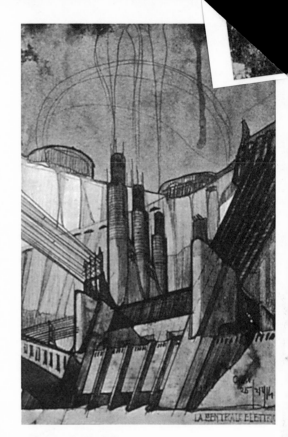

LA CENTRALE ELETTRICA

115 Antonio Sant'Elia
Electric Power Station 1914

116 Antonio Sant'Elia
Electric Power Station 1914

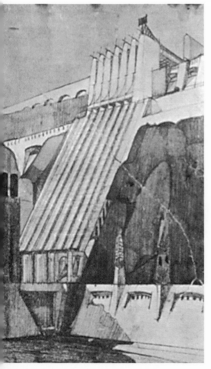

117 Sant'Elia, Boccioni and Marinetti as volunteers
in 1915

118–24 Anton Giulio Bragaglia
Frames from the film 'Perfidio inca
1916

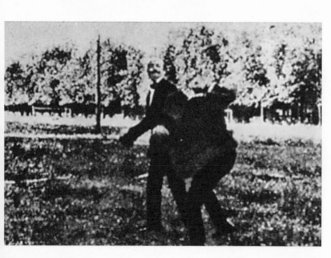

125 Arnaldo Ginna
Ginna and Marinetti engaged in
Interventionist Fisticuffs,
frame from the film
'Vita futurista' 1916

One of the last photographs of Umberto Boccioni,
[...]na, 1916

127 Umberto Boccioni
Portrait of Maestro Busoni 1916

[...]mberto Boccioni *Landscape* 1916

129 Mario Sironi *Harlequin* 1916

0 Mario Sironi
lf-portrait 1916

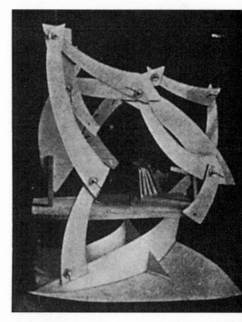

131 Fortunato Depero
Plastic Motor-Noise Construction 1915

132 Fortunato Depero
The Automata 1916

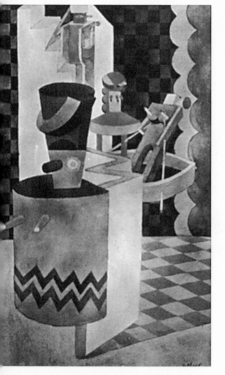

133 Pictures and words-in-freedom by Depero at a one-man show in Rome, 1916

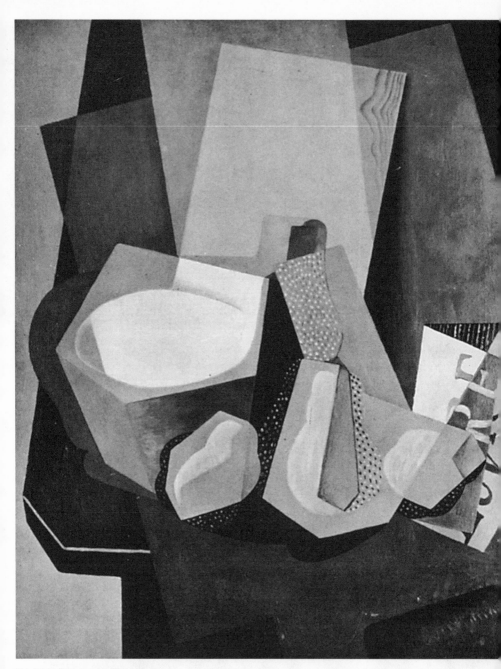

134 Gino Severini *Still-life* 1918

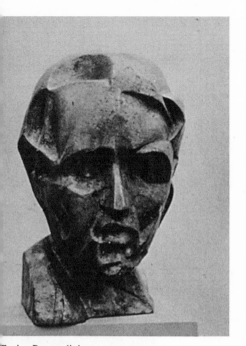

Enrico Prampolini
ognomic Dynamism:
ait of Count Bino Sanminiatelli 1916–17

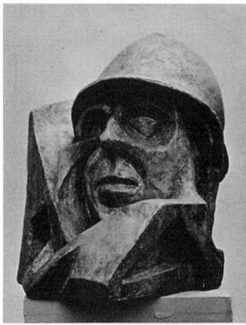

136 Enrico Prampolini
Portrait of my Brother, Figure-Surroundings
1916–17

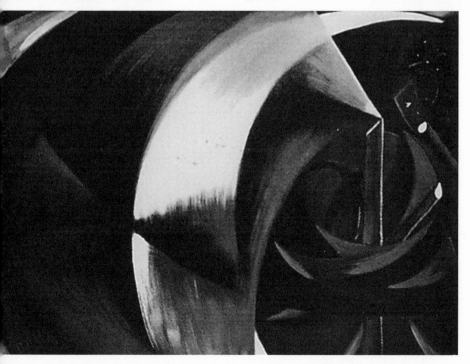

Giacomo Balla *Sketch for 'Woodcutting'* 1917

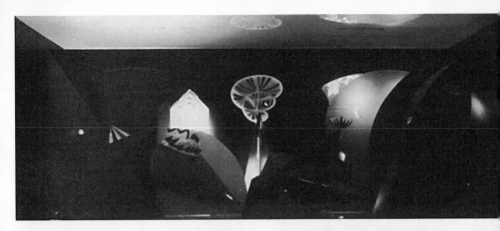

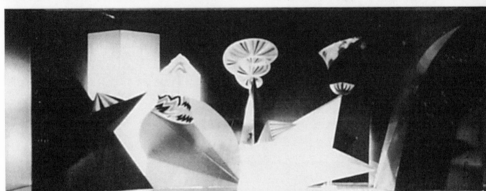

138–39 Giacomo Balla *Stage Sets for Diaghilev's 'Feux d'artifice'* (modern reconstructions, with light-effects)

140 Giacomo Balla

an enormous coat stand until they decide to join. We want to give the sensation of anger: we fracture the angry man into a whirlwind of little yellow balls. We want to give the anguish of a hero who has lost his faith and lapsed into a dead neutral scepticism: we show the hero in the act of making an inspired speech to a great crowd; suddenly we bring on Giovanni Giolitti who treasonably stuffs a thick forkful of macaroni into the hero's mouth, drowning his winged words in tomato sauce.

We shall add colour to the dialogue by swiftly, simultaneously showing every image that passes through the actors' brains. Example: representing a man who will say to his woman: 'You're as lovely as a gazelle,' we shall show the gazelle. Example: if a character says, 'I contemplate your fresh and luminous smile as a traveller after a long rough trip contemplates the sea from high on a mountain,' we shall show traveller, sea, mountain.

This is how we shall make our characters as understandable *as if they talked.*

2. CINEMATIC POEMS, SPEECHES, AND POETRY. We shall make all of their component images pass across the screen.

Example: 'Canto dell'amore' [Song of Love] by Giosuè Carducci:

> In their German strongholds perched
> Like falcons meditating the hunt

We shall show the strongholds, the falcons in ambush.

> From the churches that raise long marble
> arms to heaven, in prayer to God

> From the convents between villages and towns
> crouching darkly to the sound of bells
> like cuckoos among far-spaced trees
> singing boredoms and unexpected joys ...

We shall show churches that little by little are changed into imploring women, God beaming down from on high, the convents, the cuckoos, and so on.

Example: 'Sogno d'Estate' [Summer's Dream] by Giosuè Carducci:

> Among your ever-sounding strains of battle, Homer, I am
> conquered by
> the warm hour: I bow my head in sleep on Scamander's
> bank, but my
> heart flees to the Tyrrhenian Sea.

We shall show Carducci wandering amid the tumult of the Achaians, deftly avoiding the galloping horses, paying his respects to Homer,

going for a drink with Ajax to the inn, The Red Scamander, and at the third glass of wine his heart, whose palpitations we ought to see, pops out of his jacket like a huge red balloon and flies over the Gulf of Rapallo. This is how we make films out of the most secret movements of genius.

Thus we shall ridicule the works of the passéist poets, transforming to the great benefit of the public the most nostalgically monotonous weepy poetry into violent, exciting, and highly exhilarating spectacles.

3. CINEMATIC SIMULTANEITY AND INTERPENETRATION of different times and places. We shall project two or three different visual episodes at the same time, one next to the other.

4. CINEMATIC MUSICAL RESEARCHES (dissonances, harmonies, symphonies of gestures, events, colours, lines, etc.).

5. DRAMATIZED STATES OF MIND ON FILM.

6. DAILY EXERCISES IN FREEING OURSELVES FROM MERE PHOTOGRAPHED LOGIC.

7. FILMED DRAMAS OF OBJECTS. (Objects animated, humanized, baffled, dressed up, impassioned, civilized, dancing – objects removed from their normal surroundings and put into an abnormal state that, by contrast, throws into relief their amazing construction and nonhuman life.)

8. SHOW WINDOWS OF FILMED IDEAS, EVENTS, TYPES, OBJECTS, ETC.

9. CONGRESSES, FLIRTS, FIGHTS AND MARRIAGES OF FUNNY FACES, MIMICRY, etc. Example: a big nose that silences a thousand congressional fingers by ringing an ear, while two policemen's moustaches arrest a tooth.

10. FILMED UNREAL RECONSTRUCTIONS OF THE HUMAN BODY.

11. FILMED DRAMAS OF DISPROPORTION (a thirsty man who pulls out a tiny drinking straw that lengthens umbilically as far as a lake and dries it up *instantly*).

12. POTENTIAL DRAMAS AND STRATEGIC PLANS OF FILMED FEELINGS.

13. LINEAR, PLASTIC, CHROMATIC EQUIVALENCES, ETC., of men, women, events, thoughts, music, feelings, weights, smells, noises (with white lines on black we shall show the inner, physical rhythm of a husband who discovers his wife in adultery and chases the lover – rhythm of soul and rhythm of legs).

14. FILMED WORDS-IN-FREEDOM IN MOVEMENT (synoptic tables of lyric values – dramas of humanized or animated letters – orthographic dramas – typographical dramas – geometric dramas – numeric sensibility, etc.).

Painting + sculpture + plastic dynamism + words-in-freedom + composed noises [*intonarumori*] + architecture + synthetic theatre = Futurist cinema.

THIS IS HOW WE DECOMPOSE AND RECOMPOSE THE UNIVERSE ACCORDING TO OUR MARVELLOUS WHIMS, to centuple the powers of the Italian creative genius and its absolute pre-eminence in the world.

11 September 1916
Published by *L'Italia futurista* (Milan),
15 November 1916
Translation R W F

Giacomo Balla
The Futurist Universe 1918

Any store in a modern town, with its elegant windows all displaying useful and pleasing objects, is much more aesthetically enjoyable than all those passéist exhibitions which have been so lauded everywhere. An electric iron, its white steel gleaming clean as a whistle, delights the eye more than a nude statuette, stuck on a pedestal hideously tinted for the occasion. A typewriter is *more architectural* than all those building projects which win prizes at academies and competitions. The windows of a perfumer's shop, with little boxes and packets, bottles and futur-colour triplicate phials, reflected in the extremely elegant mirrors. The clever and gay modelling of ladies' dancing-shoes, the bizarre ingenuity of multi-coloured parasols. Furs, travelling bags, china – these things are all a much more rewarding sight than the grimy little pictures nailed on the grey wall of the passéist painter's studio.

Rome, 1918
Published in exhibition catalogue 'Futurballa',
Galleria d'Arte Contemporanea, Florence, November 1952
Translation R B

Futurism:
May the Force Be with You

1909 was a good year for the future. Henry Ford launched his 'Model T' car, Louis Bleriot flew across the English Channel and Adolf Hitler – but this can't count as 'good' – realised his historical destiny when overhearing a docent in a Viennese museum explain the mystical power of 'Longinus's Spear'. And of course F. T. Marinetti published 'The Founding and Manifesto of Futurism' in the Paris daily *Le Figaro* on 20 February. As with Hitler (the comparison is a little unfair), Marinetti's vision took him on a path to an exhilarated self-destruction which mirrored the deadly course of his nation's fate.

At the turn of the twentieth century, prophecy and vision were part of the intellectual scheme of things and manifestos were one of their fastest and most ubiquitous vehicles. Scattered from the top of St. Mark's Campanile in Venice or handed out to Milanese factory workers as they came and went to work – manifestos were the confetti of a new marriage of ideas. Artists approached Tom Wolfe's 'painted word' as never before, generating and disseminating over-cooked and half-baked theories and looking for ever new means of engaging a mass audience. There was a lot to say and time was at a premium.

The nineteenth and early twentieth centuries saw an unprecedented interest in the question of time among writers and artists as well as scientists, philosophers and eccentrically indefinable pundits. Whether it was Pre-Raphaelite and Symbolist pre-cognition, Proust's and Wells's fiction,

221

Bergson's duration, Einstein's relativity or Ouspensky's fourth dimension, the riddle of past, present and future was a dominant and obsessive theme.

Some merely analysed the question of time and memory, others sought to master it and become, so to speak, 'Time Lords', omniscient within the temporal flow as they intuitively grasped the inevitable shape of the future. Futurism seems to come with Darwinian evolution, evoking a sci-fi fantasy of 'Things to Come', with intergalactic travel, alien encounters and extraordinary transformations of the human mind and body. Strangely, these things can quickly seem as dated as Flash Gordon and last year's computer game. Marinetti understood this built-in obsolescence of the 'new' and stressed a more fundamental idea. The word 'future' comes from the Latin *futurus*, the future participle of *esse* (to be). It is thus a word which has its roots in the dynamism of now and suggests the seeds of what is to be are lying in the field of the present. Futurism was far more about the energy of present commitment and intuitive action than about space-ships and utopia. It was a blueprint for urgent political action dispatched to a new nation in a hurry. Marinetti's famous description in the 'Founding Manifesto' of his night-time drive in the 'beautiful shark', his sexualised motor car, which ends up in a muddy ditch, provided a founding myth. These were the heroic portents of a future Italy which had shed its past, its museums and second-class status in Europe and was prepared to risk all on machines and violent action. They are the words of an era still in the grip of both materialist progress and symbolist dream and provide a powerful contrast to our own pessimism and fear of what the novelist J. G. Ballard has called 'a nightmare marriage between sex and technology'.

For the Futurists the new technologies of flight, locomotion, radio, telephone, cinema, x-rays and radio provided the raw objective material of an art which aimed at re-inventing the categories of time and space, object and subject. Marconi, the Italian inventor of wireless telegraphy, was for them not only an honorary Futurist but the initiator of new patterns of consciousness which their art would manifest. The new language of radio signals suggested an unexplored realm of communication with profound implications for all the arts.

Although international in its ambitions and programme, Futurism was the product of a particular culture – that of industrial northern Italy and in particular Milan where 'HQ' was. Italy's economy had grown rapidly since the unification of 1861 and both the financial and political power lay in the north where Vittorio Emmanuele III and his government were

based. In spite of the economic resurgence, however, the new country was politically unstable, split between north and south and still dominated by regional rivalries. The new liberal regime was seen as complacent and decadent by more aggressive groups who played on both popular dissatisfaction with high taxation and aspirations to imperial expansion. By the 1880s a depression had set in and the myriad political factions created an unstable political climate barely controlled by the authoritarian Francesco Crispi. The humiliating military defeat by Abyssinia at the Battle of Adua ended his colonial ambitions and saw the arrival of the chameleon Giovanni Giolitti. Giolitti was a moderate pragmatist who operated by divide-and-rule tactics and became the hated image of Italy's weakness for radical socialists, nationalists and anarchists. Small groups plotted and ran journals full of political analysis and intellectual jousting.

The Futurists grew out of this hinterland of covert and discontented visionary activity. Marinetti was well-connected to men such as Ottavio Dinale, the editor of the splendidly named *La Demolizione*, dedicated to 'vast social battle' and cultural renewal and to Giovanni Amendola, who wrote in his journal *La Voce* of his disgust at Giolitti's lack of vision and of his sense of 'the path that will lead us to a national life in tune with our present ideals and needs'. These editors published political and art manifestos as well as examples of new painting and thought, keeping up an output of constant provocation and novelty for their readerships. The avant-garde culture of Paris was a particularly important source for the Italians as they looked for new means to express their 'national modernism'. The whole wave of French symbolist, post-impressionist, fauvist and Cubist developments from the 1880s became rich pickings for eclectically excitable Italian painters such as Boccioni and Carrà who rose to Marinetti's call for a distinctive Italian contribution to the cosmopolitan world of international art.

Futurism was thus a movement which began with words, a development out of a suggestively vague manifesto in search of its protagonists, be they visual artists, poets or political agitators. It required an intellectual reconditioning of the main philosophical tenets of art practice and found much of this in the ideas of two thinkers, Friedrich Nietzsche and Henri Bergson. Nietzsche was common currency within the avant-garde by 1909, including down-and-outs like the young Hitler. He emphasised a transformation of morals 'beyond good and evil', the rejection of the habits of the 'herd' and the imminent arrival of the 'superman' with his 'will-to-power'

223

who was easily converted by Nietzsche's disciples into the radical artist. 'Only as an aesthetic phenomenon is the world and the phenomenon of man eternally justified', he wrote with ominous foresight as well as conviction. The angry political noise-makers of *fin-de-siècle* Italy found much to ponder in the German's rejection of the Judaeo-Christian legacy and its ethical and aesthetic assumptions.

Bergson's philosophy of 'becoming' stressed the primacy of intuition over intellect and its capacity for going with the flow of time or 'duration'. Intuition, that most romantic of artistic faculties, was thus the avant-garde of the human organism as it evolved and it became a watchword for Marinetti and his followers. His lectures at the Collège de France in Paris were enormously popular with both intellectuals and the 'herd' and had a major effect on artists, writers and political theorists. The Syndicalist theorist Georges Sorel, a decisive influence on Futurist thought, was, for instance, a devotee of Bergson's concept of 'creative evolution', which seemed to justify perpetual violent social revolution as the expression of the 'life force'. Art and life were to be dissolved into one another as artists lead the way to a new level of human existence.

The Futurist artists were all political radicals of one kind or another, fiercely nationalistic in the main and zealous in their desire to make something different and striking from this powerful cocktail of ideas and circumstances. Led by the astonishing and indefatigable Marinetti, they absorbed and transformed new ideas from France and Germany and then launched them back at their places of origin in a series of touring exhibitions and events from Paris and London to Moscow and Berlin. It was the arts supplement to Italy's imperialist adventures in North Africa at the time, a belligerent attempt to carve out a bit of the action for themselves. They manipulated the media to gain maximum attention for their riotous *serate* (evenings) and 'noise concerts', headline-grabbing events with their outrageous assaults on conventional taste and frequent outbursts of deliberately orchestrated violence.

By 1912, their art had attained a certain corporate identity with its contemporary subject-mater, rude clashing colours, 'lines of force' and simultaneous viewpoints. Their aim was to grasp the spectator's attention, like a good Nietzschean should, and plunge him or her into the pictorial space the experience of which would generate a sense of dynamism, flux and instability. Past, present and future co-existed in the works as memory and anticipation were suggested and the single self, that naïve

224

assumption of yesteryear, was swirled into multiple ecstasy and uncertainty. Accompanied by gales of interviews and manifestos, these efforts had a dramatic effect both on artists in London and elsewhere who sought to emulate the provocation and aesthetic experimentation, and on a public thirsty to consume a variety of second-hand sensation. By 1914 there was not only Futurist painting, sculpture, literature, music and photography, much of it highly original, but also manifestos and action on lust, variety theatre, film, architecture, design, clothing and what Balla described as 'the futurist reconstruction of the universe'. A complete lifestyle was on offer. It was the perfect publicity campaign, masterminded by Marinetti, and the first occasion on which the distinctions between art, life and politics were seriously collapsed into a new genre of imaginative and prophetic propaganda.

Propaganda for what? When war broke out in 1914, the Futurists agitated for Italy's entrance into the conflict on the side of the allies who they saw as not only the enemies of the hated oppressors of new Italy, the Austro-Hungarian empire, but as progressive states of the future. They derided what they saw as the *passetismo* of Germanic culture and attacked the pacifism and cowardice of all those among their compatriots who did not subscribe to the need for intervention. War was 'the sole hygiene of the world', a sort of blood-letting in the interests of a cure for the creeping degeneration in the social tissue, and the natural consequence of their imperialistic urges and intellectual agenda. Thus when Italy joined hostilities in 1915, Boccioni, who bathetically died falling from his cavalry horse while training, and Carrà, who fought as an infantryman, had contributed through their edgy 'interventionist' works and propaganda to what became in effect a national disaster.

The nature of Italy's recovery from the effects of war was as dramatic for the nation as its entry had been. In spite of deaths and disruption to it, Marinetti sought a place for his movement in the emerging new order which drew on widespread antipathy to the old political and industrial leadership. This proved more difficult than he would have wished. He had identified with the *Arditi* ('The Daring Ones'), the war veterans who formed the basis of the Fascist movement under Mussolini. His own Futurist Political Party was launched in 1918 to capture such support with a broadly leftist set of proposals for 'revolutionary nationalism'. These included compulsory gymnastics, proportional representation, socialisation of the land and equal pay for women. Mussolini had been much

225

influenced by Futurist ideas, but when he came to power in 1922, following the March on Rome, he treated Marinetti and his nationwide organisation with extreme caution. Mussolini was a pragmatist who viewed the Futurist leader's radical agenda with misgivings, particularly as Marinetti had had himself voted on to the Fascist party's Central Committee in 1919. The Italian state archives show to what extent the new regime kept a close eye on the activities of movement.

Mussolini wanted to have a 'cutting edge' to his image and the Futurists provided much of this, but he was also an exponent of a more traditionally national culture as promoted by his mistress, Margherita Sarfatti, through the Novecento movement. When Marinetti spoke of anti-clericalism and 'elastic liberty' as if he meant it, 'Il Duce' recoiled. By the mid-1920s Marinetti had to make do with a rather disgruntled position as mouthpiece of an avant-garde sideshow, and in 1929 with a very un-Futurist role as member of the new 'Reale Accademia d'Italia', along with Pirandello and Marconi. He was now an unwilling voice of the past, noisy in his espousal of 'Second Futurism' and its various manifestations, but desperate for recognition and the continuance of the Italian revolution he felt he had initiated.

While former adherents such as Carrà and Sironi moved to a more traditional, if fascinating and metaphysical, *Italianità*, the second phase of Futurists included the stalwart Balla and new figures such as Fortunato Depero and Enrico Prampolini. They were all enthusiastic Fascists who chose to see Mussolini as the true heir to pre-war 'ideals and needs', rather than the cautious politician many of them no doubt realised he was. The tendency of much of their art in the 1920s was towards a design-conscious abstraction or formalism, indebted to Bauhaus approaches. By 1930, however, the launch of *aeropittura* ('aerial painting') was an attempt to rejuvenate the heroics of the early years and to re-engage with popular subject matter. The pilot was in many ways the ultimate Futurist figure – defying gravity and earthbound instincts as he became 'part of the machine', aspiring to a physical and spiritual freedom absolutely at one with the existential origins of the movement. In 1918, the Futurist Felice Azari choreographed aerial 'dances' in a plane over Milan to the accompaniment of Russolo's music, and by 1931 Italo Balbo, the first Italian to cross the Atlantic, was the living embodiment of the Fascist glorification of daring aviation. Drawing on enthusiasm for such imagery, 'aeropittura' moved in two divergent directions – towards, on the one

226

hand, a form of abstraction in the case of Prampolini, for example, where the spiritual dimension of flight was central; and on the other, to an aggressively militaristic stylised figuration. The latter, practised by artists such as Tullio Crali, often depicted the vertiginous view through the sights of dive-bombers attacking targets in Abyssinia, the theatre of Mussolini's own bid for imperial glamour. This was in truth a vulgarised, quasi-cinematic version of the styles Boccioni and others had forged before 1914.

Marinetti's loyal followers maintained the movement across Italy in the belief that it was still the expression of the authentic new Italy, even though by the mid-1930s the Ministry of Popular Culture was exercising a sustained attack on its image and activities. There was still a notion of Futurism as a way of life, with regular architectural and design displays, fascinating attempts to create a Futurist Catholic imagery and even a Futurist cookbook, with recipes such as 'Words-in-Freedom Sea Platter' recommending often inedible combinations of ingredients. But really the show was over and had been for some time.

Marinetti, the indomitable patriot, who had volunteered for duty in 1915 and again at the age of sixty during the invasion of Abyssinia in 1936, once more offered his services to his country when Italy joined the war in 1940. By now a devout follower of 'Il Duce', whom he wrote of as 'proud cosmic divinity of heroism and invisible volcanoes', he was enlisted for active service on the Russian front in 1942, and in 1943 followed his leader to the brief Republic of Salò. He died in 1944, aged sixty-eight, seemingly undiminished in his prophetic ardour and a few months before the ignoble execution of Mussolini.

RICHARD HUMPHREYS
Head of Interpretation and Education, Tate Britain
London, July 2001

Chronology

1909: 20 February. The Paris *Figaro* publishes the Manifesto of Futurism by F. T. Marinetti, later reissued as a series in Nos. 3, 4, 5 and 6 of *Poesia* in Milan and read aloud by Marinetti at the Teatro Alfieri, Turin. when his play *La donna mobile* was being performed. Marinetti meets Boccioni, Bonzagni, Camona, Carrà, Erba, Martelli, Romani and Russolo. During the general election in March Marinetti publishes his First Political Manifestos.

1910: 11 February. Balla, Boccioni, Bonzagni, Carrà, Romani, Russolo and Severini sign their names to the Manifesto of Futurist Painters, first produced as a pamphlet by the *Poesia* press; a second edition later appeared without the signatures of Romani and Bonzagni. 11 April. Balla, Boccioni, Carrà, Russolo and Severini sign the Futurist Painting Technical Manifesto. 27 April. Marinetti writes his Manifesto against Passéist Venice, signed by Atomare, Boccioni, Bonzagni, Buzzi, Carrà, Cavacchioli, Folgore, Gorrieri, Marinetti, Mazza, Palazzeschi, Russolo and Severini. 8 October. Marinetti on trial in Milan accused of an outrage against public taste in his book *Mafarka le futuriste;* acquitted. Futurist demonstration in court.

1911: 11 January. Balilla Pratella writes his Manifesto of Futurist Musicians. Exhibition of 'free art', inaugurated on 30 April in the Ricordi rooms, Milan, includes Boccioni, Carrà and Russolo. Boccioni's painting *Laughter* defaced. 22 June. *La Voce*, organ of the rival 'Florentine Movement', publishes an article by A. Soffici: 'Arte libera e libera pittura futurista', a violent attack on Futurism and the Milan exhibition. Boccioni, Carrà, Marinetti and Russolo organize a 'punitive expedition' against the author. They go to Florence, where, at the Caffè delle Giubbe Rosse, a haunt of Bohemians, they have an animated discussion with Soffici, Prezzolini, Slataper and Papini. They come to blows and are taken to police headquarters. Later, having calmed down, they discover (*ill. 60*) that Futurists and 'Vociani' really have many things in common. November. Boccioni and Carrà leave for Paris to prepare for a Futurist exhibition which is to take place the following February at Bernheim-Jeune's gallery. Through Severini they make contact with the Paris art world, and they see the work of the Cubists and meet Apollinaire.

1912: 5 February to 12 February. Exhibition of Futurist paintings by Boccioni, Carrà, Russolo and Severini at the Galerie Bernheim-Jeune, Paris. Boccioni, Carrà and Russolo are present at the opening, and later broaden their knowledge of the works of the Cubists and Symbolists. Exhibition moves to London (March), Berlin (April), Brussels (June), The Hague (August), Amsterdam (September) and Munich (October). 25 March. Manifesto of Futurist Women, by Valentine de Saint-Point. 11 April. Boccioni publishes his Technical Manifesto of Futurist Sculpture. 11 May. Marinetti publishes his Technical Manifesto of Futurist Literature, as a Preface to *Zang tumb tumb* (*Bombardamento di Adrianopoli*). Balla travels in Germany, where he works on *Hands of a Violinist* and an *Iridescent Interpenetration*.

1913: 1 January. Attilio Vallecchi, the publisher, issues the first number of the Florentine fortnightly *Lacerba*, which claims to be the spokesman of all the principles of irrationalism, stating that what counts is art and liberty, which exist on the 'superior level of a lone individual, intelligent and unprejudiced'. 11 May. Marinetti writes his manifesto, 'Imagination without Strings – Words-in-Freedom'. 20 June. Apollinaire writes his manifesto 'Futurist Anti-tradition', published in *Lacerba*, 15 September. 11 August. Carrà writes his manifesto 'The Painting of Sounds, Noises and Smells'. 11 October. Boccioni, Carrà, Russolo and Marinetti sign the 'Futurist Political Programme',

published in *Lacerba* on 15 October. Papini and Soffici quarrel.

1914: 15 January. Palazzeschi publishes in *Lacerba* his manifesto 'Against Sadness'. March. Carrà, Papini, Soffici and perhaps Palazzeschi in Paris, guests of Baroness Hélène d'Oettingen, a friend of Soffici's. In the same apartment the journal *Soirées de Paris* is published. The Futurist painters are in contact with Apollinaire, Archipenko, Picasso, Kahnweiler, Modigliani; they visit the Vollard and Ruel collections and see Rouault's paintings; Carrà visits Matisse and Vlaminck. In the meantime they hold a running argument with Delaunay. Boccioni's book *Pittura scultura futuriste* appears. 28 April. Palazzeschi publishes in *La Voce* his 'Declaration' which marks his departure from Futurism. Carrà informs Soffici that Palazzeschi has sent off his resignation from Paris to Marinetti. 11 July. Manifesto of Futurist Architecture. 11 September. Balla and Cangiullo sign the manifesto 'Anti-neutral Clothes'; as a result some 'anti-neutral clothes' are made and worn by Balla, Cangiullo and Marinetti. 15–16 September. Boccioni, Marinetti, Mazza, Piatti and Russolo put on interventionist demonstrations in Milan, at the Teatro Dal Verme and in the Piazza Duomo, and as a result are arrested.

20 September. Boccioni, Carrà, Marinetti, Piatti and Russolo sign their manifesto 'Futurist Synthesis of War'.

1915: 11 January and 18 February. Corra, Marinetti and Settimelli write their manifesto 'The Futurist Synthetic Theatre', published 1916. 11 March. Balla and Depero sign the manifesto 'The Futurist Reconstruction of the Universe'. End of March. Mario Sironi joins the Futurists. 11 April. Balla, Corra, Marinetti, Russolo and Sant'Elia join a battalion of volunteer cyclists.

1916: 1 June. The founding in Florence of the journal *Italia Futurista* directed by Corra and Settimelli. 6 July. Sant'Elia receives a decoration after an operation on Mount Zevio. 17 August. Boccioni, after falling from his horse during a military exercise the day before, dies at dawn. 10 October. Sant'Elia killed in battle.

1917: May. Marinetti wounded at the front but recovers in hospital. 17 December. Russolo is wounded.

1918: October. Anton Giulio Bragaglia opens his Casa d'Arte in Rome, 21 via Condotti. December 1918–January 1919. The founding of Fascist Futurist Clubs in Ferrara, Florence, Rome and Taranto.

Selected Bibliography

This presentation of accessible sources is arranged as a selection of: *Bibliographies* (bibl. 1–9), *General Works* (bibl. 10–62), *Monographs* (bibl. 63–77), *Catalogues* (bibl. 78–87), *Special Numbers* (bibl. 88–94), and *Periodicals* (bibl. 95–97).

Articles have been omitted since these are fully covered in the bibliographies noted, either comprehensively by Gambillo (bibl. 31), selectively by Carrieri (bibl. 23) or Martin (bibl. 49), as well as being easily updated through *The Art Index* (H. W. Wilson, New York).

BERNARD KARPEL
Chief Librarian
The Museum of Modern Art, New York

BIBLIOGRAPHIES

1. Ballo, Guido. Bibliografia. In his: *Boccioni* (bibl. 64). An exhaustive record of Futurist references, pp. 513–528, which also constitutes a chronological bibliography from 1914 to 1962.

2. Carrieri, Raffaele. Bibliography. In his: *Futurism* (bibl. 23). Contents, pp. 171–179: 1. Manifestos. – 2. Writings of Boccioni. – 3. Writings of Carrà. – 4. Writings of Marinetti. – 5. Writings of Prampolini. – 6. Writings of Rosai.

– 7. Writings of Russolo. – 8. Writings of Severini. – 9. Writings of Soffici. – 10. Periodicals. – 11. Catalogues (1910 – 1961). – 12. General References. – 13. Articles and Critical Essays.

3. Davis, Alexander. *LOMA. Literature on Modern Art: An Annual Bibliography*. London, Lund Humphries, 1969–current. Vol. 1, 1969: Futurism, no. 3023–3028. – Vol. 2, 1970: Futurism (index, p. 179).

4. Falqui, Enrico. *Bibliografia e iconografia del futurismo*. Florence, Sansoni, 1959. Bibliografia, pp. 27–110. – Iconografia: Futuristi, Manifesti futuristi, pl. 1–100.

5. Gambillo, Maria Drudi and Teresa Fiori. *Archivi del futurismo* (bibl. 31). An almost exhaustive record of references by the Futurists and about the movement. Bibliography in vol. 1 continued into vol. 2 (1962).

6. Karpel, Bernard. Selected bibliography of Futurism: 1905–1961. In: Taylor, Joshua C. *Futurism* (bibl. 58). 103 references, with brief introduction and annotations, devoted to early Futurism and later Italian art. Includes Boccioni, Carrà, Russolo, Severini, Soffici. Supplementary data in J. T. Soby: *Twentieth-Century Italian Art* (bibl. 56).

7. Kirby, Michael. Selected bibliography. In his: *Futurist Performance* (bibl. 39). Primary and secondary sources in both English and Italian, pp. 322–327. Annotations.

8. Martin, Marianne W. Selected bibliography. In her: *Futurist Art and Theory, 1909–1915* (bibl. 49). Contains, pp. 207–213, 'only the most important and/or accessible items', including a section on exhibition catalogues (1912–1918).

9. Necchi, Elda and Giani, Vrania. Bibliografia essenziale. In: Raffaele Carrieri. *Pittura, scultura d'avanguardia (1890–1950)*. Milan, Conchiglia, 1950. Omitted in English edition (bibl. 22).

GENERAL WORKS

10. Apollinaire, Guillaume. *Apollinaire on Art. Essays and Reviews 1902–1918. Edited by LeRoy C. Breunig.*

New York, Viking; London, Thames & Hudson, 1972. Documents of 20th-Century Art series. Index references to Balla, Boccioni, Carrà, Russolo, Severini. Additional data on Apollinaire and the Futurists in Martin (bibl. 49), p. 205.

11. Apollonio, Umbro. *Futurismo*. Milan, Mazzotta, 1969. Translation, *Futurist Manifestos*, published London, Thames & Hudson, New York, Viking, 1973.

12. Ballo, Guido. *La linea dell'arte italiana – del simbolismo alle opere moltiplicate*. Rome, Ed. Mediterranee, 1964. 2 vol.

13. Ballo, Guido. *Modern Italian Painting from Futurism to the Present Day*. New York, Praeger; London, Thames & Hudson, 1958. References, pp. 14–31; also chronology, p. 207ff. Bibliography only in original edition: *Pittori italiani del futurismo a oggi*. Rome, Ed. Mediterranee, 1956.

14. Ballo, Guido. *Preistoria del futurismo*. Milan, Maestri, 1960.

15. Banham, Reyner. *Theory and Design in the First Machine Age*. 2nd ed. New York, Washington, Praeger, 1967. Section 2: 'Italy: Futurist manifestos and projects, 1909–1914', includes Sant'Elia. Bibliography. First published London, Architectural Press; New York, Praeger, 1960.

16. Baumgarth, Christa. *Geschichte des Futurismus*. Reinbek bei Hamburg, Rowohlt, 1966.

17. Benet, Rafael. *El futurismo y el movimiento Dadá*. Barcelona, Omega, 1949.

18. Boccioni, Umberto. *Pittura scultura futuriste (dinamismo plastico)*. Milan, Poesia, 1914. Also included in *Opera completa* (Foligno, Campitelle, 1927), *Estetica e arte futuriste* (Milan, Il Balcone, 1946).

19. [Calvesi, Maurizio. *Il futurismo*. Milan, Fabbri, 1967]. *L'Arte Moderna* (bibl. 89) devotes vol. 5 to Futurism, consisting largely of texts by Maurizio Calvesi. Individual numbers also grouped and issued, bound in boards, as *L'Arte Moderna*, vol. 13–15.

20. Carrà. Carlo. *Guerrapittura, futurismo politico, dinamismo plastico.* Milan, Poesia, 1915.

21. Carrà, Massimo and Giorgio de Marghis, eds. *'Lacerba'*. Milan, Mazzotta, 1970. Complete photographic facsimile of bibl. 95.

22. Carrieri, Raffaele. *Avant-garde Painting and Sculpture in Italy (1890–1950)*. Milan, Domus, 1955. Revised edition of bibl. 9.

23. Carrieri, Raffaele. *Futurism*. Milan, Il Milione, 1963. Also Italian edition (1961). Includes 163 pl. (col.), manifestos, classified bibliography, exhibitions.

24. Chipp, Herschel B. *Theories of Modern Art. A Source Book by Artists and Critics*. Contributions by Peter Selz and Joshua C. Taylor. Berkeley and Los Angeles, University of California, 1968. Chap. V: 'Futurism' consists of an introduction by Joshua C. Taylor and revised translations of important manifestos by Marinetti, Boccioni, Carrà. Bibliography, p. 641. Taylor's essay should be complemented by his: 'Futurism: the avant-garde as a way of life'. New York, *Art News Annual*, no. 34, pp. 80–87, 1968.

25. Clough, Rosa Trillo. *Futurism – the Story of a Modern Art Movement. A New Appraisal*. New York, Philosophical Library, 1966. Numerous extracts from the Italian. Bibliography. Primarily on the writings and theory, the first edition was entitled *Looking Back at Futurism* (New York, Cocce Press, 1942). Bibliography.

26. Crispolti, Enrico. *Il secondo futurismo*. Turin, Pozzo, 1962.

27. Eddy, Arthur Jerome. *Cubists and Post-Impressionism*. rev. ed. Chicago, McClurg, 1919. Futurism, pp. 164–190. Bibliography. First edition, 1914; also published London, Grant Richards, 1915.

28. Egbert, Donald Drew. *Social Radicalism and the Arts: Western Europe. A Cultural History from the French Revolution to 1968*. New York, Knopf, 1970. Futurist references in index (p. xxi).

29. *Encyclopedia of World Art*. New York. McGraw-Hill, 1960–1968. American revision of Italian edition published by the Istituto per la Collaborazione Culturale (Rome–Venice). See *Index* (vol. 15) for entries under Futurism and its participants. Bibliographies.

30. Fillia (Enrico Colombo). *Il futurismo: ideologia, realizzazione e polemiche del movimento futurista italiano*. Milan, Sonzogno, 1932. Includes most manifestos, not always complete. Bibliography. Similar coverage in his *Pittura futurista* (Turin, 1929).

31. Gambillo, Maria Drudi and Teresa Fiori. *Archivi del futurismo*. Rome, De Luca, 1958–1962. Massive anthologies in two vols. of writings, documents, catalogue of works, chronology (1909–1921). Bibliographies in both vols. Photographic illustrations in vol. 2.

32. Gambillo, Maria Drudi and Claudio Bruni. *After Boccioni: Futurist Paintings and Documents from 1915 to 1919*. Rome, La Medusa, 1961.

33. Giedion-Welcker, Carola. *Contemporary Sculpture: An Evolution in Volume and Space*. New York, Wittenborn, 1955. On Boccioni, pp. xii–xiv, 76–81, 260. Bibliography. Revised edition, 1961.

34. Haftmann, Werner. *Painting in the Twentieth Century*. New York, Praeger, London, Lund Humphries, 1960. Chapter on Futurism in vol. 1 and 2; biographies. Reissued, 1965. Revision of his *Malerei im 20. Jahrhundert*. Munich, Prestel, 1954–1955, 2 vols.

35. Hermet, Augusto. *La ventura delle riviste (1903–1940)*. Florence, Vallechi, 1941. A history of Italian periodical literature. Complemented by A. Romano and G. Scala: *La cultura italiana del '900 attraverso le riviste*. Turin, Einaudi, 1960–1961.

36. *History of Modern Painting from Picasso to Surrealism*. Geneva, Skira, 1950. Texts and documentation by Maurice Raynal, Hans Bolliger, et al. Futurism, pp. 82–85. Bibliography on Carrà, Severini. General bibliography.

231

37. Huyghe, René, ed. *Histoire de l'art contemporain: la peinture*. Avec le concours de Germain Bazin. Paris, Alcan, 1935. Italian sections by Gino Severini, Vergnet-Ruiz. General and specific bibliographies, pp. 475–482. Originally published in *L'Amour de l'Art*, Nov. 1934. Reprint edition: New York, Arno, 1968.

38. Jullian, René. *Le futurisme et la peinture italienne*. Paris, Société d'Edition d'Enseignement Supérieur, 1966. 'Transcription d'un cours professé à l'Institut d'art ... de l'Université de Paris ... 1963–1964.'

39. Kirby, Michael. *Futurist Performance*. With manifestos and playscripts translated from the Italian by Victoria Nes Kirby. New York, Dutton, 1971. Covers poetry readings, declamation, 'Russolo and the art of noise', theatre, cinema, radio. Detailed index includes important and little-known references. Chronology, bibliography.

40. Lake, Carleton and Robert Maillard, eds. *Dictionary of Modern Painting*. 2nd ed. London, Methuen, 1958; 3rd rev. ed. New York, Tudor [1964]. Articles on Futurism and artists of the movement by several contributors. Translated from *Dictionnaire de la peinture moderne* (Paris, Hazan, 1956).

41. Lehrmann, G. S. *De Marinetti à Maïakowski*. Fribourg, La Gare, 1942. Extract on Futurism also published in *XXe Siècle*, no. 8 Jan.1957.

42. *Manifesti del movimento futurista*. Milan, etc., v.d. Broadsides published by Poesia, Direzione del movimento futurista, et al. Details recorded in *Archivi del futurismo* (bibl. 31) with texts; convenient chronology in Baumgarth (bibl. 16) and Carrieri (bibl. 23); reproductions in Falqui (bibl. 4) and Scrivo (bibl. 54). Also note published collections mentioned here, bibl. 30, 43, 44, etc.

43. Marinetti, Filippo Tommaso. *Le Futurisme. Théories et mouvement*. Paris, Sansot, 1911. 'Manifestes et proclamations futuristes,' pp. 137–238. Owing to several early undated editions, this has been variously noted as 1910 (bibl. 36) and 1912 (bibl. 15). Falqui (bibl. 4) and others record 1911. Translations: *El Futurismo*. Traducción de Germán Gómez de la Mata y Hernández Luquero. Valencia, Sempere, 1912. – *Futurizm*. St Petersburg, Prometej, 1914.

44. Marinetti, Filippo Tommaso, ed. *I manifesti del futurismo lanciati da Marinetti, Boccioni, Carrà, Russolo, Balla, Severini, Pratella, Mme de Saint-Point, Apollinaire, Palazzeschi*. Florence, Lacerba, 1914. Collection of texts issued before 1914.

45. Marinetti, Filippo Tommaso. *Les Mots en liberté futuristes*. Milan, Poesia, 1919. With classic examples of Futurist typography.

46. Marinetti, Filippo Tommaso, ed. *I poeti futuristi con una proclama di F. T. Marinetti e uno studio sul verso libero di Paolo Buzzi*. Milan, Poesia, 1912.

47. Marinetti, Filippo Tommaso. *Teoria e invenzione futurista*. Verona, Mondadori, 1968. Preface by Aldo Palazzeschi; introduction and notes by Luciano de Maria.

48. Markov,Vladimir.*Russian Futurism: a History*. Berkeley and Los Angeles, University of California, 1968. Bibliography on 'Italian Futurism and Marinetti', pp. 445–446. Index references to Marinetti, Boccioni, etc.

49. Martin, Marianne W. *Futurist Art and Theory, 1909–1915*. Oxford, Clarendon Press, 1968. Selected bibliography, numerous footnotes.

50. Martini, Carlo. *'La Voce': storia e bibliografia*. Pisa, Lischi, 1956. Complemented by Enrico Falqui: *Indice della 'Voce'*. Con un avvertenza di G. De Robertis. Rome, Ulpiano, 1938.

51. Pierre, José. *Le Futurisme et le dadaïsme*. Lausanne, Rencontre,1967. Futurism, pp. 11–51. – Documents, pp. 98–113. Chronology, biography, bibliography.

52. Rischbieter, Henning, ed. *Art and Stage in the Twentieth Century*. Greenwich, Conn., New York Graphic Society, 1968. Articles by Carrà, Prampolini, etc. Documentation on Futurist design. Translated from the German.

53. Scalia, Gianni, ed. *'Lacerba'* – *'La Voce'* (*1914–1916*). 2. ed. Turin, Einaudi, 1961. Partial reprints (reset letterpress) of two important periodicals of the Futurist epoch.

54. Scrivo, Luigi, ed. *Sintesi del Futurismo: storia e documenti*. Rome, Bulzoni, 1968. 78 manifestos, many in facsimile.

55. Soby, James Thrall. *Contemporary Painters*. New York, The Museum of Modern Art, 1948. Commentary on Futurism and Boccioni in 'Italy: two movements, two paintings', pp. 104–114.

56. Soby, James Thrall and Barr, Alfred H., Jr. *Twentieth-Century Italian Art*. New York, The Museum of Modern Art, 1949. 'Early Futurism' by Alfred H. Barr, Jr., pp. 7–16. Catalogue of the exhibition, pp. 125–135. Bibliography by Bernard Karpel, pp. 136–144.

57. Soffici, Ardengo. *Primi principi di un'estetica futurista*. Florence, Vallecchi, 1920.

58. Taylor, Joshua C. *Futurism*. New York, The Museum of Modern Art, 1961. Sections on Balla, Severini, Carrà, Russolo, Boccioni. Biographies and catalogue of the exhibition. Also translations of Boccioni letters to Vico Baer and four Futurist manifestos. Chronology. Bibliography by Bernard Karpel. Also note bibl. 24.

59. Torre, Guillermo de. *Historia de las literaturas de vanguardia*. Madrid, Guadarrama, 1965. Ch. 1: 'Futurismo', pp. 105–188. Bibliography, pp. 189–194.

60. Venturi, Lionello. *Italian Painting from Caravaggio to Modigliani*. Geneva, Skira, 1952. Futurism, 129–141. Biographies, bibliographies.

61. Weber, Eugen, ed. *Paths to the Present. Aspects of European Thought from Romanticism to Existentialism.* New York, Dodd Mead, 1964. Topics include Futurism, reported through sources and commentary.

62. Zevi, Bruno. *Storia dell' architettura moderna*. 2. ed. Turin, Einaudi, 1953. Commentary on "Il movimento futurista" and Sant'Elia. With associated bibliographies (see index).

MONOGRAPHS

63. Apollonio, Umbro. *Antonio Sant' Elia*. Milan, Il Balcone, 1958. Supplementary documentation by Leonardo Mariani.

64. Ballo, Guido. *Boccioni: la vita e l'opera*. Milan, Il Saggiatore, 1964. Monumental monograph. Extensive documentation of works, chronology, comprehensive bibliography.

65. Boccioni, Umberto. *Gli scritti editi e inediti. A cura di Zeno Birolli; prefazione di Mario De Micheli.* Milan, Feltrinelli, 1970. Exhaustive anthology of writings presented in classified groups.

66. Bucarelli, Palma, ed. *Enrico Prampolini*. Rome, De Luca, 1961. Texts by Prampolini, chronology, bibliography. Constitutes catalogue of exhibition at Galleria Nazionale d'Arte Moderna, Rome.

67. Carrà, Carlo. *La mia vita*. Rome, Longanesi, 1943. Second edition: Milan, Rizzoli, 1945.

68. Corra, Bruno. *Per l'arte nuova della nuova Italia*. Milan, Studio Editorale Lombardo, 1918. An anthology of essays and manifestos.

69. Fagiolo dell'Arco, Maurizio. *Balla: ricostruzione futurista dell'universo*. Rome, Bulzoni, 1968. Complemented by his *Omaggio a Balla* (Rome, Bulzoni, 1967).

70. Lemaître, Maurice, ed. *Luigi Russolo: l'art des bruits*. Paris, Masse, 1954.

71. Pacchioni, Guglielmo. *Carlo Carrà*. Milan, Il Milione, 1945. Extensive bibliography. Second edition, 1959.

72. Pratella, Francesco Balilla. *L'Aviatore Dro*. Milan, Casa Musicale Sonzogno, 1920. 'Tragic poem in three acts'. Music not included.

73. Pratella, Francesco Balilla. *Musica futurista per orchestra. Riduzione per pianoforte.* Bologna, Bongiovanni, 1912. Cover by Boccioni.

74. Russolo, Luigi. *The Art of Noise*. New York, Something Else Press, 1967. Translation by Robert Fillion of 'L'Arte dei rumori' and Russolo's brief 'Primo concerto di intonarumori futuristi'.

75. Russolo, Maria Z., Ugo Nebbia, and Paolo Buzzi. *Russolo, l'uomo, l'artista*. Milan, Corticelli, 1958.
76. Severini, Gino. *Tutta la vita di un pittore*. Milan, Garzanti, 1946.
77. Venturi, Lionello. *Gino Severini*. Rome, De Luca, 1961.

EXHIBITION CATALOGUES
A cross-section follows. For a critical list (1912–1917) see Martin (bibl. 49); for an extended list (1910–1961) see Carrieri (bibl. 23); for an exhaustive record see Gambillo (bibl. 31).

78. London. Sackville Gallery. *Exhibition of Works of the Italian Futurist Painters*. March 1912. Annotated catalogue. Three texts, reprinted in Taylor, pp. 124–129 (bibl. 58) are 1. 'Initial Manifesto of Futurism (20 February 1909)'. – 2. 'Futurist Painting: Technical Manifesto (11 April 1910)'. – 3. 'Exhibitors to the Public (5, February 1912)'. No. 1–2 are also in Chipp-Taylor (bibl. 24).
79. San Francisco. Panama–Pacific International Exposition. *Catalogue de luxe of the Department of Fine Arts*. Edited by John E. D. Trask and J. N. Laurvik. San Francisco, Elder, 1915. Boccioni text, pp. 123–127: 'The Italian Futurist painters and sculptors'.
80. Venice. Esposizione biennale internazionale d'arte. *Catalogo*. 1950, 1960. XXV Biennale: 'I firmatari del primo manifesto futurista'. Preface by Umbro Apollonio. .– XXX Biennale: 'Mostra storica del futurismo'. Text by Guido Ballo.
81. Winterthur, Kunstverein. *Il Futurismo*. 4 Oct.–15 Nov. 1959. Excerpts from manifestos, essay by Carola Giedion-Welcker, biographical notes. First shown at the Ente Prima Roma at the Palazzo Barberini, summer 1959, preface by Aldo Palazzeschi.
82. Milan. Palazzo Reale. *Arte italiana del XX secolo da collezioni americani*. 30 Apr.–26 June, 1960. Introduction by James Thrall Soby. Sponsored by Ente Manifestazioni Milanese and the International Council of the Museum of Modern Art. 192

exhibits; plates, pp. 19–190.
83. Paris. Musée National d'Art Moderne. *Les Sources du XXᵉ Siècle: les Arts en Europe de 1884 à 1914*. 4 Nov. 1960–23 Jan. 1961. Prefaces by Jean Cassou, Giulio Carlo Argan, Nikolaus Pevsner. Commentaries on the Italian artists by Giovanni Carandente.
84. New York. Museum of Modern Art. *Futurism*. 31 May–5 Sept. 1961. Shown also at Detroit Institute of Art, Los Angeles County Museum. 129 exhibits. Same title as Taylor (bibl. 58).
85. New York. Sidney Janis Gallery. *Futurism*. 22 March–1 May 1954. 33 exhibits devoted to the 'original signatories of the Futurist manifesto, February 1910 . . . in the high period . . . 1909–1914: Balla, Boccioni, Carrà, Russolo, Severini'. Quotation from Janis: *Abstract and Surrealist Art in America* (New York, Reynal & Hitchcock, 1944).
86. Como. Villa Olmo. *Antonio Sant' Elia*. Como, 1962. Catalogue, edited by Caramel and Longatti, of the permanent exhibition at the Villa.
87. San Diego. Fine Arts Gallery. *Color & Form, 1909–1914. The Original Evolution of Abstract Painting in Futurism, Orphism, Rayonism, Synchromism and the Blue Rider*. 20 Nov. 1971–2 Jan. 1972. Text by Henry G. Gardner: 'The evolution of abstract painting'; by Joshua C. Taylor: 'The concept of abstraction in Italy'. Footnotes, chronology. General bibliography, pp. 97–103. Also shown at Oakland (25 Jan.–5 Mar.) and Seattle (24 Mar.–7 May).

SPECIAL NUMBERS
88. *L'Amour de l'Art* (Paris). Nov. 1934. Italian number, articles and bibliography. Later incorporated into bibl. 37 as noted.
89. *L'Arte Moderna* (Milan). Editor: Franco Russoli; assistant: Renata Negri. Vol. 5, 1967. Vol. 5, nos 37–45 on Futurism, with texts largely by Maurizio Calvesi. No. 45, 'Antologia critica', includes index and bibliography. Additional documentation in

vol. 14, no. 129, pp. 557 (index), pp. 605–606 (bibliography). Also issued by same publisher, Fratelli Fabbri, in book format.

90. *La Biennale di Venezia* (Venice) no. 36–37, July–Dec. 1959. Futurist number. Numerous articles including Maurizio Calvesi. Bibliography.

91. *Cahiers d'Art* (Paris) Vol. 25, no. 1, 1950. Special number (276 pp.) edited by Christian Zervos: "Un demi-siècle d'art italien." Texts, manifestos, documentation.

92. *La Martinella di Milano* (Milan) Oct. 1958. Special number on Sant'Elia, v. 12, no. 10, pp. 523–543. Bibliography.

93. *Sipario* (Milan) Dec. 1967. Articles, scripts, manifestos on Futurist theatre.

94. *Der Sturm* (Berlin) Mar. 1912–Dec· 1913. Relevant Futurist material was published by the editor, Herwarth Walden, in nos. 101, 104, 105, 107, 110, 111, 112, 132, 133, 136, 137, 150,

151, 172, 173, 190, 191 during the period specified.

PERIODICALS
Major and minor Italian periodicals are conveniently indexed in Falqui (bibl. 4) and comprehensively in Gambillo (bibl. 31).

95. *Lacerba* (Florence). Editor: Giovanni Papini. Vol. 1, no. 1 – Vol. 3, no. 22, 1 Jan. 1913–22 May 1915. Articles, manifestos, reproductions. Reprint (bibl. 21, 53).

96. *Poesia* (Milan). Editor: Filippo Tommaso Marinetti. Vol. 1, 1905– Vol. 9, 1909. Primarily a literary journal, *Poesia* was a leading publisher of Futurist articles, manifestos, and an anthology by the editor (bibl. 46).

97. *La Voce* (Florence). Editor: Giuseppe Prezzolini; briefly: Giovanni Papini. Vol. 1, 20 Dec. 1908–Vol. 8, 31 Dec. 1916. An anti-traditionalist voice. Associated art critic: Ardengo Soffici. Note bibl. 50, 53.

List of Illustrations

31 *Little Girl Running on a Balcony*, 1912. Oil on canvas, 49¼ × 49¼ (125 × 125). Civica Galleria d'Arte Moderna, Milan.

34 *The Violinist's Hands*, 1912. Oil on canvas, 29½ × 20½ (75 × 52). E. Estorick collection, London.

35 *Dynamic Depths*, 1912. Tempera on paper, 13¾ × 19¾ (35 × 50). Mattioli collection, Milan.

61 *Study for 'Iridescent Interpenetration'*, 1912. 8⅝ × 7¼ (22 × 18). From the Düsseldorf notebook.

62 *Study for 'Iridescent Interpenetration'*, 1912. 8⅝ × 7¼ (22 × 18). From the Düsseldorf notebook.

63 *Iridescent Interpenetration, No. 4*, 1912–13. Oil on stretched paper, 29⅛ × 21½ (74 × 54). Palazzoli collection, Milan.

64 *Iridescent Interpenetration*, 1912. Oil on canvas, 39⅜ × 23⅝ (100 × 60). H. L. Winston collection, Birmingham, Mich.

66 *Plasticity of Lights + Speed*, 1913. Lacquer on paper, 27½ × 39⅜ (70 × 100). Slifka collection, New York.

75 *Vortex*, 1913. Oil on paper, 29¼ × 39⅜ (74·5 × 100). Balla collection, Rome.

76 *Atmospheric Densities*, 1913. Oil on stretched paper, 22 × 41⅜ (56 × 105). Private collection.

98 *Study for 'Mercury Passing in Front of the Sun'*, 1914. Oil on paper, 21⅝ × 17¾ (55 × 45). H. L. Winston collection, Birmingham, Mich.

113 *Boccioni's Fist*, 1915. Construction in iron, from a design for the letterheading of the Futurist movement, h. 23⅝ (60). H. L. Winston collection, Birmingham, Mich.

137 *Sketch for 'Woodcutting'*, 1917. Oil on stretched paper, 19⅝ × 27½ (50 × 70). Mattioli collection, Milan.

139–40 *Stage Sets for Diaghilev's 'Feux d'artifice'*, 1917. Produced in Rome with music by Igor Stravinsky. Modern reconstructions.

BOCCIONI, UMBERTO (1882–1916)
III *Dynamism of a Woman*, 1914. Tempera and collage on canvas, 13¾ × 13¾ (35 × 35). Civica Galleria d'Arte Moderna, Milan.

IV *The Forces of a Street*, 1911. Oil on canvas, 39⅜ × 31¼ (100 × 80). Hängi collection, Basle.

2 *Morning*, 1909. Oil on canvas, 23⅝ × 21⅝ (60 × 55). Private collection, Milan.

3 *Impression*, 1909. Oil on cardboard, 9½ × 12⅛ (24 × 31). Cardazzo collection, Milan.

8 *The City Rising*, 1910. Oil on cardboard, 12⅝ × 18½ (33 × 47). Mattioli collection, Milan.

13 *States of Mind I: The Farewells*, 1911. Oil on canvas, 28 × 37½ (71·2 × 94·2). Nelson A. Rockefeller collection, New York.

14 *Study for 'Those Who Go'*, 1911. Indian ink on paper. Private collection, Milan.

15 *States of Mind II: Those Who Go*, 1911. Oil on canvas, 27½ × 37⅜ (70 × 95). Civica Galleria d'Arte Moderna, Milan.

16 *States of Mind III: Those Who Stay*, 1911. Oil on canvas, 28 × 29¾ (71 × 76). Civica Galleria d'Arte Moderna, Milan.

17 *Study for 'Those Who Stay'*, 1911. Indian ink on paper, 6⅛ × 3½ (15·5 × 9). Mattioli collection, Milan.

18 *States of Mind II: Those Who Go*, 1911. Oil on canvas, 27½ × 37¾ (70·3 × 96). Nelson A. Rockefeller collection, New York.

19 *States of Mind III: Those Who Stay*, 1911. Oil on canvas, 27⅝ × 37⅝ (70·3 × 95·6). Nelson A. Rockefeller collection, New York.

20 *States of Mind I: The Farewells*, 1911. Oil on canvas, 28 × 37⅝ (71 × 95·5). Civica Galleria d'Arte Moderna, Milan.

21 *Study for 'Antigraceful'*, 1912. Pencil on paper, 12⅝ × 12⅝ (32 × 32). M. Tarello collection, Genoa.

22 *Fusion of Head and Window*, 1911–12. Mixed media. Destroyed.

26 *Matter*, 1912. Oil on canvas, 88½ × 59 (225 × 150). Mattioli collection, Milan.

36 *Burst of Laughter*, 1911. Oil on canvas, 43¼ × 57¼ (110 × 145·5). The Museum of Modern Art, New York.

37 *Horizontal Volumes*, 1912. Oil on

canvas, 37⅜ × 37⅜ (95 × 95). Private collection, Milan.

38 *Study for 'Fusion of Head and Window'*, 1912.

39 *Development of a Bottle in Space*, 1912. Bronze. Museu de Arte Moderna, São Paulo.

40 *Study for 'Head + House + Light'*, 1912. Charcoal and watercolour on paper, 24 × 19¼ (61 × 48·8). Civica Raccolta Bertarelli, Milan.

41 *Elasticity*, 1912. Oil on canvas, 39⅜ × 39⅜ (100 × 100). R. Jucker collection, Milan.

70 *Unique Forms in Space*, 1913. Bronze, h. 43½ (110·5). Mattioli collection, Milan.

71 *Study No. 1 for 'Horse + Houses'*, 1913/14. Pen drawing with watercolour on paper. Civica Raccolta Bertarelli, Milan.

72 *Dynamism of a Cyclist*, 1913. Oil on canvas, 27½ × 37⅜ (70 × 95). Mattioli collection, Milan.

73 *Dynamism of a Human Body*, 1913. Oil on canvas, 39⅜ × 39⅜ (100 × 100). Civica Galleria d'Arte Moderna, Milan.

74 *Dynamism*, 1913. Brush drawing with coloured ink on paper, 9½ × 12 (24·2 × 30·5). Civica Raccolta Bertarelli, Milan.

89 *Muscles in Speed*, 1913. Destroyed sculpture.

91 *Drinker*, 1914. Oil on canvas, 34¼ × 33⅞ (87 × 86). R. Jucker collection, Milan.

92 *Still-life with Watermelon*, 1914. Oil on canvas, 31½ × 31½ (80 × 80). Städtische Galerie im Landesmuseum, Hanover.

93 *Pavers*, 1914. Oil on canvas, 39⅜ × 39⅜ (100 × 100). H. L. Winston collection, Birmingham, Mich.

106 *Horse + Rider + Houses*, 1914. Wood, cardboard, metal, 24⅜ × 48 (62 × 122). Peggy Guggenheim collection, Venice.

107 *Charge of the Lancers*, 1915. Tempera and collage on cardboard, 12⅝ × 19¾ (32 × 50). R. Jucker collection, Milan.

127 *Portrait of Maestro Busoni*, 1916. Oil on canvas, 69¼ × 47¼ (176 × 120). Galleria Nazionale d'Arte Moderna, Rome.

128 *Landscape*, 1916. Oil on canvas, 13 × 21⅝ (33 × 55). Mattioli collection, Milan.

BRAGAGLIA, ANTON GIULIO (1890–1960)

28 *Balla in Front of his Picture*, 1912. Photograph.

29 *Young Man Rocking*, 1911. Photograph.

33 *The Guitarist*, 1912. Photograph.

118–24 *Frames from the film 'Perfido incanto'*, 1916.

CARRÀ, CARLO (1881–1966)

I *The Red Horseman*, 1913. Tempera and ink on paper. R. Jucker collection, Milan.

II *Composition with Female Figure*, 1915. Tempera and collage, 16⅛×12¼ (41×31). Pushkin Museum, Moscow.

5 *Theatre Exit*, 1909–10. Oil on canvas, 27⅛ × 35⅞ (69 × 91). E. Estorick collection, London.

11 *Girl Swimmers*, 1910. Oil on canvas, 43¼ × 63 (110 × 160). Carnegie Institute, Pittsburgh, Pa.

23 *The Movement of the Moonlight*, 1911. Oil on canvas, 29½ × 27½ (75 × 70). Private collection, Turin.

24 *Portrait of Marinetti*, 1910–11. Oil on canvas. G. Agnelli collection, Turin.

42 *Simultaneity – The Woman on the Balcony*, 1912. Oil on canvas, 57⅞ × 52⅜ (147 × 133). R. Jucker collection, Milan.

43 *Plastic Transcendences*, 1912. Oil on canvas, 23⅝ × 19⅝ (60 × 50). (Destroyed during the 1915–18 War and later repainted by Carrà; Carrà collection, Milan.)

44 *Synthesis of a Café-Concert*, 1912. Charcoal and tempera on paper. E. Estorick collection, London.

45 *Rhythms of Lines*, 1912. Oil on canvas, 23⅝ × 19⅝ (60 × 50). (Destroyed during the 1915–18 War and later repainted by Carrà; Carrà collection, Milan.)

46 *The Milan Arcade*, 1912. Oil on canvas, 35⅞ × 20¼ (91 × 51·5). Mattioli collection, Milan.

67 *Interpenetration of Planes*, 1913. Oil on canvas, 23⅝ × 31½ (60 × 80). Lost.

68 *Woman + Bottle + House*, 1913.

237

Oil on canvas, 23⅜ × 19⅝ (60 × 50). (Destroyed during the 1915–18 War and later repainted by Carrà; Carrà collection, Milan.)
69 *Interpenetration of Prisms – Centres of Force of a Boxer*, 1913. Tempera on cardboard, 13 × 11⅝ (33 × 29·5). Civica Raccolta Bertarelli, Milan.
94 *Interventionist Demonstration*, 1914. Tempera and collage. Mattioli collection, Milan.
95 *Chase*, 1914. Tempera and collage, 15⅛ × 11¾ (38·5 × 30). Mattioli collection, Milan.
96 *Still-life*, 1914. Tempera and collage, 19⅝ × 15¾ (50 × 40). Private collection, New York.
97 *Suburban Café*, 1914. Tempera and collage, 18⅛ × 12¾ (46 × 32·5). Galleria Galatea, Turin.
112 *The Dancer of San Martino*, 1915. Tempera on paper. C. Tosi collection, Milan.

DEPERO, FORTUNATO (1892–1960)
131 *Plastic Motor-Noise Construction*, 1915.
132 *The Automata*, 1916. Private collection, Milan.

DUDREVILLE, LEONARDO (1885–)
83 *Everyday Domestic Quarrel*, 1913. Oil on canvas, 87¾ × 100 (223 × 254). Private collection.

FUNI, ACHILLE (1890–)
101 *Man Getting Off a Tram*, 1914. Oil on canvas, 46½ × 52 (118 × 132). Civica Galleria d'Arte Moderna, Milan.
102 *Self-portrait*, 1914. Tempera on canvas, 43¼ × 24⅜ (110 × 62). Formerly Palladini collection, Milan.

GIANNATTASIO, UGO (1888–1958)
87 *The Turnstile*, 1913. Oil on canvas, 65 × 74¾ (165 × 190). Musée National d'Art moderne, Paris.

GINNA, ARNALDO (1890–)
125 *Ginna and Marinetti engaged in Interventionist Fisticuffs, frame from the film 'Vita futurista'*, 1916.

MAREY, E. J. (1830–1904)
32 Chronophotograph, 1888 (?).

MORANDI, GIORGIO (1890–1964)
108 *Still-life*, 1914. Oil on canvas, 27½ × 17¾ (70 × 45). Private collection, Milan.
109 *Still-life*, 1915. Oil on canvas, 27½ × 17¾ (70 × 45). Private collection, Milan.

PRAMPOLINI, ENRICO (1894–1956)
78 *Futurist Portrait*, 1913. Ink on paper, 15¾ × 11⅜ (40 × 29). Prampolini collection, Rome.
79 *Spatial Rhythms*, 1913. Tempera and collage on cardboard, 18⅞ × 12¼ (48 × 31). Prampolini collection, Rome.
110 *Mechanical Rhythms*, 1914. Watercolour, 13 × 18⅞ (33 × 48). Prampolini collection, Rome.
111 *Woman + Surroundings*, 1915. Oil on canvas, 45⅝ × 19¾ (116 × 50). Private collection, Rome.
135 *Physiognomic Dynamism: Portrait of Count Bino Sanminiatelli*, 1916/17. Bronze. Vuattolo collection, Rome.
136 *Portrait of my Brother, Figure-Surroundings*, 1916/17.

ROSAI, OTTONE (1895–1957)
99 *Decomposition of a Street*, 1914. Oil and collage on canvas, 24¾ × 19¾ (63 × 50). F. Rosai collection, Florence.
100 *Landscape*, 1914. Oil on canvas, 28⅜ × 20⅛ (72 × 51). Cardazzo collection, Venice.

RUSSOLO, LUIGI (1885–1947)
7 *Tina's Hair – Effects of Light on a Woman's Face*, 1910. Oil on canvas, 28⅛ × 19¼ (71·5 × 49). Bruni collection, Rome.
25 *House + Light + Sky*, 1911. Oil on canvas, 39⅜ × 39⅜ (100 × 100). Kunstmuseum, Basle.
55 *Self-portrait*. Oil on canvas. Private collection.
56 *Self-portrait*, 1912. Oil on canvas. Lost.
57 *Self-portrait*, 1912.
58 *Self-portrait*, 1913. Oil on canvas, 18⅛ × 15 (46 × 38). Cardazzo collection, Venice.
59 *Solidity of Fog*, 1912. Oil on canvas, 39⅜ × 25⅝ (100 × 65). Mattioli collection, Milan.

SANT'ELIA, ANTONIO (1888–1916)
115 *Electric Power Station*, 1914. Pen and watercolour, 8 × 12¼ (20·5 × 31). Paride Accetti collection, Milan.
116 *Electric Power Station*, 1914. Pen and watercolour, 11¾ × 7⅞ (30 × 20). Paride Accetti collection, Milan.

SEVERINI, GINO (1883–1966)
V *Tuscan Landscape*, 1914. Oil on canvas, 25⅝×19¾ (65×50). Private collection, Milan.
VI *Nord-Sud*, 1912. Oil on canvas, 25⅝×19¾ (65×50). Emilio Jesi collection, Milan.
6 *The Wafer Seller*, 1908–09. Oil on canvas, 23¼ × 28⅜ (59 × 72). M. A. Prunières collection, Paris.
9 *The Boulevard*, 1910. Oil on canvas, 25⅝ × 36¼ (65 × 92). E. Estorick collection, London.
47 *Still-life with Flask and Playing-cards*, 1912. Collage, 26⅜ × 21⅝ (67 × 55). Private collection, Milan.
48 *The Bear's Dance*, 1912. Tempera on paper, 15 × 20⅞ (38 × 53). Private collection, Milan.
50 *The Dancer in Blue*, 1912. Oil and sequins on canvas, 24 × 18⅛ (61 × 46). Private collection, Milan.
51 *Self-portrait*, 1912. Oil on canvas, 36¼ × 25⅝ (92 × 65). Zack collection, Toronto.
52 *Dancer at Bal Tabarin*, 1912. Oil on canvas, 24 × 18⅛ (61 × 46). Private collection, Milan.
84 *Party in Montmartre*, 1913. Oil on canvas, 45⅝ × 35 (116 × 89). Zeisler collection, New York.
85 *Portrait of Marinetti*, 1913. Mixed media, 25⅝ × 21¼ (65 × 54). Benedetta Marinetti collection, Rome.
86 *From Nothing to the Real*, 1913. Pastel and tempera. Severini collection, Paris.
103 *The Collapse*, 1914. Oil on canvas, 36 × 28¾ (91·5 × 73). Sidney Janis Gallery, New York.
104 *Spherical Expansion of Centrifugal Light*, 1914. Oil on canvas, 24⅜ × 19¾ (62 × 50). Private collection, Milan.
105 *War*, 1914–15. Oil on canvas, 24 × 19¼ (61 × 50). Bergamini collection, Milan.
134 *Still-life*, 1918. Oil on canvas, 19¾ × 24¼ (50 × 61·5). Private collection, Turin.

SIRONI, MARIO (1885–1961)
77 *Self-portrait*, 1913. Oil on canvas, 20⅞ × 19¼ (53 × 49). Civica Galleria d'Arte Moderna, Milan.
129 *Harlequin*, 1916. Collage and tempera. Private collection, Milan.
130 *Self-portrait*, 1916. Drawing, 9⅞ × 7½ (25 × 19). Private collection, Milan.

SOFFICI, ARDENGO (1879–1964)
53 *Decomposition of the Planes of a Lamp*, 1912. Oil on cardboard, 13¾ × 11¾ (35 × 30). E. Estorick collection, London.
54 *Lines and Volumes of a Street*, 1912. Oil on canvas, 20½ × 17¾ (52 × 45). Private collection, Milan.
81 *Composition with Ashtray*, 1913.
82 *Lines and Vibrations of a Person*, 1913. Oil on canvas, 21¼ × 18⅞ (54 × 48). Mattioli collection, Milan.

Index